D1266423

Painting Faces, Figures, and Landscapes

Painting Faces, Figures, and Landscapes

By Everett Raymond Kinstler

Whatever object you are painting, keep in mind its prevailing character, rather than its accidental appearance.

Benjamin West

It seems to be a law of nature that no man is ever loath to sit for his portrait. A man may be old, he may be ugly, he may be burdened with grave responsibilities to the nation . . . but none of these considerations, nor all of them together, will deter him from sitting for his portrait.

Sir Max Beerbohm

Feeling without control is the mark of the dilettante. An artist must strike a balance between the two.

Vladimir Horowitz

WATSON-GUPTILL PUBLICATIONS / NEW YORK

First published in 1981 in the United States and Canada by Watson-Guptill Publications,
a division of Billboard Publications, Inc.,
1515 Broadway, New York, N.Y. 10036

Library of Congress Cataloging in Publication Data

Kinstler, Everett Raymond.
 Painting faces, figures, and landscapes.

 Includes index.
 1. Kinstler, Everett Raymond. 2. Artists—United
States—Biography. 3. Artists' studios—United States.
4. Artists' materials. 5. Art—Technique. I. Title.
N6537.K524A2 1981 759.13 80–29264
ISBN 0–8230–3625–1

Manufactured in Japan

First Printing, 1981

Again, to the four gals in my life:
Lea, Kate, Dana —and my mother.

And to my loyal friend, master photographer
Tony Mysak, whose care, craft, and friendship
have been a constant source of value and strength.

I am indebted to many friends in the arts whose interest and affection have enriched my life: to my two oldest pals, Robert Brustein and Lee Bobker; to Chen Chi, Peter Cox, Bill Draper, Frank Field, Mary Beth McKenzie, Fay Moore Donoghue, Arthur Harrow, Clark Hulings, Hugh MacKay, Vincent Malta, Tom Orlando, Daniel J. Terra, Bettina Steinke, and Wilson Hurley; to Andrea Ericson of Portraits, Inc., and Charles Schreiber, House of Heydenryk, Inc.; to my two departed, loving friends, Inez Field and Richard Seyffert; to Marsha Melnick, who conceived of this book; to Joe Singer, who helped me remember; and most of all, to Donald Holden, who put it all in focus.

Contents

Professional History

Like most kids who grew up in the 1930s, I first saw art in the pages of books and magazines—and comic strips. From the age of five or six, I would pore over the illustrations of Howard Pyle and N. C. Wyeth. I looked forward eagerly to the newspapers and Sunday supplements that carried comic strips like Alex Raymond's "Flash Gordon" (which anticipated science fiction movies by decades), Hal Foster's "Prince Valiant," and Milton Caniff's "Terry and the Pirates."

Later on, I discovered European illustrators like Menzel, Vierge, Abbey (actually an American who lived in Europe), and especially Gustave Doré, all masters of pen and ink. Doré's illustrations of *Don Quixote*, the Bible, Balzac, and Poe nourished my interest in reading and stimulated the urge to illustrate and interpret stories.

I was tremendously excited by the imagery and the superb drawing of these men, and I wanted, more than anything else in the world, to draw like them.

Growing up in New York City, I went to the usual city public schools, played baseball, and did all the things that kids do—but most of all, I drew! By the time I was in the first grade, I was copying my favorite illustrations out of magazines. I drew constantly in black and white, charging my fellow students the price of a soft drink for a pen or pencil drawing of a movie star or a sports figure.

When I was thirteen, I was lucky enough (or so I thought) to be accepted into the famous High School of Music and Art, a school for gifted children, many of whom had gone on to become well-known artists. But this was a period when abstract art was *in* and "realistic interpretation" was frowned upon. My interest in realistic drawing and illustration was discouraged.

So, midway through my second year at Music and Art, I decided that I was in the wrong place, and I transferred to the High School of Industrial Art. This was frankly a vocational or trade school, a no-nonsense place that focused on the working disciplines and art techniques that a young artist needed to find a job and earn a living. I was encouraged to draw realistically. And I learned a lot of the basics that illustrators were expected to know in those days, like ink drawing with pen and brush, scratch board drawing, lettering, and the various reproduction methods used to print art in books and magazines.

But just before my sixteenth birthday, I made a decision that was to shape the rest of my life: I decided to leave school and try to enter the professional art field. Looking back, I realize that I was absolutely consumed with the desire to go out and become involved with the business of making a living at art. Years later, an actor friend said it was like his decision to run away and join the circus as the first step in his career on the stage. I had been a good student, and this was a time when leaving school was something nobody did if he could avoid it—something to be ashamed of. But somehow my parents seemed to understand. I was fortunate enough to have their love and support in seeking a career.

MY FIRST AND LAST ART JOB

I wish that I could say that it was talent that landed me my first salary. But it was just the World War II manpower shortage. Practically every man was away in the service, leaving many vacancies in the job market. I answered a comic-book publisher's ad for an "apprentice inker" at a salary of $18 for a six-day week, and I was hired. I was just sixteen.

Student Drawing, *pen and ink on illustration board, 8¾″ × 13¾″ (22 × 35 cm). Collection of the artist. At the High School of Industrial Art, I learned to use the crowquill pen, which has a fine point for detail. I think I adapted this drawing from a reproduction of a picture by the British marine painter Norman Wilkinson.*

Pen Drawing for Comic Book. *Since comic books were drawn and reproduced in line, I also learned to handle a pen and india ink to render intricate tone and textures. This was a crime comic book published in the 1950s.*

11

At this point in my life, I had no interest in painting or even in color. I was fascinated by black-and-white drawing and I loved the comics. It was a perfect first job.

The mechanics of creating comic strips haven't changed much since I first broke into the field. Panels, representing pages, are designed and drawn in pencil by one artist, inked by another, and finally lettered by a third. Occasionally, one artist is skilled enough to combine the first two functions, and in rare cases, all three. I'd receive the penciled pages, and then I'd ink in the figures and background with a brush at the rate of six to eight panels a day, eight hours a day, with just Sunday as my day off.

This grueling routine was invaluable training for a young aspiring artist. I was called upon to draw hundreds of faces, figures, animals, objects, and landscape backgrounds. I learned how to tell a story with pictures and to hold the reader's attention. This meant having to portray action, suggest mood, render accurate detail, and carry a narrative married to dialogue. Subject matter ranged from history and costume drama to science fiction, westerns, contemporary romances, even animals. I was constantly challenged to make creative use of perspective, dramatic angles and compositions, and all sorts of shading and other special effects to convey the script. I also learned how to get a job done quickly, simply, and on time.

FREE-LANCING

After a year in this staff job, I wanted to see if I could make it on my own. In the little spare time I had—I was still working a six-day week—I began to approach other publishers for free-lance assignments. The best known house was Street & Smith, the oldest and largest publishers of "pulp magazines"—named for the cheap paper they were printed on and the forerunners of today's paperback books. They gave me some work and I began moonlighting.

These thick, pocket-size magazines consisted of short stories for a mass audience, each story with a single black-and-white illustration. I got commissions to do "The Shadow" and "Doc Savage," who were familiar figures in popular fiction in those days and comparable to the heroes of today's TV cop shows. Drybrush drawings were made with india ink and an old, worn sable brush to produce a rough, granular tone that was ideal for reproduction on the coarse "pulp."

I continued to show my work to publishers, and I gradually got enough work to assure me of a free-lance income. So, at the age of seventeen, I left my first and last salaried job to go it alone.

Now I was doing illustration jobs for the "pulps" and also doing comic strips. At last I got to create my own strips, inking and penciling adventure strips that ranged from patriotic war stories to "Zorro," "Tom Mix," and "Hawkman." Like most kids in those days, I'd gone to the movies every week. I thought in cinematic terms. I was producer, director, researcher, set designer, costume designer, cinematographer, and film editor of my own motion pictures in comic-strip form.

I began to build up a reference "morgue" of photos, clippings, and movie stills of every subject that I might have to draw. This file, coupled with the New York Public Library, gave me all the research material I needed for a tremendous diversity of assignments. I was still a teenager, but I was eager to learn—and I was having great fun learning to behave like a professional.

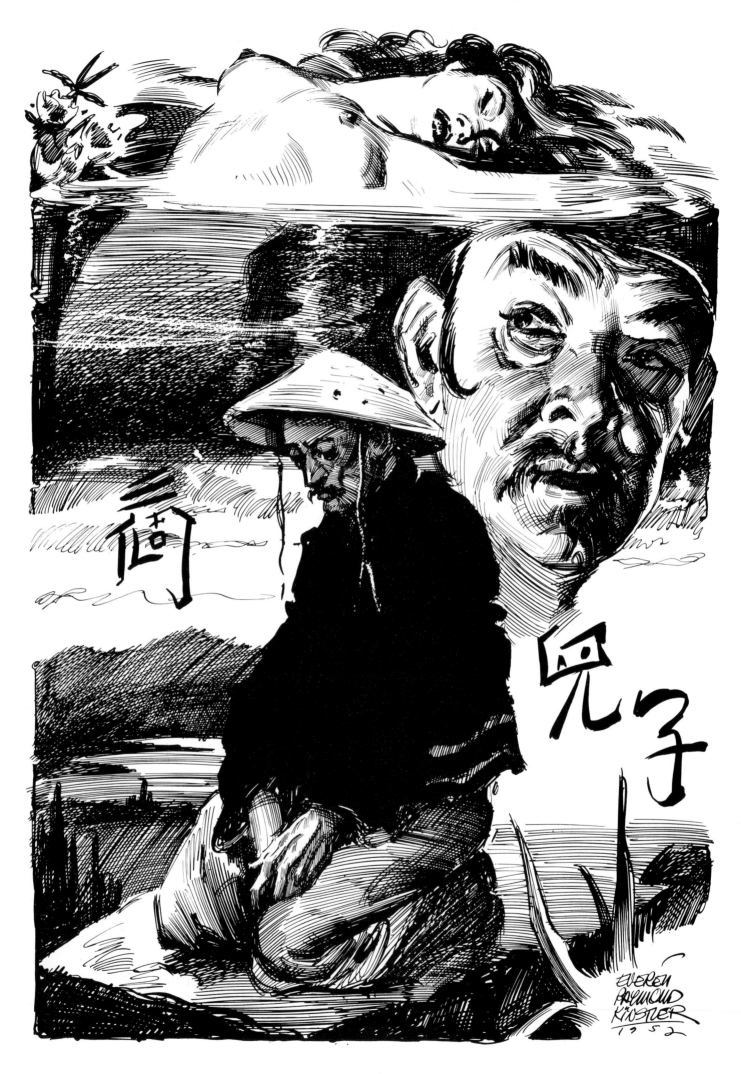

EVERETT RAYMOND KINSTLER

Science Fiction Pulp Magazine *(opposite page). This large drawing, roughly 28″ × 20″ (71 × 51 cm), was published in the* Avon Science Fiction and Fantasy Reader *in January 1953. Working on such a large scale, I found that I could "paint" large tonal areas with the pen. Only the jacket on the kneeling figure was drawn with a brush. If you could see the original pen drawings of Gibson, Flagg, and Christy, you'd be surprised at how big they are.*

Western Pulp Magazine *(left). Cowboy fiction was also an important market for the black-and-white illustrator in the 1950s. This drawing was done for a pulp magazine called* Ranch Romances. *I worked with a very loose, scribbly pen line to render the rumpled quality of the cowboy's coat. The corner of a razor blade was used to scratch the white lines into his dark trousers.*

Brush Drawing for The Shadow *(below). Probably the most popular pulp magazine of its day was* The Shadow, *for which I did this brush drawing. For the halftones I pasted on pieces of "shading film," which is a kind of thin, transparent, self-adhesive paper pre-printed with a pattern of lines or dots that is still sold in art supply stores that serve illustrators. At the time I did this drawing, I was very much under the influence of Tom Lovell, a marvelous illustrator who had done most of the drawings for this series before I got there.*

Pulp Magazine Cover. *This was the first oil painting I'd ever sold and my first cover. It's typical of the "hot dawg westerns" of the 1940s and 1950s. The art director had said he wanted a feeling of fire, and so I painted almost the entire picture in reds and yellows.*

BACK TO ART SCHOOL

While I was still working at a staff job, one of the *older* artists—he must have been thirty!—suggested that I ought to have more training, especially in working from life. He encouraged me to go back to art school.

Now that I was free-lancing, I could make my own schedule, and so I took his advice and enrolled in the Phoenix School of Art, with Franklin Booth, a brilliant master of pen and ink. But I soon realized that what I really wanted to do was study with the marvelous painter-illustrator Harvey Dunn, who taught at the Grand Central School of Art. So I quit Phoenix after just two weeks and headed for Grand Central—where I discovered that Dunn's classes were packed solid and had long waiting lists. My next stop was the Art Students League.

I began by attending some evening drawing classes with Jon Corbino, a regionalist painter who was a master of the figure. Working from life—with models, not clippings and photos—was an exciting experience and showed me all too clearly how badly I needed more of this training.

And then, one day, I saw a fine portrait by another League instructor, the legendary Frank DuMond, and my life took an important new turn. I elected to spend my afternoons studying with DuMond. This proved to be one of the pivotal decisions of my life.

FRANK V. DuMOND AT THE LEAGUE

Up to the time that I entered DuMond's class at the Art Students League of New York, I'd had practically no experience with color and I'd never used oil paint. My first oil painting was a monstrous head, twice life size. I used black for the shadows—probably because of my training in drawing comic strips—and white for the light. As Mr. DuMond walked toward my easel to look, I gestured like a traffic cop and blurted, "This is my *first* painting!" He put a kindly hand on my shoulder, looked from the painting to me, and said, "No—really?"

From that first meeting until Mr. DuMond's death seven years later, he was both my teacher and my friend. An American who was trained in France, he was an extraordinary human being and an excellent painter who had known the greatest American painters then living abroad, Whistler and Sargent. He was an enormously influential teacher whose students ranged from a great traditionalist like Norman Rockwell to pioneer modernists like John Marin and Georgia O'Keeffe. At the time of his death in 1951, he'd taught at the League for fifty-eight years! Although DuMond himself was a traditional painter, he had a remarkable ability to inspire the hearts and stimulate the minds of all kinds of students because he believed in curiosity and experimentation—as well as discipline.

I spent a fruitful year with Mr. DuMond. Drawing and painting from life was a new and tremendously enjoyable experience. So was the summer painting outdoors with him in Vermont. To support myself at the League, I continued to produce comics and illustrations. In the morning I showed my work to editors. Then I worked far into the evening, often keeping myself going around the clock with coffee and cigarettes to meet those constant deadlines. Between the free-lance assignments, I spent every possible daylight hour learning to paint.

DuMond insisted on working over your canvas. I used to dread it when he'd pick up the brush and his hand would shake. But he'd zero in like a fencer. He was always trying to pull your picture together by working everything toward a middle tone, saving the strong lights and darks for accents. He'd constantly glaze and scumble over your tones, solidifying and simplifying, and making very subtle transitions between tones.

He always encouraged his class at the Art Students League to paint more than the model. If I complained that I couldn't see the model because there were students in front of me, he'd say, "Why don't you go to the back of the room and paint the room itself with all the people?" I've always remembered that, and I suggested the same thing to my own students at the League many years later.

One of my most valuable sessions with DuMond turned out to be one of those days when I was painting the room with all the students at work. The room was crowded and so was my canvas. I was struggling to create a convincing sense of space. DuMond came over and mixed a kind of "soup" that seemed like a delicate orange with a touch of cerulean blue to cool it. He scumbled that "veil" of tone over the more distant parts of my picture—and suddenly everything fell back into place. He always talked about what he

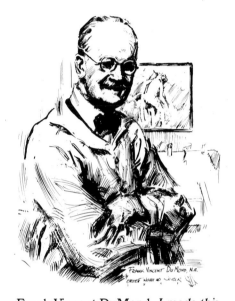

Frank Vincent DuMond. *I made this pen-and-ink drawing of my teacher, Frank DuMond, in 1951, which was the last year of his life. I hope I caught some of the kindliness and generosity of this man whose friendship meant so much to me. I now live and work in his former studio at the National Arts Club in New York City.*

17

called the "veil," and now I knew what he meant.

Later on, when I went with DuMond to Vermont and painted outdoors for the first time, he showed me how to do the same thing with the mountains. As you know, the grass on the mountain is *really* green, but the mountains look blue from the distance. DuMond's method was to paint a bluish "veil" over the distant mountain to create that sense of space, atmosphere, and cohesion. He taught his students to use that "veil" to make a picture compact and solid.

DuMond also talked endlessly about halftones, those silvery edges where the light meets the shadow on a head or a figure. He taught us that these transitions were cool—he actually called them "silver." Once again, he was teaching us that the middle tones—not the lights and darks—were what held a picture together.

He was an enormously popular instructor and he *deserved* that popularity.

Frank V. DuMond's influence on me was profound. He encouraged me and took a constant interest in my development. I first met him when I was eighteen years old; now, as I write about him more than thirty years later, I still feel a deep and immediate debt.

The most important thing that Mr. DuMond said to me was: "I won't try to teach you to paint, but to observe."

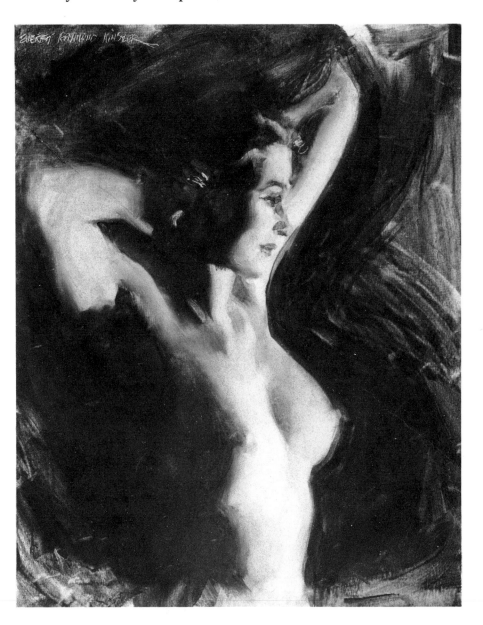

Nude, *oil on canvas, 20" × 16" (51 × 41 cm). Collection of Arthur Diamond. This was one of the oils I painted when I was still very much under the influence of Frank DuMond, with whom I studied at the Art Students League of New York. The painting was done in a very limited color range, mostly umbers and siennas and a yellowish white. The darks of the background were washed in very thinly. The shadows on the figure were also painted very thinly. I saved my heaviest strokes for the lights on the figure.*

Judas *(opposite page), oil on canvas, 21" × 16" (53 × 41 cm). Here's another painting from the days shortly after I studied with DuMond. The figure was inspired by one of the Passion plays. The psychological impact of this painting, which I still like after all these years, has a great deal to do with the turbulent, irregular brushwork in the background and on the figure; the moody lighting on the head; and the strange way that Judas twists his body away from you and then turns to look at you over his shoulder.*

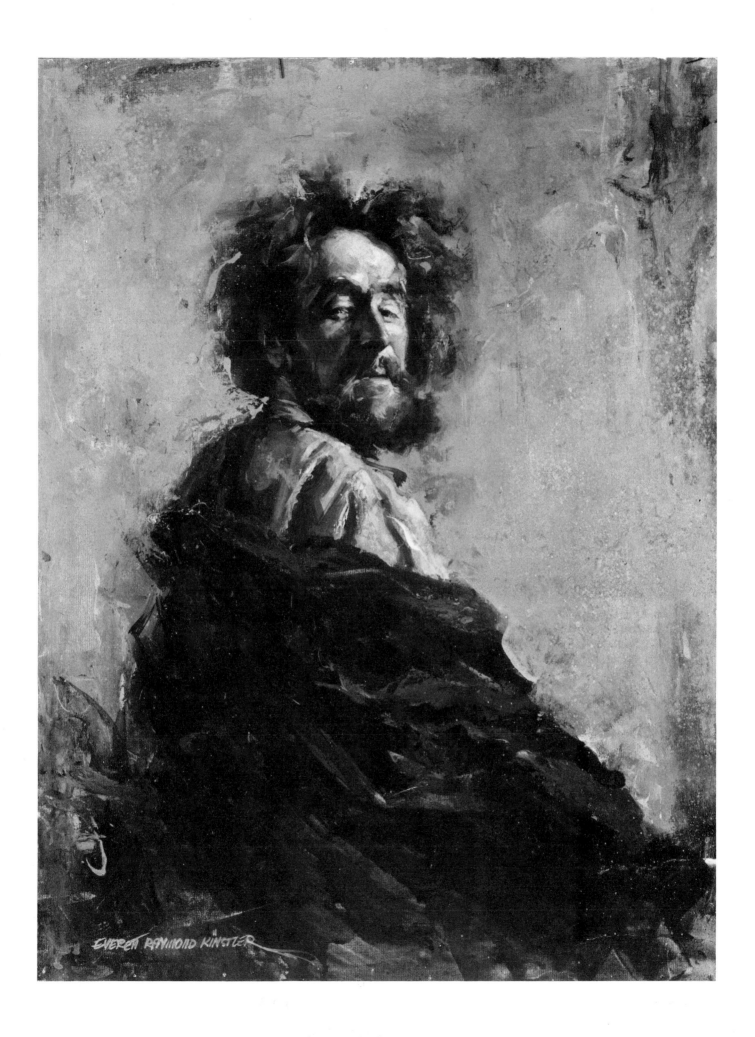

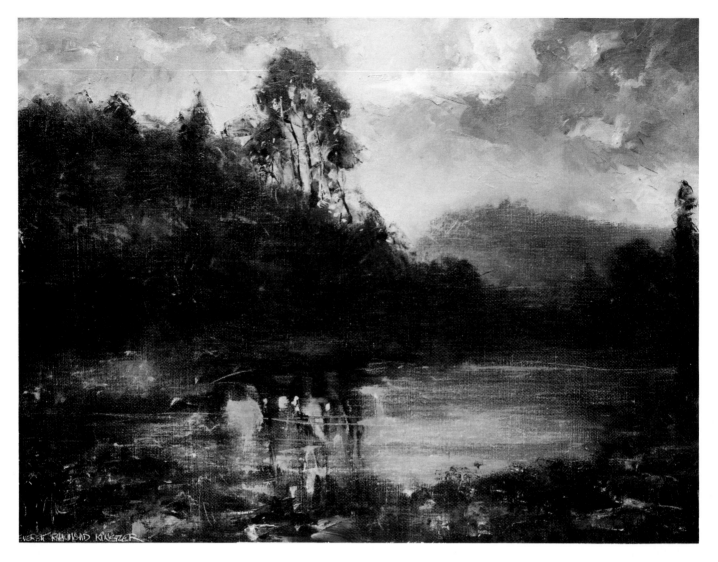

Crepuscule, *oil on canvas, 22" × 30"*
(56 × 76 cm). This moody, romantic
landscape was from my DuMond years,
but I was also very much under the
influence of the great French painter-
illustrator, Gustave Doré. I chose a
time of day when the sun was low in the
sky so that the shape of the land would
be a dark, brooding silhouette against
the glowing tones of the setting sun,
which are also reflected in the water in
the foreground.

WAYMAN ADAMS AND THE BRUSHSTROKE PAINTERS

At one point, I spent a few weeks studying portrait painting
with Wayman Adams in Elizabethtown, New York. Adams had been
a student of Robert Henri—he provided class notes for Henri's
superb book, *The Art Spirit*—and had a great gift for spontaneous
painting. He was a facile and colorful portrait painter who worked
with big, bold strokes.

Adams never painted on the student's canvas, so far as I can
remember. He would walk by, look over your shoulder, and then
make criticisms that were very short and to the point. Like Henri,
he worked the gesture. That is, he taught us that the gesture of the
brush should capture the movement of the subject. For example,
he once said to me: "When you paint the hair, make believe the
brush is a comb." He taught us to work for the candid camera shot,
to capture the vitality, the feeling. He was interested in that one eye
with the glint of the highlight in it.

I remember that he'd step back and look at his own canvas from
three, five, maybe six feet away before he made a stroke. Each
stroke was a decision. When he'd made that decision, he'd come
forward like a fencer and make a bold gesture with his brush.

Adams kindled my interest in the early twentieth-century mas-
ters of the bold, decisive brushstroke: John Singer Sargent, the
most famous portrait painter of his day, who painted magnificent
watercolors just for fun; Anders Zorn, the celebrated Swedish

portrait and figure painter, who was also one of the most original etchers of his day; Giovanni Boldini, a high-fashion Italian portrait painter who was famed for his dazzling brushwork, and Joaquin Sorolla, that glorious portrayer of Spanish sunlight. In New York's Metropolitan Museum of Art and Boston's Museum of Fine Arts, I was fascinated by rare examples of the work of Antonio Mancini, an extraordinary Italian painter whose work is virtually unknown on this side of the Atlantic.

AN INTERRUPTION BY UNCLE SAM

Toward the end of 1945, I was drafted into the army. By that time World War II was over, and I spent most of my service time at Fort Dix, New Jersey. As a sergeant in the peacetime army, I didn't have much to do. But Fort Dix is so close to New York City that friendly art directors sent me illustration assignments that I executed during my off-hours. I also produced a weekly comic strip for the army newspaper—strongly influenced by "Male Call," the popular strip that Milton Caniff had created for servicemen, featuring well-endowed young women who wore as little as the law would permit.

A giant in his profession, Milton Caniff was and still is a major influence on everyone who aspires to draw comic strips. Through his powerful drawings and his superb skill as a storyteller, Milt raised the adventure strip to the level of an art form.

BACK TO WORK

Saving "kept in training" by making countless drawings of soldier friends, I looked forward eagerly to returning to the League when I was discharged from the army in 1947. But Thomas Wolfe wrote that "you can't go home again," and so it was. I found that I'd entered a different phase of my life. Instead of going back to the Art Students League, I wanted to get on with my career.

I went back to drawing comic strips. But I also began to get book assignments: covers and inside illustrations in oil and watercolor. Paperback books were a new publishing phenomenon that would eventually grow to incredible proportions. For an aspiring illustrator with his eye on the great old illustrated magazines like the *Saturday Evening Post* and *Cosmopolitan*, paperback covers were a great opportunity. I painted covers for authors as diverse as Agatha Christie, D. H. Lawrence, W. Somerset Maugham, and Zane Grey.

I was learning more about the technical side of printing. I learned how to select my medium and adjust my style to suit the method that would be used to reproduce my art. For pulps or comics that were printed on cheaper paper, it was necessary to work with bold, simple forms and shapes, since fine lines would be lost when the drawing was reduced to fit the printed page. For this type of work, I generally made brush drawings. For book illustrations—which meant better printing, paper, and reproductive processes—I could use a pen, fine lines, and sometimes crosshatching.

At that time, paperback covers often bore very little relation to the content of the book—or ignored it altogether. I learned to adapt and remain flexible in order to get the assignment done. I began to use professional models or friends to pose for my illustrations; I worked from life and I also photographed my models. Comics and pulps barely paid enough to hire models, and so I learned a lot more

by doing book covers and magazine illustrations, which paid better and gave me more time to do a thorough job.

Although it wasn't always possible, I tried to read the story before I designed the picture. I usually submitted five or six watercolor sketches to the art director. When he selected the one he wanted, I would paint it in oil. If tight, detailed painting was required, I worked on illustration board, primed with gesso. If the art director wanted a looser look, I worked on stretched canvas. My cover oils were usually about 20″ × 24″ (51 × 61 cm), while the black-and-white illustrations for the inside pages were slightly larger. There's really no hard rule about sizes; I worked on that scale because it was comfortable for me.

Certain overnight jobs called for casein—this was before the development of acrylic—which dried quickly and reproduced well. I was always wary of using watercolor because the art director often required corrections that would wipe out the spontaneous quality of the painting.

I was so convinced that the art director would find something to change in every illustration that I deliberately drew or painted something that *didn't* belong in the picture, such as a hanging rope, a barrel, or some other prop. This would distract the art director. He'd ask me to make this minor change and not ask for any major ones. It's amazing how often this ploy worked!

If I could sum up these years, I'd say that an illustrator could almost always sell a picture that had the two C's: cowboys or cleavage, or both.

In the late 1940s, Fawcett Publications asked me to sign an exclusive contract to illustrate a series they were planning on a cowboy. I remember looking at photos of the proposed hero and saying that the books would never be successful: "It's absurd—white hair and black pajamas for a cowboy hero? He looks like a sissy!" The character I turned down was Hopalong Cassidy, one of the most successful personalities to be published in the 1950s.

MY FIRST STUDIO

I always confided in Frank DuMond, and I expressed my need for a studio. In 1949, he found me a modest studio with north light in his own building, the historic National Arts Club in New York City. I've been there ever since. Moving into the club was a milestone in my life. The members and residents of the club included leading artists, writers, and creative people in many fields. I was surrounded by extraordinary people—and I was also surrounded by originals by many of the American painters I admired. I was particularly excited by th work of George Bellows, who, like George Gershwin and Thomas Wolfe, reflected the American way of life so vividly and died in his forties.

While illustration paid the bills, I made time to paint. Both in my illustrations and in my independent painting, I concentrated on people, since the human face and figure had always interested me most. I was most stimulated when I was interpreting the individual character of a person.

I also managed to take two European trips, carrying a compact watercolor kit in my coat pocket. I filled sketchbooks with studies and notes of Paris, London, Italy, and the Alps. I was also able to visit many of the great museums, where I was thrilled to see the work of Rubens, Rembrandt, and Hals, as well as other masters from all periods. I returned from these trips stimulated and even more anxious to paint without the pressures of editors and deadlines.

Magazine Illustration in Oil. *I painted this illustration in oil, entirely in black and white, for a story called "The Midget Marshal," published in* Real *magazine in the late 1950s. An actor named Steve Holland posed for all the figures. After the art director approved my sketch, I'd show it to Steve and tell him what I wanted. As he posed he captured the mood and attitude of every actor in my little drama—from the bartender to the marshal to the man on the floor.*

Double-Page Magazine Illustration. *This story, called "The Three Musketeers," also appeared in* Real *magazine. The painting ran across two pages, with the split running down the big white space in the middle of the painting. Although Steve Holland posed for all three marshals, I did a lot of "homework" to find ways to make each figure look different. One marshal wears boots, while another wears chaps. The figure at the extreme left wears a glove on one hand but keeps the glove off the other so that he can reach for his gun.*

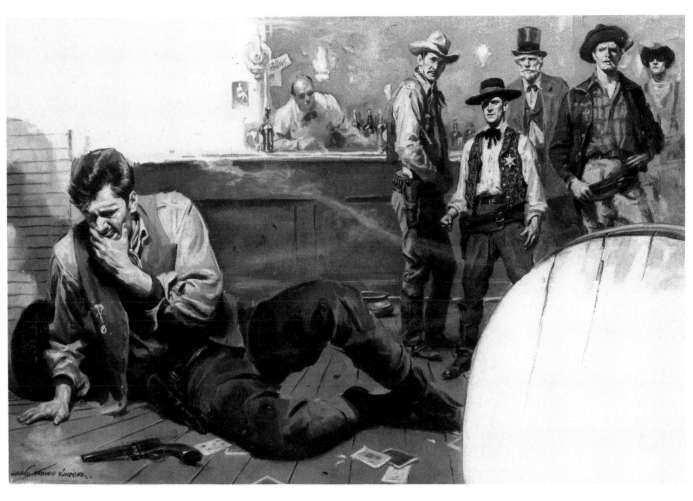

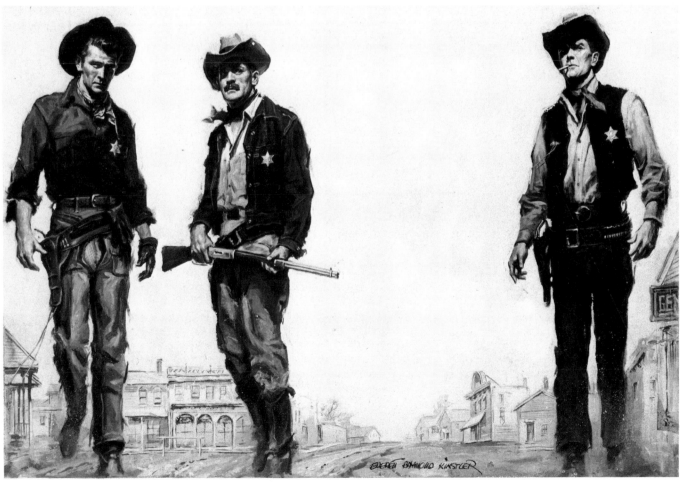

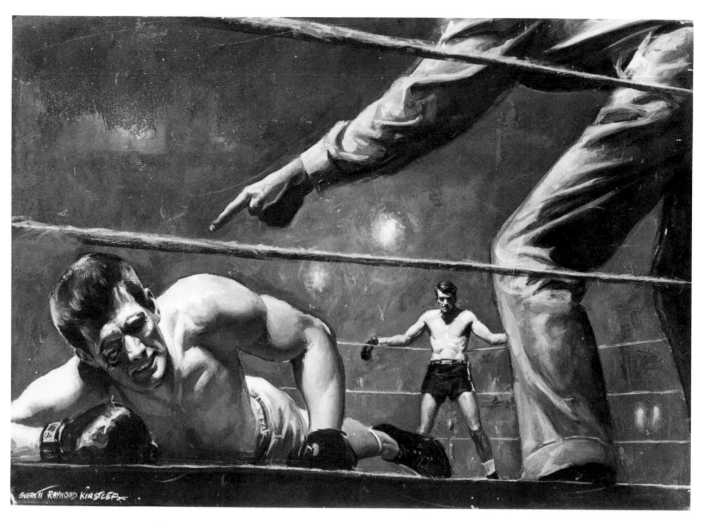

Magazine Illustration for Sports Fiction *(above). The title of this story was "An Eye for Pugs." I remember the caption that accompanied the illustration: "Beaten Mal tried to blink the blood away as the referee counted him out." Once again, I did my "homework" to make sure that details like the trunks, gloves, and shoes were accurate. But I had to make one thing inaccurate: the ropes were an important factor in the composition, and so I had to make them a lot thinner than they really were so they wouldn't obstruct the figures. This black-and-white oil painting also appeared in* Real.

Paperback Cover for Women in Love. *In the late 1950s it was the* artist's *work that sold paperbacks, even if the writer was as important as D. H. Lawrence. In painting this cover, I'm afraid my job was to treat this great novel like any other piece of spicy, romantic fiction. Unfortunately, I made the painting a little too spicy; the art director asked me to repaint the model's gown and cover her up a bit (see my original at right).*

Paperback Cover for Gone to Texas. *As illustrators "between engagements," we'd paint things that we thought art directors might use and then took them around. So this cover wasn't actually painted to order. I just happened to show the painting to the art director of Avon at the right time. He had a suitable book in the works, and he thought the painting would do the job. I'd painted it in oil on a 24" × 18" (61 × 46 cm) sheet of illustration board that had been sized and then primed with gesso. The smooth surface was particularly good for detailed work like the texture of the wall with the bullet holes.*

AVON
50c
G-1021

By the author of
"LADY CHATTERLY'S LOVER"

D. H. LAWRENCE

WOMEN in LOVE

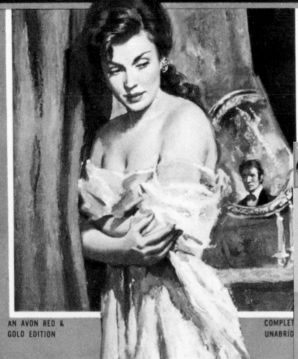

AN AVON RED &
GOLD EDITION

COMPLETE
UNABRID...

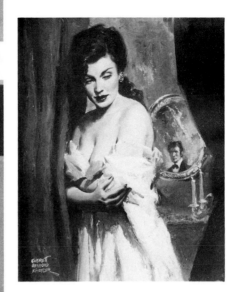

AVON
T-85

A THRILLING PAGE FROM AMERICAN HISTORY

GONE TO TEXAS

A story of the aftermath of the Civil War

35c

COMPLETE &
UNABRIDGED

J. W. THOMASON, JR.

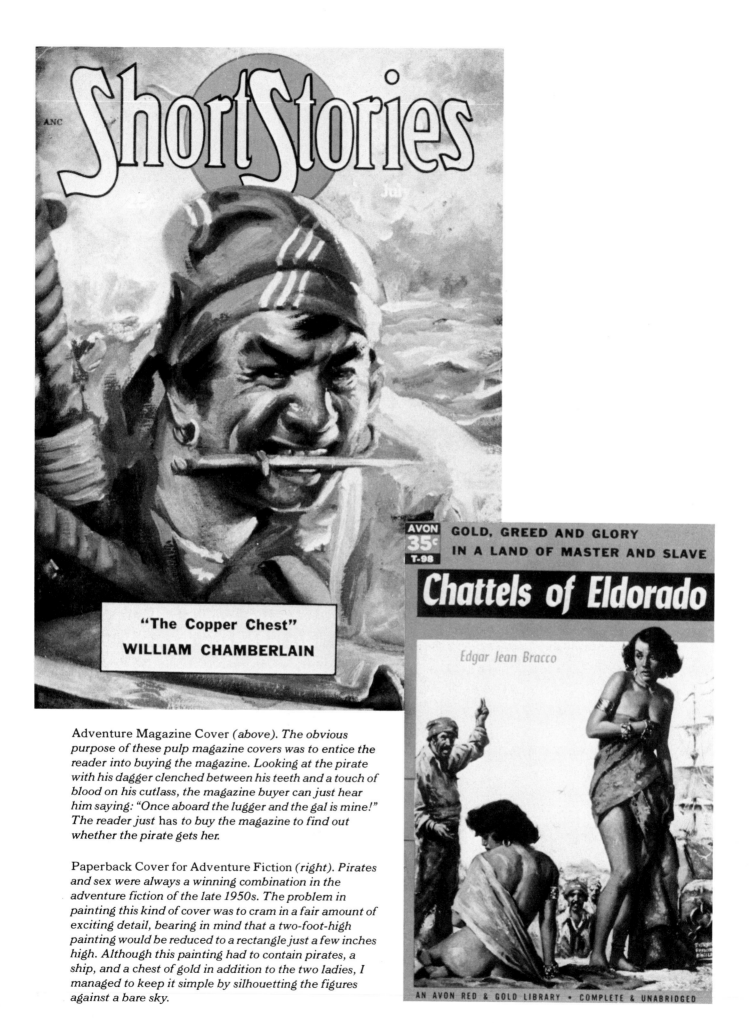

Short Stories

July

"The Copper Chest"
WILLIAM CHAMBERLAIN

GOLD, GREED AND GLORY
IN A LAND OF MASTER AND SLAVE

Chattels of Eldorado

AVON
35c
T-98

Edgar Jean Bracco

AN AVON RED & GOLD LIBRARY • COMPLETE & UNABRIDGED

Adventure Magazine Cover (*above*). *The obvious purpose of these pulp magazine covers was to entice the reader into buying the magazine. Looking at the pirate with his dagger clenched between his teeth and a touch of blood on his cutlass, the magazine buyer can just hear him saying: "Once aboard the lugger and the gal is mine!" The reader just has to buy the magazine to find out whether the pirate gets her.*

Paperback Cover for Adventure Fiction (*right*). *Pirates and sex were always a winning combination in the adventure fiction of the late 1950s. The problem in painting this kind of cover was to cram in a fair amount of exciting detail, bearing in mind that a two-foot-high painting would be reduced to a rectangle just a few inches high. Although this painting had to contain pirates, a ship, and a chest of gold in addition to the two ladies, I managed to keep it simple by silhouetting the figures against a bare sky.*

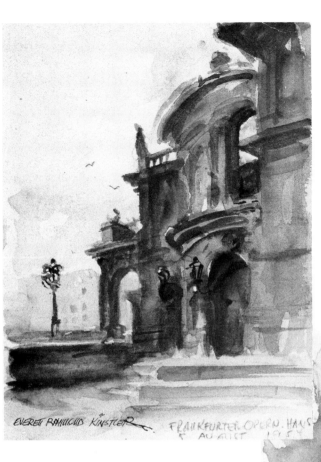

Frankfurt Opera House *(left)*, watercolor on paper, 7″ × 5½″ *(18 × 14 cm). Collection of the artist. I painted this little watercolor on my European trip in 1954. I used to carry a wonderful little Winsor & Newton watercolor box that consisted of a bottle of water, a tiny box of pan colors, and a little compartment for a brush, all in one. This rig was ideal for rapid, on-the-spot sketches like this "quickie" of the bombed-out opera house after World War II.*

English Garden, Munich *(below)*, watercolor on paper, 10½″ × 7¼″ *(27 × 19 cm). Collection of the artist. Spotting this bored hack driver waiting for a client on the back seat of the carriage, I painted this little watercolor sketch in fifteen minutes. I developed some of these watercolor sketches into larger pictures, but because this one seemed to tell the whole story, I never did anything else with it.*

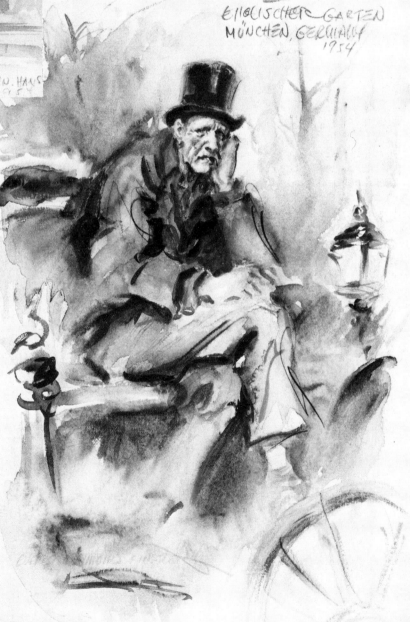

27

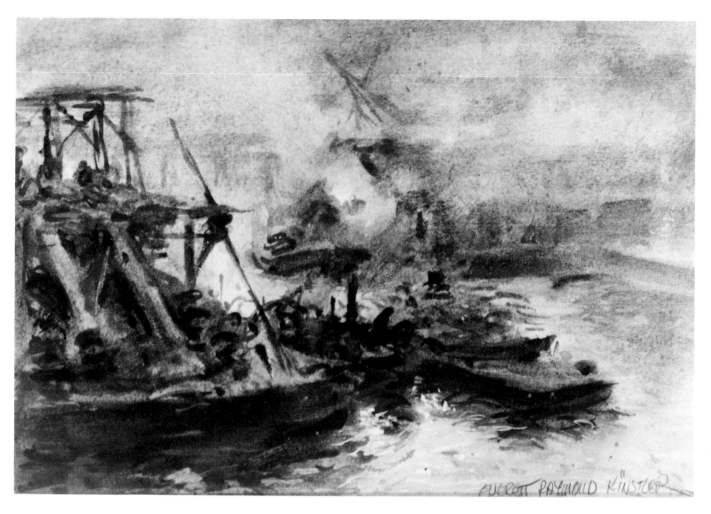

Harbor Scene, *watercolor on paper, 7¼" × 10½" (19 × 27 cm). Collection of the artist. This atmospheric watercolor was also painted on my 1954 European trip, but I can't remember where. The misty tones were painted wet in wet, and then I painted the foreground shapes when the paper was dry —to emphasize the contrast between the foggy background and the dark wharves and barges in the foreground.*

MONTY FLAGG

Since childhood I'd admired James Montgomery Flagg, who had been America's most popular illustrator during the first forty years of this century. In 1949 I met him. Our friendship lasted until his death in 1960, when I delivered the eulogy at his funeral.

Reproductions of Flagg's paintings and drawings had appeared in every major periodical for four decades. His best known work, of course, was Uncle Sam pointing a finger and saying "I WANT YOU!" Not many people remember that the original painting first appeared as a cover for the once popular magazine *Leslie's Weekly*.

Flagg's prowess as an artist was staggering. He worked in any medium with equal ease: pen and ink, charcoal, pencil, watercolor, oil. Watercolor was his great love and reflected the most personal side of his talent. He was a brilliant draftsman. His work was marked by style, taste, and vitality.

He was also one of the great wits of his day, a colorful and articulate conversationalist, a testy gent with a zany sense of fun.

I was tremendously stimulated by Monty's enthusiasm, his frankness, and his knowledge of art. His background was vast. As a student at the League, Monty had studied with the great American impressionist John Twachtman, as well as with DuMond, who'd been my own teacher fifty years later! Monty's career as an illustrator and painter had begun at the end of the Victorian era and stretched into the days of modern magazine publishing. I was impressed not only by his technical mastery but by his conviction that art was *feeling* – that the medium was simply a means for the artist to express what he had to say.

James Montgomery Flagg, *charcoal on illustration board, 20" × 16" (51 × 41 cm). Collection of the artist. Another one of my great mentors was the famed illustrator James Montgomery Flagg, whose portrait I drew in about forty minutes when Monty was in his late seventies. For the darks and halftones, I blended the soft charcoal like oil paint, picking out the lights with a kneaded rubber eraser and adding quick lines for the details of his features.*

Unlike DuMond and Adams, Flagg was never really my teacher. But I spent more time with him than I spent with any other artist, and he was certainly the greatest influence. One of the most important things that I learned from him was that the medium is secondary. For instance, his wonderful pen-and-ink drawings taught me a lot about *painting*. His pen followed the form like a brush — and that's why he could create the feeling of a living body inside a dress or a suit, treating every form with the same respect, intelligence, and feeling.

I also learned a lot from Flagg's method of painting watercolors on the spot with a box of pans (not tubes), very much like Sargent. When he painted on location, he was very spontaneous, yet very decisive and disciplined.

Although he had enormous technical facility, he really had no technical tricks. He was actually quite simple. For example, he liked to paint watercolors on a plate-finish bristol board that had such a smooth surface that he couldn't rely on the texture for any technical effects. He said he liked the challenge of the smooth surface.

What Flagg taught me, I think, is that technique isn't important in itself. It's only a means to an end. I'm interested in brushstrokes only if they contribute to the feeling conveyed by the picture. I don't think there's any special magic in thin strokes or heavy strokes. There's just as much beauty in the thin brushstrokes of Vermeer or Holbein as there is in the swaggering, impasto strokes of Sargent.

Technique is no substitute for feeling. Whether you're painting a child or a sunset or an abstraction, it's your *feeling* that's got to come across. You can convey feeling just as well with a smooth, controlled technique as with a free, spontaneous one. If my paint-

EVERETT RAYMOND KINSTLER

30

ings look spontaneous, it's because I've been painting for almost forty years, not because I'm *trying* to be spontaneous.

Monty also introduced me to the paintings of his favorite landscapist, Monet. We talked admiringly of the great French artist's use of color, his exceptional acuity of vision, and his constant experimentation. My love of Monet has deepened through the years. Along with his contemporaries, Degas and Lautrec, Monet has remained a source of inspiration.

A
FROM ILLUSTRATION TO PORTRAIT PAINTING

s the 1950s unfolded, a significant change was taking place in American publishing—and in my own career. With the advent of television, the magazines and periodicals that used illustration ran into hard times. One by one, they began to fold or change their ways. Photography and graphic design began to dominate the pages that used to be filled with drawings and paintings. The final blow came when the *Saturday Evening Post* no longer gave a credit line to the illustrator!

Book and magazine illustration—with an occasional comic book—continued to pay my bills. I also painted some album covers for Columbia Records, as well as some pictures for product advertising. To keep going, I was constantly seeing art directors and prospective clients. I disliked having to hustle for my work, but it had to be done if I was to earn a living.

Meanwhile, I began to receive portrait commissions. While I wasn't consciously aware of it, I was gradually backing into portraiture. This was really a natural progression, since painting people was always what I enjoyed most. Living and working at the National Arts Club also encouraged me to think more seriously about portraiture. As chairman of the exhibition committee, I helped to arrange programs and functions that honored famous personalities like Eleanor Roosevelt, the celebrated surrealist painter Salvador Dali, the sculptor Paul Manship, and illustrator/mural painter Dean Cornwell. Meeting such remarkable people, listening to their conversation, watching their faces, and observing their movements and personalities intensified my interest in human nature and in interpreting his on canvas.

As I continued to draw and paint on my own—pencil and charcoal portraits, landscapes, watercolors—I found that I was turning more and more to portraits. I spent time in museums and pored over art books, admiring the great masters of the human face and figure: Rembrandt, Hals, Goya, Velásquez, Rodin, and Eakins.

In 1958 I took a few of my portrait paintings up to Portraits, Inc., a gallery devoted to representing leading portrait painters. Shortly thereafter, I received my first commission from this organization—the first of hundreds of commissions. So now I was "officially" launched as a portraitist.

Around this same time, I had my first one-man exhibition at the Grand Central Art Galleries in New York City. I showed some landscapes in oil and watercolor, charcoal heads, and several oil portraits. Although not a single picture was sold, the exhibition confirmed the fact that I was starting a new career. I was on the road from illustration to painting.

James Montogomery Flagg, *oil on canvas, 30″ × 25″ (76 × 64 cm). Collection of the artist. Monty's heyday was before I knew him, and I wanted to see if I could paint him as he looked in the old days, when he was at the height of his powers. I tried to show him as a tough, magnetic man who looked you in the eye and could knock you dead with his wonderful wit. The whole portrait focuses on the head, which is dramatized by the dark shape in the upper left-hand corner. He put on the monocle as a kind of theatrical stunt. The rest of the portrait is purposely kept quite sketchy.*

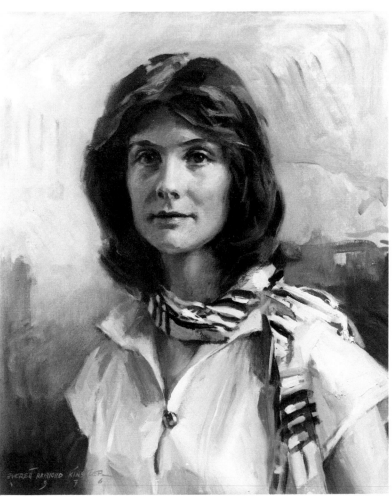

James D. Landauer, *oil on canvas, 34" × 32" (86 × 81 cm). Collection of Mrs William Estes. The sitter was a highly successful, brilliant businessman, but since his portrait was painted for his family, we all agreed that it would be right to paint him in sport clothes. He was an avid fisherman, so I painted him in his L. L. Bean sport shirt and jacket, under an open sky. The result, I think, is a personal and affectionate portrait that captures Landauer's warmth and vitality.*

Virginia Mills, *oil on canvas, 28" × 24" (71 × 61 cm). Collection of Mr. and Mrs. J. Lawrence Mills, Jr. This young lady's bright, open face is framed by her dark hair, which, in turn, is framed by the light background tone. I started out painting her in a canary yellow dress. But on the third sitting, she brought along the scarf, which I added to the picture because it gave the portrait a bit more style. I painted the scarf very simply, with a few broad strokes, so that the stripes wouldn't be distracting.*

Ambassador Elliot Richardson *(opposite page), oil on canvas, 44" × 34" (112 × 86 cm). Collection of the United States Department of Defense. At the time I painted him, Elliot Richardson was ambassador to Great Britain, but the painting's purpose was to portray him as Secretary of Defense. I started the portrait at the sitter's home in Virginia, where the summer sunlight kept flashing on his eyeglasses, and I was having a great deal of trouble capturing the concentrated look of the sitter's thoughtful, sophisticated face. At one point the ambassador went upstairs for a moment and then came back down to resume the pose. He asked me: "How are the eyes coming?" I said: "It's interesting, I don't seem to see the reflection anymore." He burst into a grin and showed me that he'd gone upstairs to get a frame without lenses.*

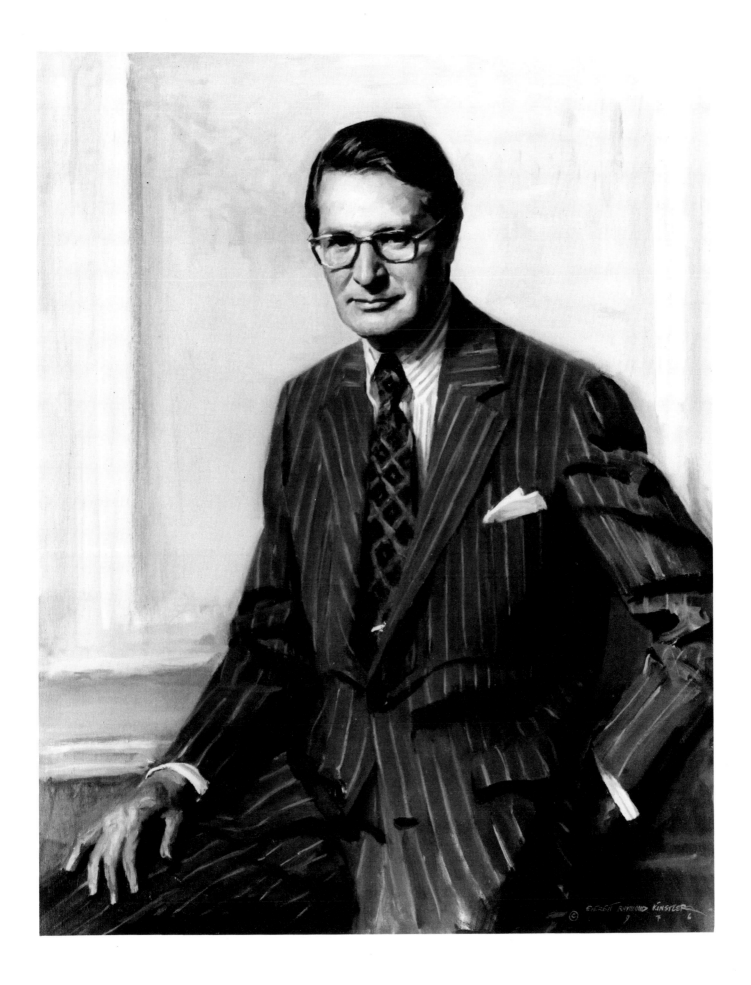

33

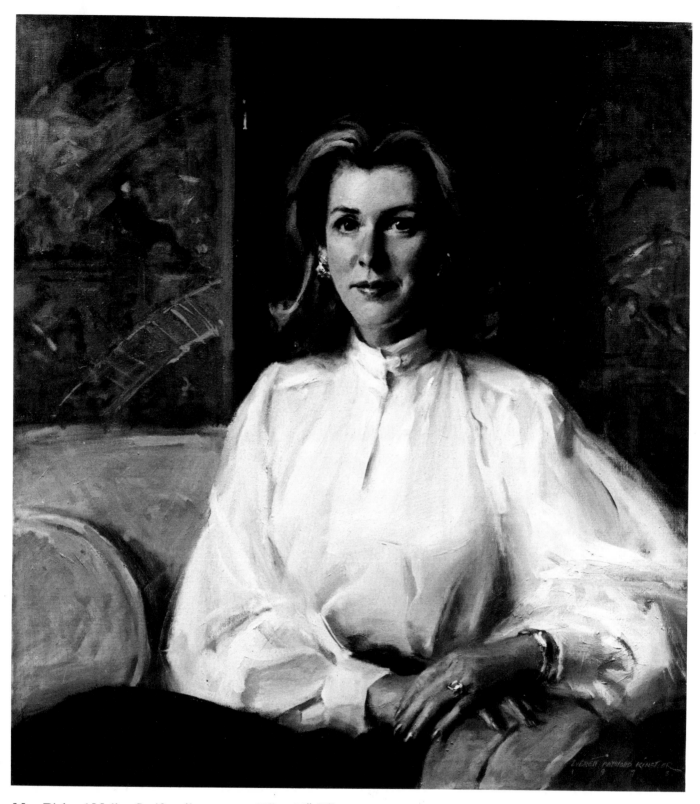

Mrs. Richard Mellon Scaife, *oil on canvas,* ***38" × 34" (97***
× 86 cm). Collection of Mr. and Mrs. Richard Mellon
Scaife. I flew to Pittsburgh to paint this portrait on location.
The couch and screen behind this handsome lady were
actually part of the living room, where the portrait was going
to hang. It's important to choose the right lighting for the
sitter. Here, most of the head is in the light, with just a few
shadows on one side of the nose and along the edge of the
head.

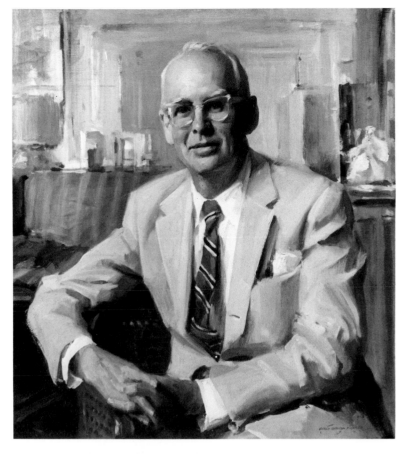

Charles Scribner, Jr., *oil on canvas, 36" × 34" (91 × 86 cm). Collection of Mr. and Mrs. Charles Scribner, Jr. Before I did this informal portrait, I had painted the distinguished publisher for his company, and he had become a very special and valued friend. So I was especially touched when his family asked me to paint him for their home. I was even more disarmed when he said to me: "Ray, we want your interpretation of me; if you like it, we will." This is actually a very tough challenge for an artist. It was summertime, and I decided to paint him in his light summer suit, relaxing in a chair in my studio. This informal, personal portrait purposely avoids the feeling of a posed portrait and is meant to communicate the fact that it's a portrait of a friend. fact that it's a portrait of a friend.*

Richard D. Wood, *oil on canvas, 44" × 34" (112 × 86 cm). Collection of Eli Lilly Corporation. The sitter was chairman of Eli Lilly Corporation, and I flew to his corporate headquarters in Indianapolis to see where the portrait would hang and to determine its size. He then came to New York periodically throughout the winter to pose in my studio. The lighting, which comes from one side and from slightly above, creates strong shadows around the sitter's features to emphasize the well-cut planes of his head. Both his head and hands are silhouetted against darkness.*

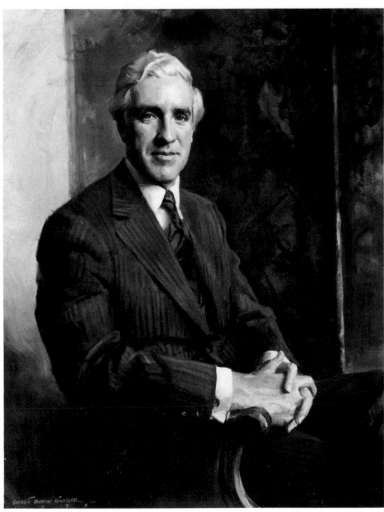

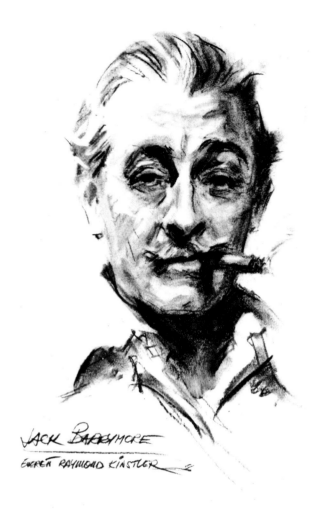

John Barrymore, *charcoal on bristol board, 20″ × 16″ (51 × 41 cm). Collection of the Players Club. The great actor had been a close friend of James Montgomery Flagg. When the Players Club asked Monty to do a drawing of Barrymore, the illustrator's eyes were already failing. He said: "I know a young artist who could give you an interpretation of Jack." I decided not to base this drawing on his glamour years when he was known as "the great profile" but on an image of him that reflected a certain quality of sadness and a bit of jaded elegance.*

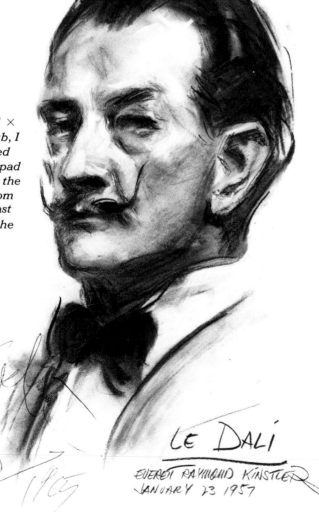

Salvador Dali, *charcoal on bristol board, 20″ × 16″ (51 × 41 cm). Collection of the artist. At the National Arts Club, I was master of ceremonies at a dinner honoring the famed surrealist painter Salvador Dali. I took my bristol board pad along with me and kept working on his head throughout the evening whenever I could grab a minute. I drew him from slightly below to emphasize his haughty bearing. The last touch was to sharpen the points of his mustache, which he called "Dali's antenna."*

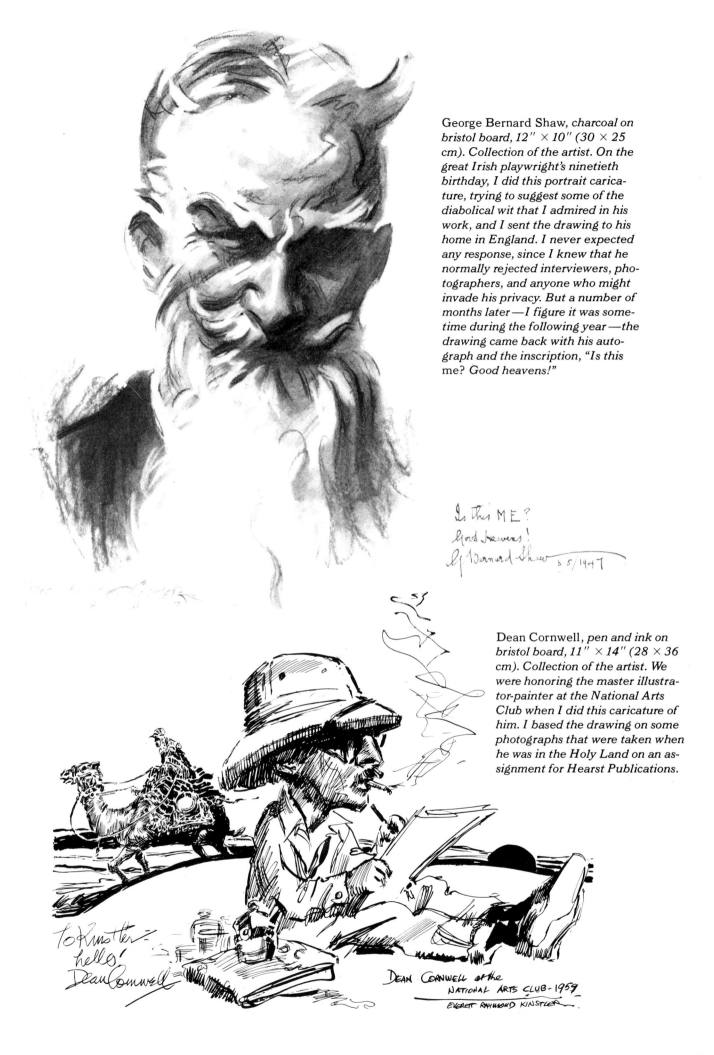

George Bernard Shaw, *charcoal on bristol board, 12" × 10" (30 × 25 cm). Collection of the artist.* On the great Irish playwright's ninetieth birthday, I did this portrait caricature, trying to suggest some of the diabolical wit that I admired in his work, and I sent the drawing to his home in England. I never expected any response, since I knew that he normally rejected interviewers, photographers, and anyone who might invade his privacy. But a number of months later—I figure it was sometime during the following year—the drawing came back with his autograph and the inscription, "Is this me? Good heavens!"

Dean Cornwell, *pen and ink on bristol board, 11" × 14" (28 × 36 cm). Collection of the artist.* We were honoring the master illustrator-painter at the National Arts Club when I did this caricature of him. I based the drawing on some photographs that were taken when he was in the Holy Land on an assignment for Hearst Publications.

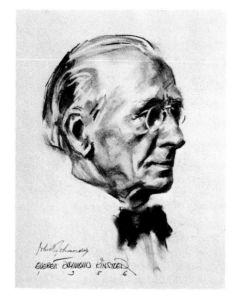

John Johansen, *charcoal on illustration board, 20" × 16" (51 × 41 cm). Collection of the artist. I owe a great deal to this wonderfully wise, thoughtful man, and I tried to capture his quiet integrity in this drawing. I like to use charcoal like oil paint, blending it and picking out the lights with a kneaded rubber eraser and then striking in a few accents with the point of the charcoal stick.*

JOHN C. JOHANSEN

Although Frank DuMond had died in 1951—in the very studio that I now occupy at the National Arts Club—another mentor came into my life. At the time John Johansen moved into the studio above me, he was in his late seventies. He'd had an enviable career. His six decades of portraits recorded an extraordinary parade of sitters, like a vast panorama of history. Yet a visit to his studio revealed no paintings on his walls except for a halftone reproduction of Velásquez's *Pope Innocent X*. The simplicity of the studio reflected the simplicity and *integrity* of the man.

Johansen had studied with Frank Duveneck, one of America's great portrait painters, and Duveneck had had a profound effect on him. It was Duveneck who had come back from Munich in the nineteenth century and introduced the dark palette and strong, simple designs of Wilhelm Leibl and other German masters to the American painters of that day. In Johansen's simplicity of concept and broadness of execution, there was much that was reminiscent of the instructor of his youth.

The art was like the man. He was philosophical, noble, spiritual, yet earthy. He echoed DuMond about the importance of observation, above all. He deplored "cleverness" and what he called "recipes." Sincerely interested in helping younger artists, he cautioned me about my facility, encouraged me to paint "statements—truths," and warned me about leaning on photographs. He was forever urging me to dig and probe, to go beneath the surface, and to achieve simplicity and solidity. In a sense, he was passing on Duveneck's principles and theories, such as working the brush *across the form* and thinking in sculptural, three-dimensional terms.

Above all, Johansen taught me to probe and plan. He said: "Make your painting fit your conception, and it will have more truth to it than if you accept nature for what it is."

He made me very conscious of the importance of making studies. He made countless studies! He'd pose the sitter to get a feeling of the person, watching his gestures carefully, and then he'd bring in another model to pose for studies when the sitter was absent. I can remember posing in General Arnold's air force uniform and in Bishop Sheen's robes. Johansen would remember some characteristic gesture of the sitter—the hand resting against the head in some particular way—and then he'd describe it to me and ask me to "get that gesture." He'd prepare himself for the final portrait by making studies from me and from other models.

I was enormously touched when he left me some thirty or forty panels—actually cigar-box tops that had been primed—on which he'd made studies of hands, paying careful attention to the gestures and the details of the fingers. Johansen never told the sitter to "hold that pose" or place his hands in a certain way. Instead, the artist remembered the gesture and recreated it in his studies.

Johansen was a direct, simple painter, and he'd often scrape out and repaint in order to maintain that simplicity. He'd sometimes say that he did a head in two hours—after wiping it out eight or ten times before. He was like an eighty-year-old child, always learning, always digging. He said: "A frank error is better than a hesitant truth."

Working in the same building as John Johansen in the last years of his life, I was fortunate to have his counsel, his presence, and his affection on a daily basis. Johansen, like DuMond and Flagg, enriched my life. Their inspiration is still with me.

BOOKS, THEATER, MUSIC

Meanwhile, I also maintained close friendships with two artists of a different sort—dating back to my public school years. Lee Bobker, who later headed his own motion picture company, and Bob Brustein, now dean of the drama school at Harvard, were constant pals. We shared a love of movies and theater, music, and books. Their insight and their friendship contributed a great deal to my mental growth.

Thirsty for learning, I read all of Mann, Shaw, and Maugham; listened endlessly to Wagner, Richard Strauss, and jazz; and was fascinated by the German artists who were active before World War I, notably the lusty, sensual canvases of Lovis Corinth.

Lest all this sound unbearably highbrow or stuffy, I should point out that I was still an incurable cartoonist! But now I drew them for fun. I wrote lots of letters, and almost all of them bore a watercolor caricature or some kind of silly drawing—as my letters still do.

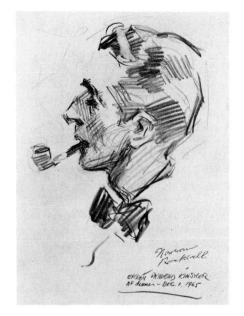

Norman Rockwell, *pencil on bristol board, 12¾" × 9" (32 × 23 cm). Collection of the artist. When the Artists Fellowship honored Norman Rockwell at a dinner, I sat next to the great illustrator and made this quick pencil note on a sketch pad. Looking at the quick, broad strokes, you can see that I was working very rapidly, doing the drawing very much the way I'd do one of my many pencil studies for a portrait in oil. The sketch simply records the contours of his face and the big patches of halftone and shadow— all done with broad, parallel strokes.*

FULL-TIME PORTRAITS

Since 1960 I've earned most of my living by painting portraits. That master of portraiture John Singer Sargent made the famous comment that a portrait was "a painting with something a little wrong with the mouth." What he was saying, of course, is that portrait painting is never easy. Eventually, he got fed up and announced that he was "tired of painting *paughtrets*—no more MUGS!" He finally turned his back on portraits and devoted the rest of his life to landscapes, figures, and interiors in watercolor and oil, as well as one major mural commission.

At first glance it may look as if I've kept switching around—turning my back on one art field and launching into another. But I see all these changes as a logical evolution, with one phase gradually leading to another. Starting with comics and pulps, I shifted to paperbacks and finally to book and magazine illustration before moving on to portrait painting. I started with black-and-white line, then learned about tone, and finally moved into color. I never turned my back on any phase of my life, and I don't look condescendingly on anything I've done. I don't think more of portraits than I do of comic strips—or less. It's all been part of the learning process—and fun. And I'm still learning.

TEACHING AT THE LEAGUE

When I started to teach at the Art Students League of New York, I carried this attitude into the classroom. I felt that cartooning, illustration, and portrait painting were all just different aspects of art, requiring the same kind of skills, and I remembered Sargent's advice to a student who wanted to specialize in portrait painting: "Become a painter first and then apply that knowledge to a special branch." So, if someone entered my class and wanted to focus on portraiture, he was told that he was in the wrong class. My class was in "painting, drawing, and composition."

I don't agree with Shaw's famous remark that "Those who can, do; those who can't, teach." I find it a bit flip. You can't *make* someone into an artist, but I believe that a good teacher can stimu-

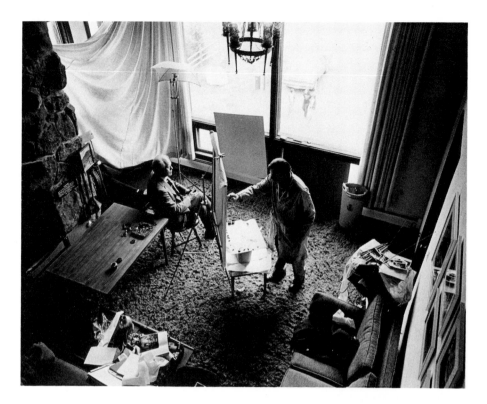

Painting President Ford's Portrait (above, right). When I painted former President Gerald R. Ford on location in Vail, Colorado, in the summer of 1977, I had to make all kinds of improvised changes in my surroundings. The brilliant light from the windows was diluting the effect of light and dark on his face, and so I stretched out the curtain and taped it to the wall; then I blocked out the lower windows with some big sheets of cardboard. Fellow portrait painter Felix De Cossio, who was painting Mrs. Ford at the same time, lent me a tripod with a floodlight and a diffusing umbrella, which I could use in an emergency if the weather got dark. Because the apartment contained no table high enough to hold my palette, I filled a plastic wastebasket with some books and rocks, and then I placed my palette on top.

President Gerald R. Ford (right), oil on canvas, 30" × 25" (76 × 64 cm). Collection of Mr. and Mrs. Gerald R. Ford. In contrast with the President's official White House portrait, which you'll see in the "gallery" at the end of the book, I painted two informal portraits that were commissioned by Daniel J. Terra, a friend of the President, one of which was to be a gift to Mr. and Mrs. Ford for their new home in California. I went out to Palm Springs, California, in 1978, the year after I completed the White House portrait, and I did this painting, which reflected more of the outdoor life and informal life-style that Mr. Ford enjoyed. I painted him with an open golf shirt and one of his favorite sport jackets.

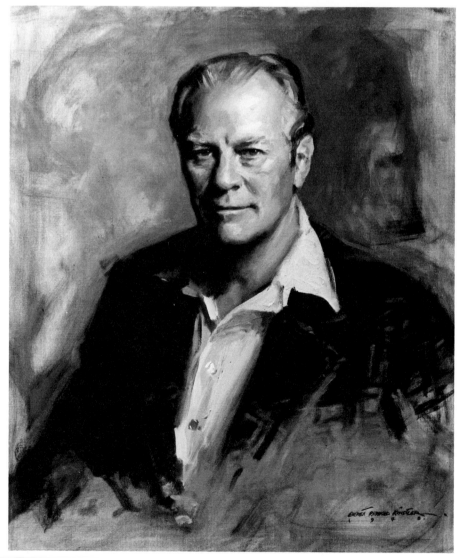

late and offer valuable insights and technical advice.

I taught Tuesdays and Thursdays for five years. Getting out of my studio to exchange ideas with students was a refreshing experience. As every teacher knows, I probably learned more from the students than they did from me. I was challenged to think clearly—to explain myself precisely when I had to criticize a student's work. For example, I learned to use the word *highlight* to mean the glint on a piece of metal or jewelry, not the light at the tip of a nose or a chin, which was really a *light plane*. I learned to use the word *restate* instead of *repaint*, so that the student realized that it wasn't simply a matter of painting technique but a matter of observation and feeling.

Let me explain what I mean by *restating* rather than just *repainting*. There's a big difference. It's not enough just to scrape out the hand in a portrait and repaint it more skillfully, or scrape out the rocks in a landscape and render them more accurately. You can still lose sight of the hand in relationship to the portrait, or the rocks in relationship to the total landscape. If you just *repaint*, you may lose sight of those qualities in the picture that excited you—the total personality of the sitter or the feeling of the sunlight on the landscape. To me, restating means keeping in touch with the excitement of the whole painting, going back intellectually and emotionally to make your brush work toward those feelings that stirred you in the beginning.

I had strong feelings about the importance of experimentation—the necessity for the student to find his own "personality." I was pleased when people said that each student in our class exhibition seemed to work differently. I wasn't interested in turning out rubber stamps!

Each month I would paint a demonstration picture, usually in oil. Sometimes I'd paint a head, sometimes a landscape or a figure. Several times I worked from photographs to show the dangers and limitations, as well as the advantages.

Perhaps my most instructive demonstration was a 34″ × 40″ (86 × 102 cm) canvas of a reclining female nude. I'd gotten off to a great start, and I actually canceled my next day's portrait sitting in the studio so that I could return to the League to continue with that figure. The word had spread around the school, and we had a standing-room crowd. I felt good about my first morning's work, and I proceeded to paint for three more hours. The results went from bad to disastrous! The painting simply got away from me. It looked dreadful.

Surprisingly, many of my students told me that it was my most instructive demonstration. The students learned from my mistakes: losing my drawing, missing my color transitions, not observing many obvious nuances. Seeing my mistakes was a valuable experience for the class—even though it was nerve-wracking for me!

The students learned to use their wits and not be concerned about whether the model moved—or about whether they could even see the model. Sometimes they painted interiors and each other. They tried self-portraits, cityscapes from the window, or just some object lying on the floor of the classroom. They were a stimulating, exciting group, and their enthusiasm spilled over onto me. After five years of teaching, I felt my own work "opening up," and I left the League to devote renewed energy to my own painting.

Incidentally, my classroom at the League—like my studio at the National Arts Club—turned out to have been DuMond's old place.

Quick Sketch of the President *(above), pencil on paper, 11½″ × 8″ (29 × 20 cm). Collection of the artist. This is typical of the quick sketches I make when I'm planning a portrait like the one I did of the President. Such a drawing takes about five minutes —or less. I usually work with a broad pencil on smooth paper.*

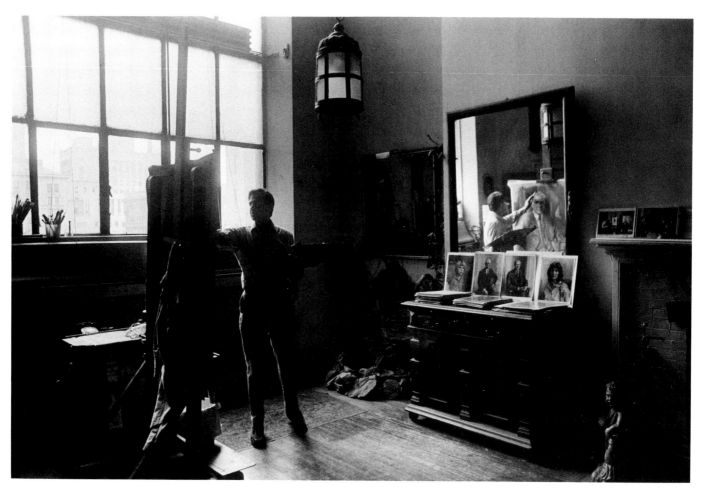

My Manhattan Studio. *Here's a glimpse of my studio on Gramercy Square. My lofty window faces north. Just under the window is my taboret, where I sometimes rest my palette — though I often hold it as I'm doing in the photograph. I normally work with that big mirror behind me so that I can see the painting in reverse. For some reason it's easier to spot errors that way. When necessary I can boost the lighting in the room by turning on big fluorescents at the top of the window and moving around various portable light fixtures.*

This seems like the right time to invite you into my studio. I've always been intrigued by studios, since it's obvious that they're a reflection of the artist's personality, an extension of his working and thinking, a kind of self-portrait.

For over twenty years I've occupied the studio originally used by the late Frank DuMond. The room is about 20 feet wide and 30 feet long. It's got a high ceiling — over 20 feet — with a window facing due north. The lower edge of the window starts about 5 feet above the floor and extends all the way up to my ceiling. This handsome expanse of glass is about 10 feet wide. As you can see, my two primary considerations are light and space.

To control the natural light, I have two opaque shades that roll *upward* to force the light higher if I need a stronger contrast of light and shadow to add strength and character to the sitter. The glass is translucent — not transparent — to reduce glare.

Halfway up, I have a horizontal fluorescent lighting fixture, containing four tubes, each 6 feet long. The tubes alternate cool–warm–cool–warm and give me an intense light that's almost equal to normal daylight. I use the artificial light on gray days or when I want to paint in the evening.

To the rear of my studio, facing east, I have another window that catches occasional sunlight and gives me some variety in posing models. I want to avoid the effect of sameness that results from working under unvarying north light. I may also supplement the light with a lamp that stands on the floor: I can raise it, adjust it, or change the bulbs to create different lighting effects on my subject. A large folding screen has a textured silver finish on one side to reflect light when necessary. All these different kinds of lighting

allow me to experiment with a variety of lighting effects and avoid monotony in painting portraits or figures.

My Connecticut summer home has a similar studio in the barn with roughly the same proportions and the same lighting arrangements. However, since the summer foliage tends to block out the light, I've added a skylight.

Since I stand while I work, and I need space so that I can move back to view my painting at a distance, it's important to have a studio that allows enough room to maneuver. I also find it helpful to have a large mirror hanging behind me, so that I can see my work in reverse. I constantly refer to this mirror image as I paint, since there are lots of little errors that become obvious when I see my painting backward. When I work on location, I carry a small hand mirror for the same purpose.

I know that right-handed people usually paint with the light coming over their left shoulder, and vice versa, but I do just the opposite. When I first moved into my studio, I was frustrated to find that the window light bounced across my canvas in a disturbing manner, exaggerating ridges in the fabric and impasto effects in the paint. Somehow, this annoying effect was caused by the height and location of the buildings near my studio window, buildings that had probably been put up long after my studio building was constructed in 1906. The solution was to turn my easel so that the light comes over my right shoulder, even though I'm right-handed. This is supposed to be "against the rules," but it works for me.

The model stand in my studio is 4 feet square and 2 feet high. The wooden stand is on casters so that I can roll it around. When I stand at the easel and my subject sits in a chair on the model stand, his or her head is at my eye level. When I want to change the angle of the pose, I can move the entire model stand without asking the sitter to get up from the chair. Many years ago, an older gentleman's chair slid off my model stand as he was posing! I didn't want to lose any *more* clients that way, and so I tacked a piece of carpet on the platform so that future clients could stay put.

To create a variety of backgrounds behind my models, I have drapes in different textures and colors. I try to keep my backgrounds simple and uncluttered, and so these fabrics, plus my unadorned, folding screen, are enough to give me the diverse shapes and colors I need to organize a picture.

Different chairs seem to be right for different sitters. It's important to have the right chair to match the feeling of the portrait and suit the size and character of the subject. So I have a few chairs of different, very simple styles.

Finally, I have two sturdy studio easels, each large enough to support a full-length canvas, with or without a frame. This is important because I generally prefer to finish my picture in a frame to see the final effect. For travel and outdoor painting, I have a portable French easel. But that's mainly for landscapes. I never use it for a studio portrait.

My taboret is a waist-high chest with casters. The drawers hold my tubes of paint, bottles of varnish, painting knives, and a roll of paper towels, which I prefer to rags.

My palette is the traditional wooden oval with a thumbhole. I like to move around when I'm painting, and so I generally carry my palette (slipping my thumb through the hole) until I've got the overall concept on the canvas and I've blocked in the large shapes. Then I'm likely to set the palette down on the taboret. I also have a sturdy studio table, firm enough to support a figure. Now and then, I ask someone to pose by sitting on the edge of the table.

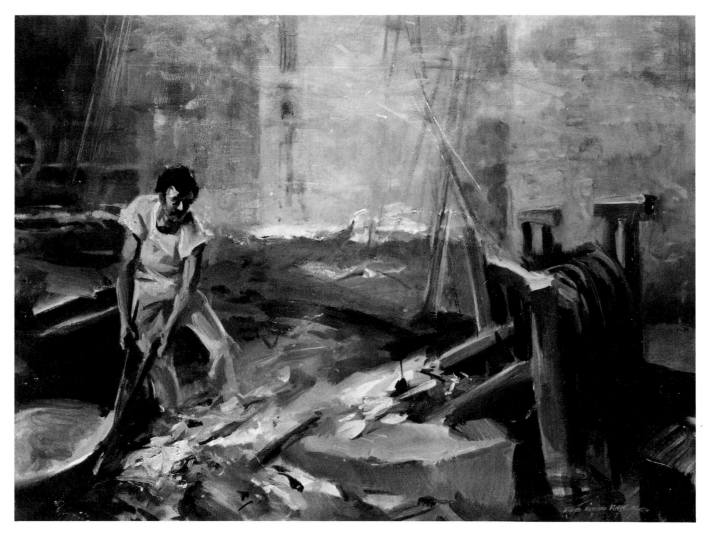

Foundry Worker, Mexico, *oil on canvas, 24" × 30" (61 × 76 cm). Private collection. When I was planning a trip to Mexico, I collected various magazine articles and other travel literature that would help me find places to visit—places that might not otherwise be on the itinerary. I found some pictures in the* National Geographic *that showed a setting like the one in this painting. Then, when we visited Guadalajara, I made some little watercolor notes of workers in some kind of foundry. I later combined the clippings and the watercolor sketches to paint this hard-working man in a bleak, mysterious setting. I'm not really sure what he's doing, but it doesn't matter. What* does *matter is the strange, rather lonely mood of the picture.*

When the sitter isn't with me, I drape his costume on my life-size studio mannequin to study the patterns and shapes of the folds. This is particularly helpful when the sitter is posing in a uniform, academic robes, or some kind of costume. Perry, my mannequin, was the perfect understudy for a general when I once had to paint rows of medals on the soldier's jacket. My friend Perry is cooperative and patient—and he never talks back.

My studio also has bookcases, pictures by artist friends, and all sorts of personal souvenirs and mementos. There's hardly a day when I don't refer to my picture books filled with works by artists I admire and constantly study. I keep changing the display of pictures on the walls—clippings, photos, paintings—to suit my mood. My plaster cast of Michelangelo's *Moses* sits beside a stone fountain with its constant trickle of water. My stereo set plays constantly, *except* when I've got a sitter in the studio—when I need silence for concentration and conversation.

MY OIL PALETTE

I normally work on a toned canvas, and so I find it helpful to work on a wooden palette whose natural surface is a middle tone. Because I'm a tonal painter, I find it helpful to mix my colors on the palette's natural background tone, which helps me determine my exact range of values.

Actually, I think of my palette as a kind of piano keyboard, with the light colors representing the high notes and the darker colors

representing the lower notes. I lay out my colors from light to dark — a habit that dates back to my student days. Along the upper edge of my palette, I squeeze out my colors from right to left in the following order: Permalba white, cadmium yellow medium, raw sienna, cadmium orange, cadmium red light, alizarin crimson, burnt sienna, raw umber, cerulean blue, ultramarine blue, chromium oxide green, and ivory black. I occasionally use viridian or light red, depending on the subject I'm painting. For landscape painting I generally add phthalocyanine green and phthalocyanine blue. I leave a large oblong section for mixing.

Each day I add extra paint to my palette, working with the individual mounds of colors as long as they remain pliable. But once the colors begin to dry or cake, I scrape off the remains with a knife and lay out fresh colors. Periodically I transfer the accumulated colors one by one to an auxiliary palette on which I mix the paint with my knife for reuse.

As you can see, I try to keep things simple. I use about fourteen colors, but half of those would probably suffice, since most of them are just variations and shades of the three primaries. (You could almost paint everything with these three colors and white!) It's valuable to limit your number of colors so that you're forced to think simply and learn to control your colors.

My kind of painting depends primarily on values. When I think about color, I first think of values, and that awareness of values becomes the key to achieving the right color relationships. Color in itself doesn't mean much: it's a question of relationships, one color next to another, each considered as part of the entire picture. Thus, I don't think that there's such a thing as a "muddy color," any more than there's a "bad" note of music. It's all a question of finding the right value and placing the color in the right relationship to the other colors in the painting.

MEDIUMS AND SOLVENTS FOR OIL PAINTING

On my taboret I keep a 6-inch-high coffee can that's open at the top. Inside this can I've placed a smaller can that's less than 2 inches high. The top and bottom of the smaller can have been removed, and the top has been replaced with a piece of wire screen. The big can is then filled with turpentine, which I use for blocking in the painting and cleaning my brushes. The residue sinks beneath the wire screen. When the sediment builds up, I toss out this contraption and start with new cans.

Since I just thin my paint with turpentine in the early stages of the picture, I occasionally add a few drops of cobalt dryer to speed up the drying process, especially when I'm painting on location. But it's important not to overuse cobalt dryer, which can darken, crack, and flatten your colors if you add too much.

Once the painting has been blocked in and begins to develop an overall character, I no longer dilute my paint with pure turpentine; I use instead a combination of turpentine and linseed oil or a ready-made copal painting medium. If you just thin your paint with turpentine, you'll find that this solvent weakens your color and also weakens the adhesion of the paint to the canvas. Adding linseed oil with a resinous painting medium, such as copal, preserves your color, toughens the paint film, and gives the paint a buttery quality that I like. On the other hand, it's important not to add *too* much oil because it creates a shine, which I dislike, and also has a tendency to yellow and darken with the passage of time.

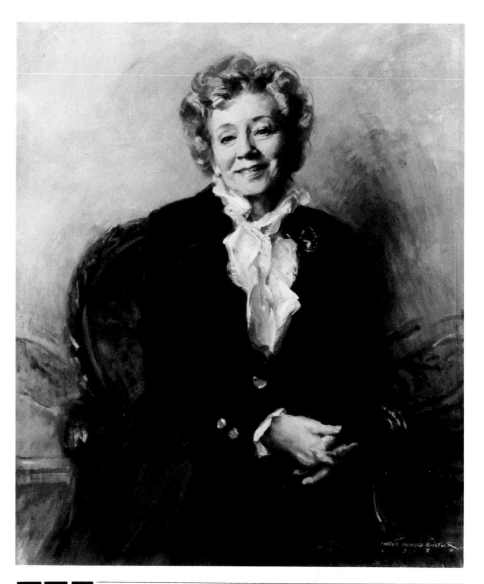

Margaret Wickliffe, oil on canvas, 42"
× 34" (107 × 86 cm). Collection of
Wickliffe House. The lively pose —
with the sitter leaning on one arm of the
chair and then tilting her head slightly
in the opposite direction —was meant
to convey the vivacity, warmth, and
marvelous alertness of this delightful
southern woman. It's interesting to see
that there are virtually no straight lines
in this portrait. All the shapes curve
and tilt to reflect the convivial charm of
the sitter. The portrait was painted to
hang over a mantel in a home that Miss
Wickliffe had given to the city of
Charleston, South Carolina.

W *VARNISHING AN OIL PAINTING*

hen oil colors dry they tend to sink in a bit, and so I spray on a coat of retouching varnish to restore brilliance. Sometimes I spray it over the entire canvas and sometimes only on specific passages.

A final, protective coat of picture varnish — which is heavier than retouching varnish — should be applied only after many months of drying time. Once again, it's important not to overdo the varnishing. Too much varnish can produce an unpleasant sheen that looks artificially glossy, like a coat of plastic. I prefer a slightly matte surface, and so I use varnish sparingly.

A *BRUSHES AND KNIVES FOR OIL PAINTING*

s every oil painter knows, there are two basic categories of brushes: the rugged, resilient bristle brushes, and the soft-hair brushes, such as sables, oxhairs, and the recently developed nylons.

I favor the bristles. I like their spring, resilience, and character. For my direct kind of painting, I like the fact that the stiff, sturdy bristles can hold a lot of paint and create interesting textures.

Most of my brushes are the shape called a filbert, which is a flat brush whose bristles taper to a slightly rounded tip. Occasionally I

use a flat bristle brush—which comes to a squarish tip—or a round brush. About a dozen filberts carry me through most of my painting; they range from a small number 2 to a broad number 14.

I try to isolate my brushes, keeping certain ones for light areas of the picture, others for darker areas, and still others for middle tones. As I paint, I select a particular brush that suits a particular area of the picture. I study the form that I'm painting and then pick the brush whose shape enables me to follow that form when I make a stroke. As the brushes begin to wear, I save them for rough, textural passages.

I use sable brushes less often. The soft, flexible hairs of the sable will carry a lot of liquid paint and are excellent for detail. The soft sable is especially good for blending, and it's also effective for painting areas where you don't want the strokes to show. I also use sables in transitional passages, where you want to blend the meeting point of a thinly painted shadow and a heavily painted light.

I rarely paint with a knife, but I do use the palette knife as a handy tool for scraping and cleaning. If I find some area of the painting too thick or too heavily textured, I use the flat side of the blade to reduce the paint. This is particularly important where my impasto seems to pick up too much light. And I also use the knife blade to clean the mixing area of my palette every day.

SURFACES FOR OIL PAINTING

Single-primed linen canvas gives me the slight texture that I need. I generally work on stretched canvas because I enjoy the spring of the surface when I touch it with my brush. However, I do use canvas boards for demonstrations, on-the-spot color studies, and outdoor painting—when I like the canvas board because the sunlight doesn't come through the painting surface, as it does when you work on stretched canvas outdoors.

I always have several rolls of canvas in various widths. I like to be generous with canvas when I stretch it, always allowing some extra inches to hang off the edges. Thus, if I find that my composition would be improved by lopping off some canvas at one edge, I still have some extra inches that I can bring around from the other edge. This extra canvas allowance gives me the chance to experiment with various sizes and shapes as I work on a painting. I don't hesitate to pull out the nails and restretch the canvas if I can improve the picture in some way.

MY WATERCOLOR PALETTE

I love the simplicity and directness of watercolor. Because it's convenient to carry, I find watercolor a natural for painting on holidays. While I often use watercolor as a sketching medium—particularly when I travel—I do find time to paint "finished" watercolors in the studio. I try to hang in and complete a watercolor in one session, but it doesn't always work out that way. Often, I start a picture and then put it aside for hours, even days, and then complete it—or scrap it and start over!

Because of the wonderful simplicity of watercolor, I find that I can achieve my effects with a smaller palette than I use in oil painting. In fact, I've cut down my number of colors in recent years.

When I work indoors, I squeeze tube colors onto my palette in this order: new gamboge, cadmium yellow medium, vermilion, alizarin crimson, phthalocyanine blue, cerulean blue, phthalo-

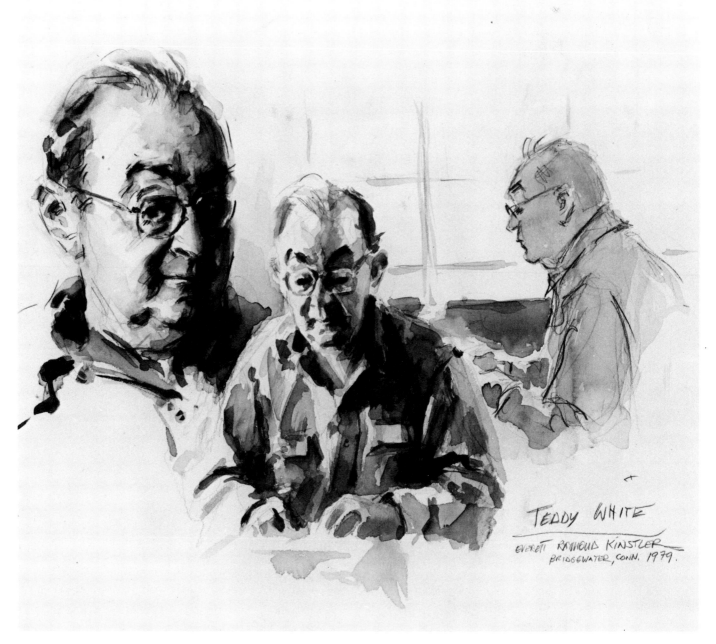

Theodore H. White, *watercolor on bristol board, 12″ × 17″ (30 × 43 cm). Collection of the artist. One day, when Teddy White was working on one of his* Making of the President *books, I went over to his workshop-studio and did this triple portrait study in pencil and brown watercolor on a sheet of bristol board. As you can see in the head at the left, the pencil lines don't just form an outline but become an integral part of the drawing.*

cyanine green, burnt sienna, and raw umber. I also keep a tube of opaque white around for occasional use.

My indoor palette is a white enamel tray about 16″ × 20″ (41 × 51 cm). On this clean, white surface—which obviously matches my white watercolor paper—I can see my values clearly as I mix them.

For painting watercolors outdoors and on the spot, I still use Monty Flagg's old watercolor box, which has pans of color and two flat mixing trays that hinge outward from either side of the box.

WATERCOLOR BRUSHES

I always work with top-quality sables. The round brushes range from the finest point to a big number 12. I also use flat sables, which are indispensable for large washes.

For special effects, I have an assortment of old, ragged bristles, other worn brushes, and a rigger. The old, battered brushes are handy for dragging, pushing, and scrubbing colors around and creating all kinds of happy accidents. The rigger is a long, slender, round sable that comes to a flat tip. Originally used by sign paint-

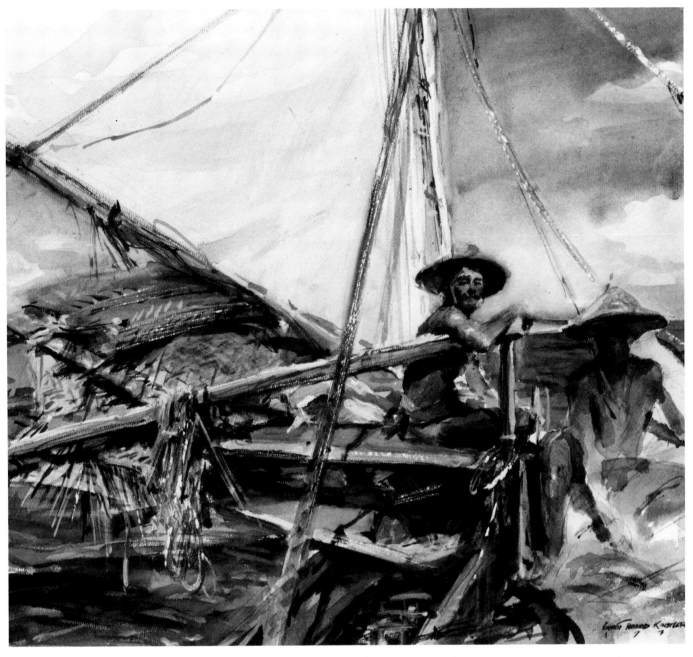

Truk Outrigger, *watercolor on watercolor board, 24" × 30" (61 × 76 cm). Collection of the artist. This is the watercolor that kept getting rejected by the American Watercolor Society until the society finally gave it a top award. I've never been to the island of Truk, and so this was based on a clipping I'd found in some magazine. I was interested in the abstract design of all those diagonals, with the clutter of the boat played up against the bare triangle of the sail and the squarish shape of the sky at the right.*

ers for lettering, the rigger makes certain kinds of crisp strokes that are useful to the watercolorist.

Of course, I always carry a pencil, which I use to draw my composition on the watercolor paper before I pick up my brushes. Other essential tools include a sponge, a razor blade, cleansing tissue, and masking tape.

WATERCOLOR PAPER

Unlike many watercolorists, I don't like working on a strongly textured or rough paper. I prefer to create my own textural effects without fighting the painting surface. Generally, I paint on smooth watercolor board or smooth paper. I often enjoy working on 5-ply bristol board, which is relatively nonabsorbent. I like the way the wet colors float on the paper's surface — they're fun to push around and easy to wipe away.

When I work outdoors in watercolor, I carry an 8" × 10" (20 × 25 cm) watercolor pad or watercolor block.

49

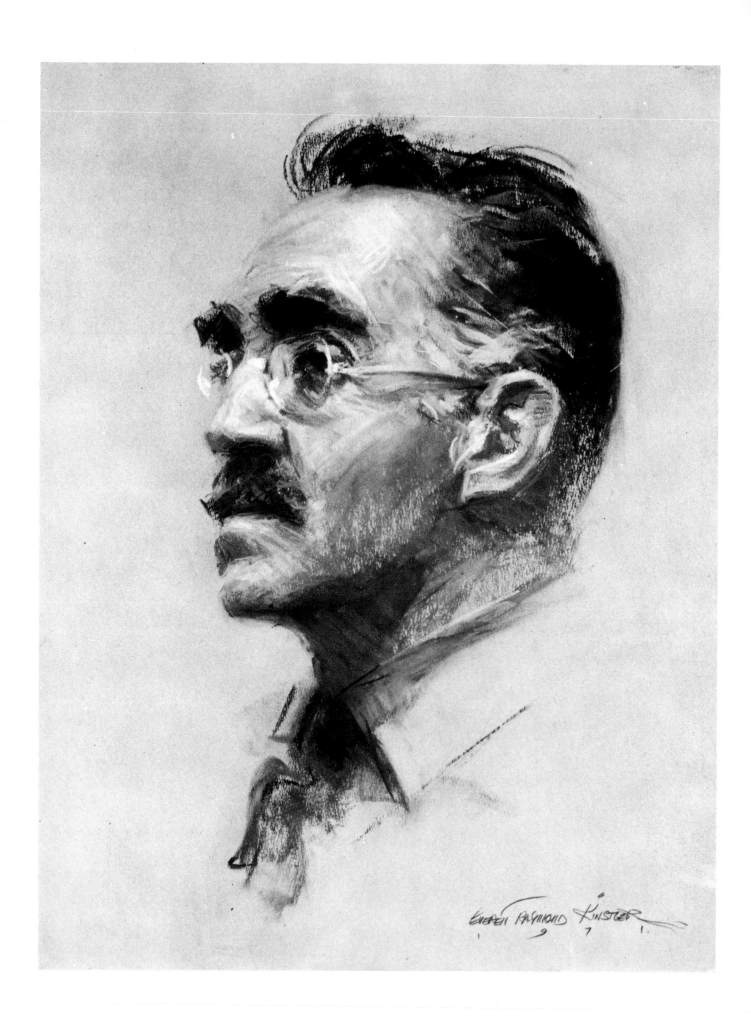

U

ntil a few years ago, I'd used pastel only for color notes and small studies. But when Joe Singer asked if he could include my work in a book he was writing on pastel portraits, I thought it would be an interesting challenge to try my first real portrait head in pastel.

Initially, I spoke to a few friends who worked in pastel, and they suggested that I needed at least two hundred colors, or even more. This was a pretty discouraging prospect, and so I just chose about ten chalks similar to my palette of oil colors. And I chose a middle-tone pastel board—similar to the toned canvas I use for oil painting—whose color would also be part of the picture.

I ended up finding my own way of working in pastels, applying some lessons from my work in oil. I used a stick of vine charcoal to suggest the outline, and then I blocked in the dark shadow areas and the light planes, letting the paper show through for the middle tones.

With subsequent pastel paintings, I enlarged my number of colors to around forty, but this is still quite a limited palette by the standards of most people who work in pastel. But I like to keep things simple.

M

y first romance with art was working in black and white. While I enjoy working with pencil and carbon, it's charcoal that's always had a special place in my work. I always turn to it with great enthusiasm, because it gives me a unique chance to paint in black and white.

I combine natural sticks of vine charcoal with compressed Russian charcoal, which has a rich, sensuous tone. I lay in "washes" of tone with the Russian charcoal, using it like paint. Then I reach for the vine charcoal to sharpen and delineate the forms.

Much of the success of a charcoal drawing depends on the artist's ability to leave things out and use the white paper as part of the picture. I'll make charcoal drawings on anything: not only on conventional drawing paper, but on commercial stationery, bristol board, even Kraft paper. I prefer white paper that has very little texture. Although many artists make fine charcoal drawings on

S. J. Perelman, pastel on board, 24" × 20" (61 × 51 cm). Collection of the artist. This pastel portrait of the great American comic writer was done on a pastel board, which is really toned paper that's been mounted on a board by the manufacturer. I did the portrait when the National Arts Club was going to give Perelman its gold medal for literature. As I usually do when I work on a pastel portrait, I picked no more than eight or ten colors from the box and then used the sandy color of the board as a definite tone that shows throughout the head. For me the great thing about pastel is that it's a very simple, spontaneous medium. I like to keep it simple by using as few chalks as I can get away with. If I have three or four chalks for the lights in the head, three or four for the halftones and shadows, and a couple more for the darks, I think that's enough. After all, old masters like Rubens and Watteau often did marvelous portraits and figures with just three pieces of colored chalk on a toned sheet of drawing paper. Note that I didn't blend my tones very much but that I let the strokes stand out as much as possible.

William Mayer, *charcoal and opaque white watercolor on tracing paper, 13″ × 11″ (33 × 28 cm). Collection of Mr. and Mrs. William Mayer. It's always fun to interpret friends because I have more freedom to experiment. When I drew composer-musician Bill Mayer, I thought of drawing him on a sheet of music paper with one of his own compositions. But then I found that the musical notes competed with my drawing. So I took a sheet of cloudy tracing paper and* pasted the music sheet behind it. The pale image of the music came through the tracing paper, but the notes were no longer strong enough to compete with my drawing. I then did the drawing on the tracing paper with a charcoal stick. However, the tracing paper looked a little too gray, and so I took some opaque white watercolor to strengthen the lights on his collar, back, arms, and hands.

toned paper—using white chalk for the highlights—I'm wary of this technique, since the chalk may turn out to be a crutch. It's best to use big, solid tones to suggest the planes and create form.

I make tones by rubbing the charcoal strokes with my fingers or with stomps. I use my kneaded rubber eraser not for corrections but as a drawing tool to pick out light planes and accents. I spray the drawing with workable fixative, which tends to darken the effect—sometimes improving the drawing and sometimes not.

I think it's important to use charcoal boldly. I like the legend that a teacher once took a sharpened charcoal stick out of a student's hand, broke the stick in half, and then returned the rough pieces to him. This was the teacher's way of forcing the student to work broadly and concentrate on large forms.

I still have a special affection for ink drawing, since my earliest work was done with brushes and india ink. In those days I used fine, pointed sables for line and detail and worn brushes for strong, solid areas where contrast was important. And I still remember my old penholders with their crowquill pens and my faithful Gillott number 170 pen points. My drawing surface was always bristol board in a plate or kid finish.

My graphite and carbon pencils are marvelous thinking tools. I use them for doodling ideas, as well as for delineating sharp detail. Their main function is to assist me in noting movements and gestures for future use in a portrait or figure painting.

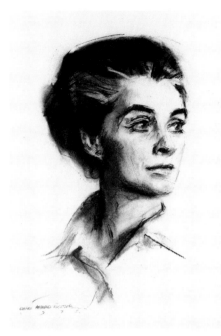

Mrs. Robert Spatola, *charcoal on illustration board, 20" × 16" (51 ×41 cm). Collection of Mr. and Mrs. Robert Spatola. For this portrait sketch, I laid the charcoal on very heavily for the hair, blended the tone with my thumb, and then used my thumb like a brush to carry the shadows down the side of the sitter's face, jaw, and neck. Most of the lines are in the features, while the outer contours of the head are mostly touches of tone.*

THOUGHTS ON PORTRAIT PAINTING

I've been painting commissioned portraits for over twenty years. Some of my sitters have been famous people, and others—often equally distinguished in their fields—have been unknown to the general public. But they were all people who touched me in some way, whom I was glad to paint because the job gave me the chance to project and interpret a human being. I was always glad to be there, in front of the easel, because of my intense desire to paint real people. It's never been just a commercial venture for me. If you're interested in portrait painting merely as a commercial venture—which means that you feel it's beneath you—don't paint portraits!

A portrait painter should enjoy and respond to people. That doesn't mean *liking* everybody, however. When I was painting Will Hays, Jr., I asked him about the famous line attributed to the late Will Rogers: "I never met a man I didn't like." Although I enjoy lots of people, I said that I couldn't understand how Rogers could possibly like *everybody*. If one admires some people, I thought, one must dislike others. As a young man Will Hays had known Will Rogers, and Hays assured me that Rogers never used the oft-quoted line. What Rogers really said was: "I never *kidded* a man I didn't like." And this makes a lot more sense to me.

The portrait painter reacts, responds, analyzes—and tries not to judge. The artist views his subject in the harsh light of his own intelligence. He observes the details of the sitter's facial expressions, movements, gestures, and what the sitter wears and how he wears it. Above all, the artist is trying to understand the person beyond appearances—to capture the *character* of the individual and to paint more than just what you see.

This really means that the artist and his subject must create the painting together. It's not merely a likeness—a camera can do that. The painter's keen, penetrating eye must discover the uniqueness

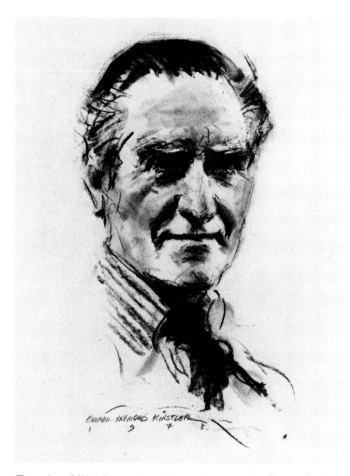

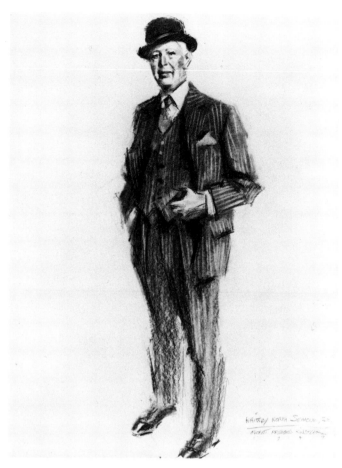

Brendan Gill, *charcoal on illustration board 20″ × 16″ (51 × 41 cm). Collection of Brendan Gill. The late publicist Benjamin Sonnenberg commissioned me to do this portrait as a gift to his friend (and mine) Brendan Gill, the distinguished writer and drama critic. I tried not to blend charcoal tones too smoothly; I wanted every mark on the paper to look loose and spontaneous.*

Whitney North Seymour, Sr., *charcoal on bristol board, 21″ × 16″ (53 × 41 cm). Collection of the artist. This drawing was done for an exhibition at the Century Club in New York, where I was showing 100 drawings of fellow members. As a departure from drawing heads, I decided to do a full figure of the noted lawyer in a pin-striped suit. However, I used the device that photographers call "selective focus," concentrating my sharpest detail in the head and the upper part of the figure.*

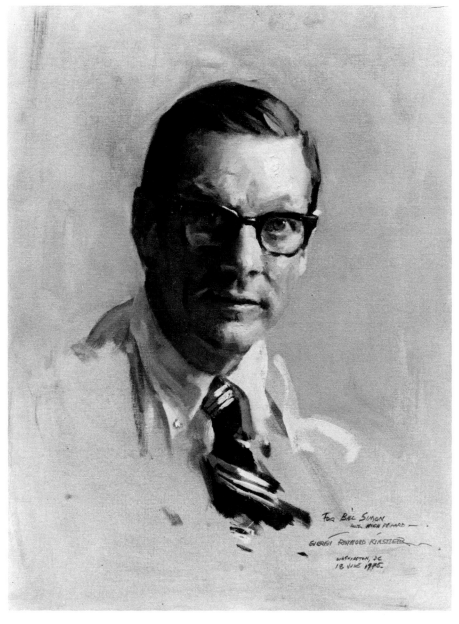

William E. Simon, *oil on canvas board, 24" × 20" (61 × 51 cm). Collection of William E. Simon. At the time that I was working on a large, three-quarter-length portrait of William Simon as Secretary of the Treasury, I also did this informal head in the sitter's office. I worked on a toned canvas and retained most of the tones, treating the head as a vignette. I hope this sketch conveys the tremendous energy of the sitter's powerful personality.*

of the sitter's personality and translate the artist's interpretation of that personality onto canvas.

Because the painting is an *interpretation*, it must reflect the artist's own viewpoint, his personality reacting to the essence of his sitter. However, the artist's feelings mustn't take over so completely that they overwhelm the individuality of the subject.

When I worked as an illustrator, I used my models to conform to a *type* that I wanted to portray. My model was used for form, detail, and pose — but I already had the *type* in my head.

In this sense portrait painting is profoundly different from illustration. From the very first moment I meet the sitter, I must begin to get to know him so that the portrait becomes a specific person. My first session is often spent just conversing and exchanging ideas. I watch for the sitter to relax and (I hope) assume a characteristic pose. When one subject asked me how I wanted him to pose, I replied, "*You* are going to pose yourself." I look for any factor that may help to get my creative juices flowing: a colorful way of dressing or a particular setting. This flexible attitude compels me to use my inventiveness and leads to an imaginative portrait — avoiding repetition, formula, and routine, which are the greatest dangers facing a busy portrait painter.

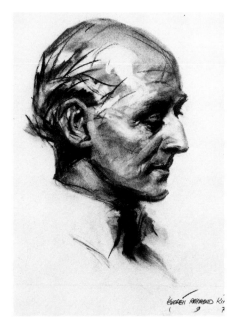

Sir Rudolf Bing, *charcoal on illustration board, 20" × 16" (51 × 41 cm). Collection of the National Arts Club. This drawing was commissioned by the National Arts Club when Mr. Bing received the club's gold medal for music. I wanted to capture the sitter's distinctive profile, which is strong and fine boned at the same time. Practically the entire head was covered with tone, and then I struck out big patches of light with a kneaded rubber eraser. I then squeezed the eraser to a tiny point to pick out the lights on an ear, nostil, and lower lip. Note that practically all the contours are tones—not lines.*

When I was commissioned by the United Nations to paint Secretary General Kurt Waldheim, my sitter arrived wearing his customary pin-striped suit with an ecru sweater vest. When he started to remove his vest, I asked him to keep it on. I suggested that he sit on the edge of a large table in my studio, keeping his jacket open and placing his hand on his hip. This was the conception I elected to paint.

When the secretary general came to see the completed portrait, his reaction was what Walt Whitman called "the deafening crash of silence." He had no criticism of the likeness or the painting technique, but it was clear that he didn't feel enthusiastic about my *conception*. As we discussed the painting, he suggested, with the greatest courtesy, that he would never wear a sweater vest in public or assume the posture that I showed in the picture. Finally, he pointed out that he'd sat in a pose that I'd chosen for him.

It was obvious that I'd made the kind of mistake that I warn other portrait painters against. As I studied his elegant, formal manner and dress, I realized that I'd used him as I once used models for illustrations: in my haste to paint him, I hadn't taken time to consider and study his personality. I'd moved so swiftly that I failed to form a mental picture of my sitter as an individual so that we could *agree* on a vivid, intelligent conception. I should have made haste more slowly.

I felt that it would have been wrong simply to change or rework the painting. Instead, I asked Dr. Waldheim if he would consent to start the painting again. He cooperated, of course, and my second, less theatrical portrait was certainly a more valid interpretation of the thoughtful man who carried the world's problems on his shoulders with such dignity.

In the second version of the portrait, I think I saw Dr. Waldheim with more depth, more dimension. Although I like the relaxed, casual character of the first version, I think the second version does a better job of conveying the personality of a man who's a diplomat, who's able to carry immense responsibilities because he knows how to sit quietly and listen to people, because he weighs his words and his actions carefully.

I've often thought that it would be fun to paint two different impressions of a sitter if I had the time and the budget. Actually, I've often started a second version on my own. Sometimes I've found the second one preferable, and sometimes I've gone back to the first. I haven't done this just to please the sitter, but as a way of exploring the full potential of the painting. I do this out of a sense of responsibility to myself. That's one of the things that DuMond taught me: the artist must have a sense of responsibility to *himself*!

Although I still prefer the first portrait as a *painting*, there's no question that the second version is a more truthful *portrait*.

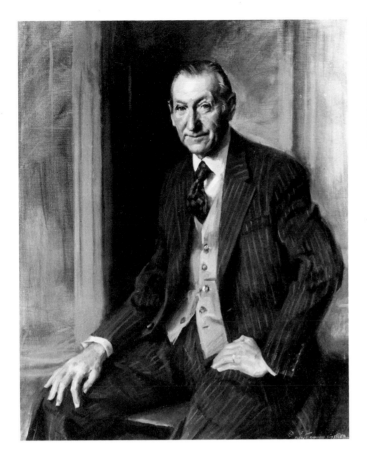

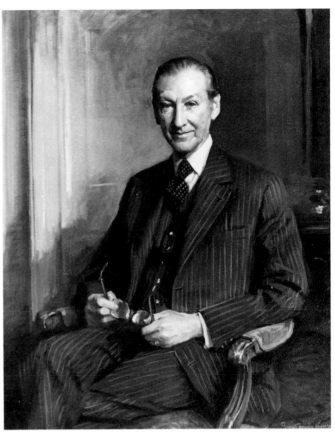

Kurt Waldheim *(first version), oil on canvas, 50" × 40"
(127 × 102 cm). Collection of the artist. My first portrait of
the Secretary General of the United Nations satisfies me as
a painting,* but both the pose and the dress are too casual.

Kurt Waldheim *(second version), oil on canvas, 50" × 40"
(127 × 102 cm). Collection of the United Nations. This
version places Dr. Waldheim in a chair rather than on the
edge of a table; eliminates the casual vest in favor of one
that matches his suit; puts him in a formal setting; and even
changes the pattern of his necktie to a much smaller one.
There's also a bit less contrast in the lighting on the head.
The portrait hopefully conveys the diplomat's thoughtful
dignity.*

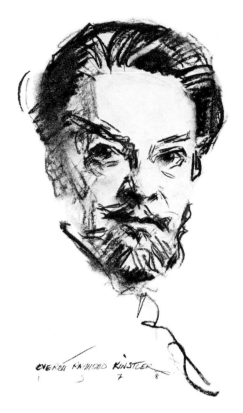

Alfred Drake, *charcoal on drawing paper, 16" × 12" (41 × 30 cm). Collection of the Players Club. This charcoal sketch was done so quickly — in less than half an hour — that it consists almost entirely of scribbly strokes and practically no tone. The only spots where I bothered to blend my strokes were a few places in the hair, along one side of the cheek, and just under the corner of the chin. This is a much more linear drawing than most of my charcoal sketches, but I think the rapid strokes convey the vibrant personality of the sitter.*

Alfred Drake, *oil on canvas, 30" × 25" (76 × 64 cm). Collection of Mr. and Mrs. Alfred Drake. Before starting my big portrait of Alfred Drake in costume, I made this oil study of his very impressive head. I felt that strong contrasts would emphasize the sitter's vivid, theatrical character. So I painted him with strong lights and shadows surrounding his features, and the entire head was framed by dark hair and a dark suit against a pale, slightly toned background.*

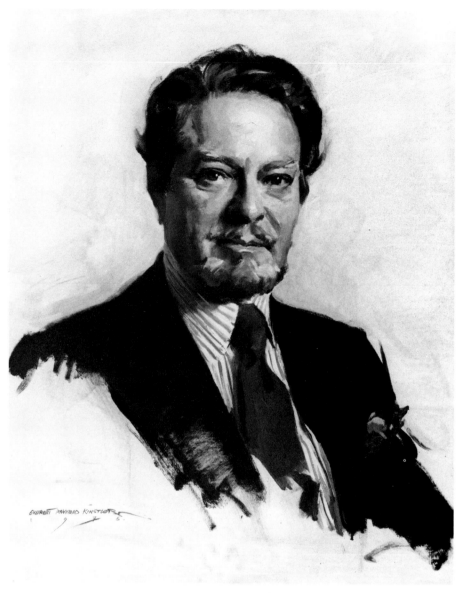

PAINTING ALFRED DRAKE

The Players Club in New York City is an association devoted to theater and drama. In 1978 the Players Club commissioned me to paint a portrait of its president, Alfred Drake, to hang in the club's landmark building on Gramercy Square. I was particularly honored by this commission because the club's great collection of memorabilia includes portraits of the great names of stage and screen by such important artists as John Singer Sargent, Augustus Saint-Gaudens, Thomas Sully, and Gilbert Stuart. I also looked forward to painting Alfred, whom I'd known and admired for his impressive career as an actor, singer, and director.

I began by asking Alfred to come to my studio, where I painted a life-size head of him in oil while we discussed "our portrait." We spoke about the idea of portraying him as he looked in his famous roles in *Oklahoma* or *Kiss Me Kate.* But Alfred decided that his personal favorite was Haj, the leading role in *Kismet,* which he performed on both sides of the Atlantic twenty years before. I responded to the idea, particularly when he showed me photographs of himself in the part and described the play and his feelings about it. Fortunately, the original cast recordings were still available, and so I was able to listen to that memorable recording again and again. I soon knew the whole production. In fact, I felt

that I could sing every musical number!

Unfortunately, Alfred's original costumes were no longer available. But this was a challenge that brought back my experience as an illustrator. Using Alfred's shirt and vest, I improvised the decorations with aluminum foil to conform to the *Kismet* photographs. I borrowed jewelry, a dagger, and an earring. Everything looked right to me, and Alfred confirmed that the effect was reasonably accurate.

The biggest challenge, of course, was to portray Alfred as he originally looked in a role twenty years before — to reach back nearly a quarter of a century and recreate the character. As I studied the early photos, I realized that he hadn't changed dramatically over those years. The beard was grayer, the eyes a little more hooded, but the hairline, expressions, and other characteristics seemed essentially the same. The structure was there.

To supplement the original oil study of Alfred's head, I drew a charcoal portrait. I then felt thoroughly familiar with my subject and ready to go ahead with the large portrait in oil.

As I started to paint him in the costume we devised together, Alfred spoke and sang his role. He fell naturally into a characteristic pose and assumed the right attitudes and gestures. Uppermost in my mind was the urge to convey Alfred's powerful theatrical sense.

At one point, while I was working on the portrait, Alfred felt that my interpretation suggested the sinister Iago in *Othello* rather than the delightful con man in the Arabian Nights setting of *Kismet*. This was an important, subtle insight that helped me to steer the portrait in the right direction. As I do with all my subjects, I welcomed Alfred's suggestions about my work in progress. I feel that the sitter will pose more intelligently if he's involved with the portrait as it progresses.

PAINTING JOHN WAYNE

At the time I was portraying Alfred Drake, I received a commission to paint John Wayne for the National Cowboy Hall of Fame.

Always a movie buff, I was excited by the challenge of painting this legendary personality. I'd also drawn and painted hundreds of cowboys when I was illustrating western stories, and I knew that this experience would help me when I painted "The Duke." On the other hand, I knew that the job wouldn't be easy. After all, Wayne's face was known to millions, and my interpretation would surely invite critical comment. How was I to paint a fifty-year career on one canvas?

I flew to California to meet Wayne at his home in Newport Beach. I was immediately impressed with his size — the larger-than-life feeling that he projected. He was a man who dwarfed others in his presence, even those who were physically larger than he was. Although he'd been ill recently, he was a figure of granite, a man of sculptural proportions. And the effect was more than visual. He'd been quoted as saying that he didn't act — he reacted. He projected amazing charisma. He conveyed it vocally and in his way of moving. He was a total personality.

We discussed our painting over breakfast and later over cocktails. At his house I made color notes and a few pencil drawings from life. I studied photos and movie stills that covered his half-century on the screen. As I watched him, I made notes of characteristic poses, movements, and expressions.

From the time I learned of the commission, I was convinced that

Sketch of John Wayne, *pencil on bond paper, 8½" × 5½" (22 × 14 cm). Collection of the artist. On my first trip to visit Duke in California in November 1977, I grabbed some letter paper from my hotel and stuffed it into my pocket with some pencils to be prepared for any contingency. As we talked, I made this pencil sketch. It took just a few minutes, but it was helpful when the time came to do the oil portrait.*

Note from John Wayne. *This note,
about my drawing of John Wayne on
horseback, is one of my treasures.*

John Wayne on Horseback, *pen and
ink on bristol board, 20" × 16" (51 ×
41 cm). Collection of the Estate of John
Wayne. When John Wayne was in the
hospital for a heart operation, I sent
him this drawing as a kind of "get-well
note."*

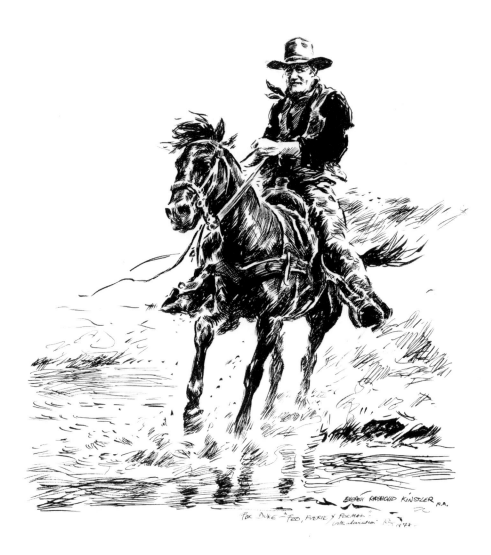

Wayne should be portrayed outdoors. With this in mind, I asked if
he'd let me take photos on his patio for future reference. As he
stood there, the harsh California sun wasn't kind to Wayne's worn
and salty features. Somehow, he didn't look particularly "western"
as he stood outside in his brown polo shirt, suntans, and sneak-
ers. I asked if he might have a "chapeau." He produced a battered,
much traveled hat that dated back to his early John Ford movies.
As soon as he put it on, he was no longer seventy years old. The
years seemed to disappear, and I saw that legendary image, the
illusion of a man half his age. I felt that I was sitting in a movie
theater, watching the ultimate western hero once again. I noted
his belt buckle: a memento from *Red River*.

I noted his characteristic stance, hands on hips. This stance,
much copied by his imitators, dated from his college football days.
(Football outfits had no pockets, and so this was a logical way to
stand.) He took that stance with him into his movie career.

I shot numerous color photos with my 35 mm camera. The Duke
knew all the right camera angles. At one point he squatted and
looked up at me. "Try this angle, Ray," he suggested. Instinctively I
started to squat to his level. "No," he said, "shoot as if you're
standing." With his long experience and knowledge of his own face,
he knew that I'd catch him looking directly at me. When he *stood*,
he was so tall that my camera was looking up under his chin.

I got back onto the plane for New York, armed with sketches, oil
studies, notes, and rolls of film. Soon afterward, complications
arose: the Duke was hospitalized, limiting his availability for

further work on the portrait. But we corresponded, and I treasure the letters he wrote, colorfully describing how he wore his hat, how he rode his horse, and other details that were important to my portrait.

When the painting was completed a year later, I flew out to Wayne's California home once again. The portrait was "unveiled" for the Duke as I watched with Dean Krakel and Rich Muno from the National Cowboy Hall of Fame and Wayne's friend Bob Norris. Duke had recently recovered from a serious operation, and I remarked on how well he looked. He gestured at the portrait: "I'd rather look like him. I like that fellow in the portrait — he's ready!"

M A LITHOGRAPH OF TENNESSEE WILLIAMS

aking a lithograph is a rare assignment for a portrait painter, and so I was fascinated by the project of creating a limited-edition lithographic portrait of Tennessee Williams for the National Arts Club scholarship fund that bears his name. In a sense, the project was a "collaboration" because Williams had to approve the concept before I went ahead.

A lithograph is essentially a drawing made directly on the stone or zinc plate from which the image will be printed. The beauty of the medium lies in those tender, delicate, sensitive tones that are totally different from the kind of tones you create on a sheet of drawing paper.

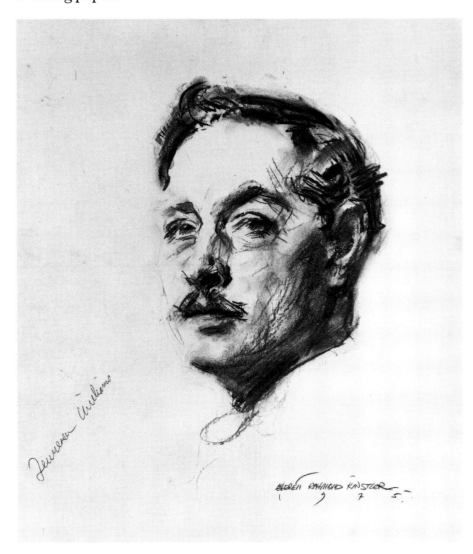

Tennessee Williams, *charcoal on bristol board, 20″ × 16″ (51 × 41 cm). Collection of Eleanor Lefkowitz. I did this charcoal portrait of the celebrated playwright from life as preparation for the lithograph that you'll see in the "gallery" at the end of the book. It's interesting to see that the lighted edge of the face has practically no line or tone, although the head seems quite complete. I left out even more when I did the lithograph, concentrating mainly on the features. When I did the drawing, I'd never done a lithograph before, and I didn't realize that the image would be reversed when it was printed from the stone. In other words, I drew him facing to my left on the stone, which meant that he'd be facing right when the image was transferred from the stone to the paper. However, both the drawing and the lithograph are good likenesses, and hope that I'm the only one who's aware of the switch from left to right.*

The project brought back a lot of my feelings and experiences as an illustrator. I was given total freedom to choose my own concept and my own method of execution. As my theme I chose some significant lines from Williams's play *Camino Real*, one of my favorites.

It was also like an illustration job in the sense that I had to work within specific technical limitations. I was cautioned that there would be no chance to correct or erase a stroke once I put it down on the zinc plate—an admonition that made me rather anxious, I must admit. My friend Will Barnet, a superb lithographer, pointed out that my drawing would be reversed when it was printed on paper, an important consideration in designing the image. And I decided on a lithograph in several colors, which meant drawing a separate plate for each color.

The whole job required a lot of "homework." I traveled back and forth to the lithography shop to learn the mechanics of processing the plates and "pulling" the proofs. Then I made numerous sketches, pencil notes, and preliminary designs of my conception.

When I was ready to draw on the plates, I worked right at the print shop, executing my Williams lithograph with crayon and liquid tusche for solid tones and delicate wash effects. (Those rough brushes really took me back to the days of my pulp illustrations.) Finally, I made repeated trips to the shop to make final adjustments in the plates and keep an eye on the printing. Thus, I was involved in my print from inception to finish.

LANDSCAPE PAINTING

Working in my studio throughout a long, gray winter, I'm constantly working with a model and indoor surroundings. When summer comes I need to refresh myself, both technically and creatively, by taking painting trips to far places.

In 1969 I had a strong urge to paint outdoors—somewhere with vibrant colors and strong light effects. I'd long admired the paintings that my friend Ogden Pleissner had done in Portugal, and he suggested some places to go. I rented a house for two months in Estoril, a small town on the Portuguese coast. As soon as the kids were out of school for their summer vacation, I headed across the Atlantic with my wife, Lea, and my two young daughters, Kate and Dana. Discovering that exciting world of tropical color was the beginning of a love affair with the brilliant light of the Mediterranean coast, Mexico, and the Caribbean.

The landscape is a big place, and one of the most intriguing questions is *what to paint*. I remember my teaching days at the Art Students League, when students often objected that they couldn't see the model because the classroom was so crowded. I simply suggested that they paint whatever they saw around them in the room: canvases stacked over the lockers, the fire-alarm box, and odd corners of the classroom itself. In short, they learned to train their eyes to *create* interesting paintings from whatever they saw. The students set up inventive still-life compositions: shoes, arrangements of brushes, glass jars. They observed and recorded objects that seemed ordinary, learning to interpret the effects of light on form. All this was a valuable lesson for me when I attempted a landscape subject.

You can waste a lot of time looking for the "perfect" subject. On my outdoor painting holidays, I make it a practice to start out early each day and give myself no more than half an hour to find a spot to paint. If I haven't selected my subject by that time, I force myself to

Church, Portugal, *oil on canvas, 24" × 30" (61 × 76 cm). Collection of the artist. I painted this little town with its sunlit church on three successive mornings, going back each day at the same time to get the same light effect. In a sense the church is spotlit: the wall of the church and the steeple are the only elements that are in full sun, while the other buildings are painted in halftones and shadows. The long strips of shadow at the right lead your eye to the church, which is the painting's center of interest.*

Bazaar, Nazaré, *oil on canvas, 12" × 18" (30 × 46 cm). Collection of the artist. Looking down from the balcony of our hotel, we saw the fruit and vegetable bazaar that was characteristic of Portuguese villages. I was fascinated by the abstract pattern of the awnings in the foreground, all converging toward that single building in the middleground, which was, in turn, silhouetted against the dark promontory. You don't often come across a ready-made pictorial design like this one. I did the oil sketch on a canvas board, working very quickly and finishing in about half an hour.*

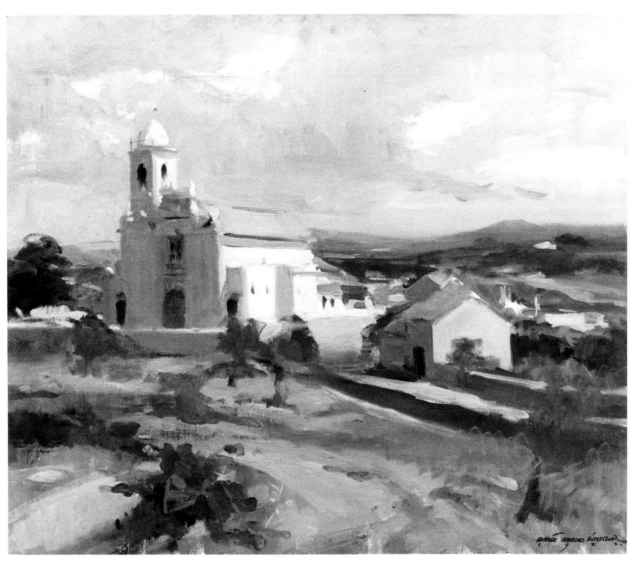

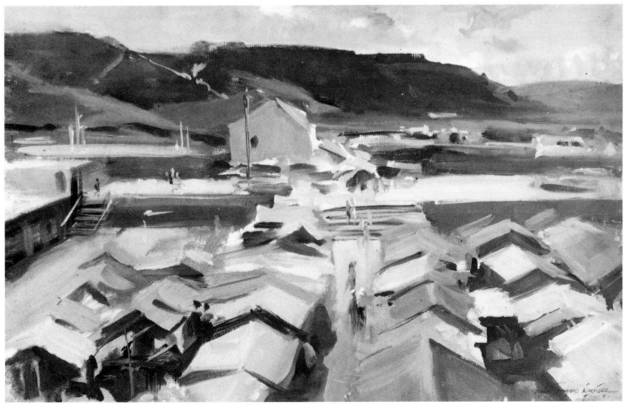

stop wherever I am and paint something right there.

I don't mean that I always walk out, park anywhere, and just paint anything that happens to be in sight. But I do find that there are always lots of images around me, always exciting subjects available if I can just *see* them. Painting the obvious is easy, but I think that beauty can be found anywhere. It takes awareness, sensitivity, and observation to paint the ordinary objects around us — and the result has greater artistic value, I think, than painting a subject that's obviously beautiful.

I've gotten into the habit of painting in the early morning and late in the day, when the lighting is most luminous and fascinating. (Besides, the midday sun is blinding!) I remember wandering through the back country of Portugal, hoping to paint the cactus plants and acquiring an assortment of cactus needles in all the wrong places. Despite the needles, I painted daily, discovering more and more pictorial ideas among the fig trees, the rocks, and the stunted tropical growth. Sometimes I finished a painting on the spot, while other times I made rapid impressions for possible future use. I learned that it was vital to return to an outdoor subject each day at the *same* hour so that the painting would remain consistent, despite the changing light.

I do take photographs — generally in color — for future use back in the studio. Occasionally the photo records a figure or other details that I can incorporate into a painting later on. But an outdoor painting captures something that no color photograph can ever convey. The artist finds himself with a kind of heightened awareness, an intensity, a sensitivity to light and color that lend a special energy to a painting done on the spot. For this reason I always caution students about painting *solely* from slides or photos. Unless you've had firsthand contact with your subject so that you understand and *feel* what it's like to be there, I don't think you can achieve an honest, exciting painting. If you just work from photos, you tend to copy things rather than convey your personal response. I'm not interested in just painting pretty pictures but in sharing an experience.

Painting outdoors is exhilarating, but it's also tough going. You have to find ways to cope. In a hot or tropical climate I've learned to wear a cap with some kind of visor to avoid the heat and glare. It's also a problem when the sunlight hits the face of your painting or reflects through the canvas; so I generally paint on panels or carry a piece of hardboard to which I tape my canvas.

When possible, I try to leave additional canvas around my planned composition so that I can recompose and crop when I stretch the canvas later on. I often find that I need additional canvas to enlarge or amend my composition. I also find it an advantage to have more than one canvas or panel available when working on location, just in case I want to start a painting of another size or shape.

Working early in the morning or late in the day, I find that the light moves swiftly as the sun rises or sets. To maintain a consistent light effect in the painting, I try to keep in mind the direction of the light and stay with that direction even as the light changes. Water and clouds are also difficult to paint because they change rapidly. When I paint water I decide what effect I want to capture, try to fix that in my mind, and record it even if the subject changes. Clouds change their shapes, and so it's important to record the shapes decisively, bearing in mind that clouds have a solid structure and don't look like cotton candy.

Back indoors, looking at the painting in neutral or north light, I've often been disappointed to find that my colors and values

Donald Rumsfeld, *oil on canvas, 44" × 34" (112 × 86 cm). Collection of the United States Department of Defense. In contrast with more formal portraits of statesmen —such as Elliot Richardson and Kurt Waldheim elsewhere in this book —I painted a "shirt-sleeve portrait" of Donald Rumsfeld as United States Secretary of Defense. The informal dress is matched by the relaxed pose and by the suggestion of workmanlike clutter on the desk. Even the lighting in the portrait gives you the feeling that this is the normal sort of light that comes through the sitter's office window as he's working. Obviously, this sitter likes the idea of being painted as he might appear on a typical day in the office.*

aren't what they seemed to be when I was painting outdoors. Colors and values often seem insipid, lacking in contrast, or generally bleached out. Seen outdoors, colors may look a lot richer than they look when you take the canvas inside. I've learned to think more carefully about color, which often means exaggerating. For example, if the shadows in nature are very deep, I may use alizarin crimson and cobalt blue, even if the shadow looks too dark when I look at the picture in sunlight; the colors will be more subdued when I take the picture inside. Conversely, for light areas, I may dip into lemon yellow and white to create more vivid lights than I may actually see so that the lights will remain vivid indoors.

When I work outdoors, I generally paint for at least two hours continuously, returning each day at the same time to continue the picture. To get the right tonal contrast, I begin by blocking in the dark areas, leaving the canvas to represent the lights or halftones. Thus, I work from dark to light to capture the strong contrasts of values that are typical of sunny climates.

WORKING AT THE PAINTER'S CRAFT

When someone asked me how long it took me to paint Governor John Connally's portrait, I replied, "Two years—and one weekend." I wasn't trying to be facetious. I was quite serious. I worked on Governor Connally's portrait whenever he was available to come to my studio. I made countless sketches

and color studies. Dissatisfied with my result, I put the project aside to start afresh. After struggling with the concept for two years, I finally worked out what I wanted to do, and *then* I painted his portrait in just two days.

The truth is that every painting represents a struggle. There's rarely an easy solution. It's not unusual for me to put aside paintings, reconsider my whole approach, and begin anew — sometimes to the displeasure of my sitter.

This is why I'm distrustful of the painting demonstrations that I'm often asked to give before art groups. Unless the demonstration is to benefit some group for which I have special feelings, like the Art Students League or the National Academy, I generally refuse.

I'm reluctant to give demonstrations because I consider them a stunt, an ego trip that illustrates the artist's facility without showing what's really involved in creating a painting. Unfortunately, when I'm able to paint a head in an hour, the audience thinks that it's a simple job. Such a demonstration can mislead the student into thinking that it's all technique — and that acquiring technique is easy. So I always preface my demonstration by saying that it's just a performance. But I'm not sure that my viewers always believe me.

The ideal "demonstration" would take days, even weeks, with the audience following me through all the agonizing hours of rethinking, scraping out, and restating. Then they'd learn, once and for all, that recipes, formulas, and speed of execution mean nothing. Spontaneous painting is the result of years of experience — working, reacting, reading, living. Technique is simply the instrument for conveying the artist's feelings in the most direct way.

Another thing that an audience would see in my studio would be the gold medal and the rejection card that sat for many years, side by side, on my mantel. I received them separately for the same painting. I kept them together as a reminder that neither success nor rejection should be taken too seriously.

Several years ago I submitted a picture to the jury of the annual exhibition of the American Watercolor Society, of which I'm a member. I was disappointed when the work was rejected. I couldn't understand why, and I asked several artist friends for their reaction, urging them to be honest. They all thought it was a good watercolor, and they suggested that I resubmit it the following year. I did, and it was turned down a second time. The third year, when the A.W.S. show rolled around again, I had no painting available except for my twice-rejected piece. I thought I might as well have three rejections, and so I sent it in again. Not only was the painting accepted, but it won a top award!

I might add that I was rejected three times for membership in the National Academy of Design, and then I was accepted on the fourth try.

There are really two lessons here. It's important to keep plugging away, and it's also important to keep some perspective about both success and rejection. And a sense of humor helps, too.

The main thing is to keep working, questioning, experiencing, growing. You've got to train your eye and develop your emotions to work together. We're all students. There's no end to learning. As John Sloan said, "I am still a student, chewing on a bone."

Demonstrations

DEMONSTRATION ONE

Brook

Oil on canvas, 20" × 24" (51 × 61 cm). Collection of the artist.

<div style="text-align: right">

STEP 1

</div>

Working on a white canvas, I thin my tube colors with turpentine to scrub in the general plan of the rocks and the water. I'm working with big, scrubby strokes all over the canvas, laying out the general distribution of the shapes, concentrating on structure rather than accurate drawing. In the early stages, I'm working with just three brushes—all medium-sized filberts. My palette is just burnt sienna, raw sienna, cerulean blue, and ultramarine blue—plus white, of course. Each warm tone is essentially a mixture of one of the siennas and one of the blues, plus some white. The strong darks in the foreground are generally mixtures of burnt sienna and ultramarine blue, while the softer tones are mixtures of raw sienna and cerulean blue. I'm particularly fascinated by the warm tones within the cool shadow sides of the rocks in the middleground. The shadows on those rocks are delicate mixtures of raw sienna, cerulean blue, and just a touch of ultramarine blue, plus white.

STEP 2

Now I cover most of the canvas, carefully leaving bare spots for those important patches of light on and around the rocks in the middle distance. I'm still working with the same four colors, but I add a bit of alizarin crimson here and there; you can see the dark, reddish strokes scattered among the rocks, particularly down in the shadows along the lower edges. I'm still making most of my mixtures with a sienna and a blue, but I add a touch of chromium oxide green to the halftones that you see on the sky and across the surface of the rocks. I want to establish a halftone across the lower half of the canvas to integrate all the details and to create a contrast between the foreground and the brightly lit middleground. I like to introduce two colors into the shadows—one warm tone and one cool tone—as you can see in the foreground rocks, as well as in the sunlit rocks in the middleground.

STEP 3

I'm probably no more than twenty or thirty minutes into the painting, and I think the pattern of light and shadow is established clearly enough to keep me on the right track, even if the weather changes radically. I'm beginning to strengthen the colors in the middle distance, using combinations of cerulean blue or ultramarine blue and alizarin crimson for various touches of pink and purple. I also build up the shadows with much darker strokes of ultramarine blue and burnt sienna, as you can see along the lower edges of the rocks. I'm adding stronger touches of chromium oxide green, which you can see most clearly in the upper right. The shapes of the rocks are generally stronger and more three-dimensional now. But I still haven't done much with the sunlit rocks and water in the middleground. I'm saving these lights the way I'd save areas of bare paper when I do a watercolor. Right now I'm working with around five large and medium-sized brushes: two for the shadows and two or three for the middle tones.

STEP 4

Dipping into cadmium yellow, raw sienna, and white, I begin to lay on the top planes of the sunlit rocks in the middle distance. I also begin to develop the soft grays in the middle distance with raw sienna, cerulean blue, and white. I begin to suggest the feeling of the water with parallel bands of color, brightened here and there with the same mixture I'm using for the sunlit tops of the rocks. In the lower right you can see I've also begun to develop the color and movement of the water that spills through the rocks into the foreground. The rocks in the foreground are gradually becoming more structured, more solid, but notice that I'm also softening some of the edges where the rocks overlap one another; this interplay of hard and soft edges helps to create the illusion of three dimensions. Just above the lower left, I begin to add a few touches of cadmium yellow and white to suggest the sunlight hitting the flowers that spring up from the ground along the edge of the water and the rocks.

STEP 5

I'm now about an hour into the painting, and I'm beginning to bring the picture into sharper focus. For example, there's more detail in the water in the lower right, where I've even used the sharp end of my brush handle to scratch a few lines to indicate the flickering light. There's also more detail in the water in the middleground, where I've added pale strokes to suggest the light and movement of the stream. I'm continuing to build up the sunlit planes of the rocks with cadmium yellow, raw sienna, and white. At the same time, I'm beginning to heighten the colors on the shadow sides of those rocks, where I blend in a blush of warmer, richer color. I'm also picking up reds and yellows and blending them into the foreground rocks. I add cooler, brighter touches to the shadow sides of the two rocks in the distance, just below the top of the picture, so that these shadows now look more luminous and transparent. I keep working all over the picture, rather than concentrating on any one spot.

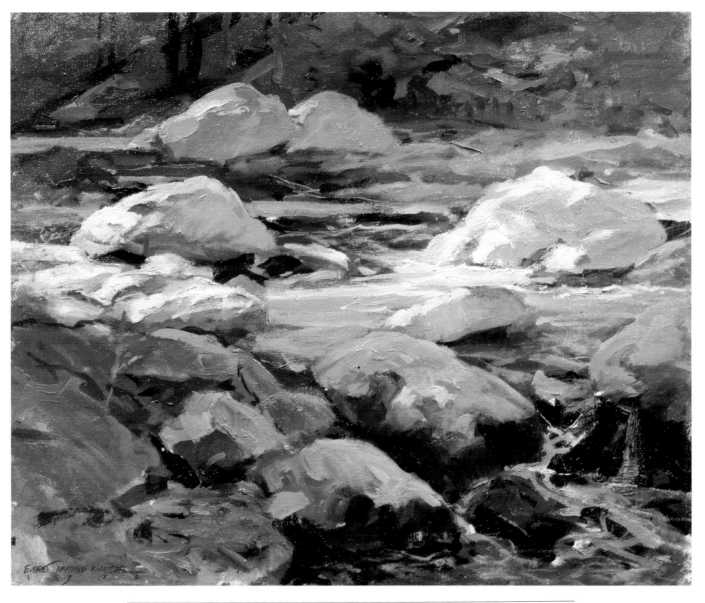

STEP 6

The final stage—working on the touches that give character and structure to the painting—probably takes another hour, and so the painting takes roughly two hours altogether. Now I strengthen and sharpen the shapes of the rocks, building up the lights with thick strokes (as you can see in the left middleground) and also building up the colors within the shadows. The water has more lights, halftones, shadows, and details. So have the rocks in the foreground. Probably the most important color change is the introduction of a lot of subtle blues and violets, which are blends of ultramarine or cerulean blue (or both) with alizarin crimson and white. Notice how I indicate the action and detail of the water in the lower right with wiggly strokes of violet and blue. I also heighten the effect of the sunlight among the trees in the upper right; these strokes are cadmium yellow, chromium oxide green, and white. The distant rocks, just below the top of the picture, are brighter and more colorful, but they're still soft enough to hold their places and not compete with the sunlit rocks and water.

Frick Cove, Bermuda

Acrylic on canvas board, 16″ × 20″ (41 × 51 cm). Collection of the artist.

STEP 1

I begin by toning the canvas with a very pale mixture of raw sienna and cerulean blue—plus white and a lot of water—and then I suggest the rough outlines with a charcoal stick. Now I block in the darks of the foreground rocks with chromium oxide green, raw umber, and cerulean blue. I record three distinct shades of blue in the water: the dark blue band at the horizon is ultramarine blue, cerulean blue, and white; the next band down is greener because I add chromium oxide green; and the paler water along the beach is ultramarine blue, chromium oxide green, and a lot of white. I pick up the rock tone to suggest a few rocks around the edge of the promontory. Along the top of the promontory, I brush in some strokes of chromium oxide green, cadmium yellow, and raw umber. Those notes of hot color, like the strokes in the lower left, are burnt sienna and chromium oxide green. The big rock at the right casts a cool shadow on the water; I add more chromium oxide green to the mixture of ultramarine blue and cerulean blue. In the lower right, I wash in a faint hint of cadmium yellow.

STEP 2

Suddenly the weather is turning stormy, and I can see the sky turning from a sunny blue to a darker, more turbulent color. I quickly brush in big strokes of ultramarine blue, cerulean blue, raw sienna, and just a speck of alizarin crimson toward the horizon. Between the dark shapes I leave gaps of raw canvas, which I'll work on later. I brush a bit more color over the promontory with a mixture of chromium oxide green, a little burnt sienna, and white. Then I move into the foreground, brushing a thin wash of ultramarine blue and chromium oxide green over the bright water in the lower right; that touch of yellow, applied in step 1, shines through. I also begin to brush more tone over the big rocks in the foreground with pale mixtures of chromium oxide green, raw sienna, and burnt sienna.

STEP 3

Now that I'm about forty-five minutes into the painting, I begin to work with a wider range of color. I dip into alizarin crimson, burnt sienna, and white to indicate the bright notes of the houses on the promontory. I continue to build up the colors of the sky by brushing warmer tones of raw sienna and cerulean blue over the areas of bare canvas and then adding alizarin crimson to my blues to enrich the darker areas of the sky and warm up the tone along the horizon. As I work on the sky colors, I also build up the water, brightening and deepening the water just above the rocks with cerulean blue and chromium oxide green. I brush more color over the promontory with chromium oxide green, ultramarine blue, and raw sienna. And I continue to darken the foreground rocks with various mixtures of the two siennas, the two blues, and chromium oxide green.

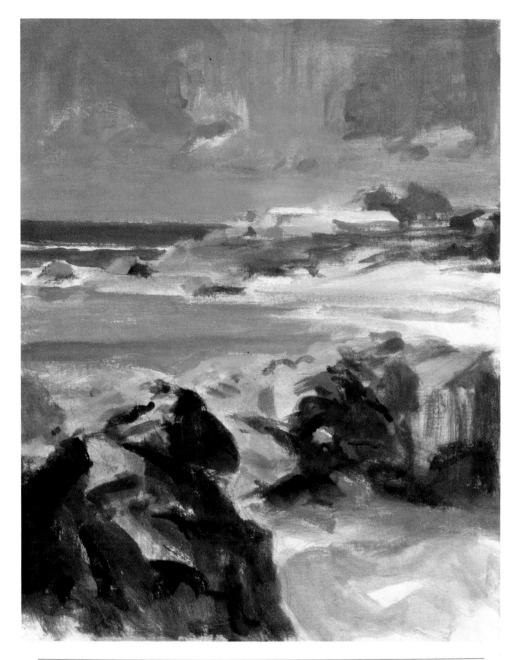

I keep building up the tones of the rocks with the same mixtures I've used in step 3. I'm also beginning to reflect some of the sky colors in the rocks, as you can see in those cool touches scattered across the tops. I darken the cool shadow of the big rock in the lower right and add more color to the water, curving my brushstrokes to suggest the swirling movement of the water. I continue to build up more color in the water along the edge of the beach—where the water is distinctly greener than the two bands of darker blue in the distance, beyond the promontory. I blend cadmium yellow light and raw sienna for the sunny colors of the sand along the edge of the promontory and for the rooftops. The trees and their shadows on the promontory (at the extreme right) are darker strokes of chromium oxide green and burnt sienna. And I strengthen the tones of the sky with the same mixtures I've been using all along, though now I define the shapes of the clouds more distinctly. I'm working all over the picture, tying it together by repeating colors like the cool mixtures that appear in the sky and water, and that then reappear at the edge of the promontory and along the tops of the foreground rocks.

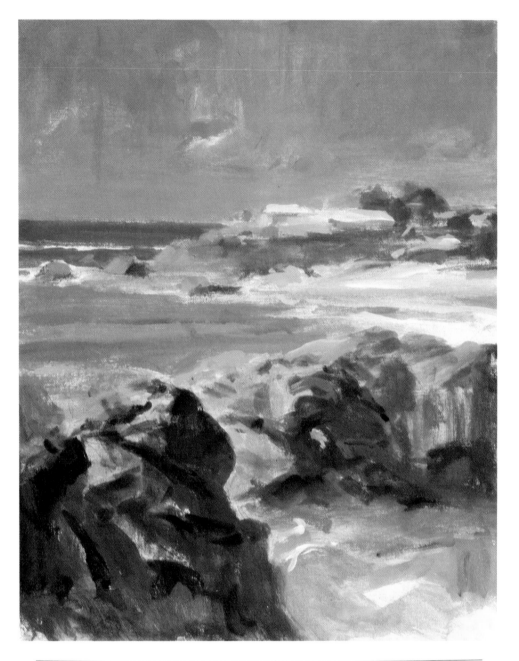

By this stage the changes are becoming more subtle. I soften the edges of the shapes in the sky—where the warm and cool shapes meet. I add a bit more detail to the promontory, suggesting other houses among the trees, small patches of sand among the foliage, a shadow along the edge of the beach, and a few flashes of sun on the yellow sand. Just as there's a strong sense of light hitting the clouds, I want to give that same feeling to the water, where I brush in some brighter strokes to suggest the light hitting the breakers. I darken the shadow sides of the foreground rocks and add a few more strokes to the swirling water in the lower right to suggest more action as the water pours between the rocks. Notice that in the big rock at the right there's a little hole through which you can see the bright, pale color of the distant water.

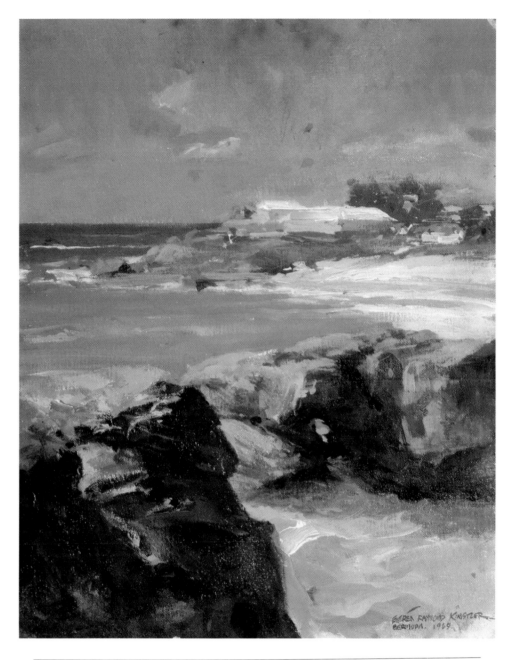

STEP 6

In this final step I go over the whole picture, defining the shapes with solid, distinct strokes of fairly heavy color. You can see the strong, decisive strokes in the sky, where I've added some bright blue touches to the left of the big cloud and the blush of violet along the horizon at the right. I also build up the foliage on the promontory with solid strokes and then move down into the water with long horizontal strokes to suggest the sunlight on the edges of the waves. I build up the sunny tops of the big foreground rocks with thick strokes and then move down over the shadowy sides to solidify the tones and tie them together. I also brush thick, creamy strokes over the swirling water in the lower right. All this is done with thicker, somewhat brighter versions of the original mixtures, derived from quite a limited palette of colors: cerulean and ultramarine blue, raw and burnt sienna, chromium oxide green, cadmium yellow, alizarin crimson, and lots of white.

Elizabeth Helm

Oil on canvas, 46" × 34" (117 × 86 cm).

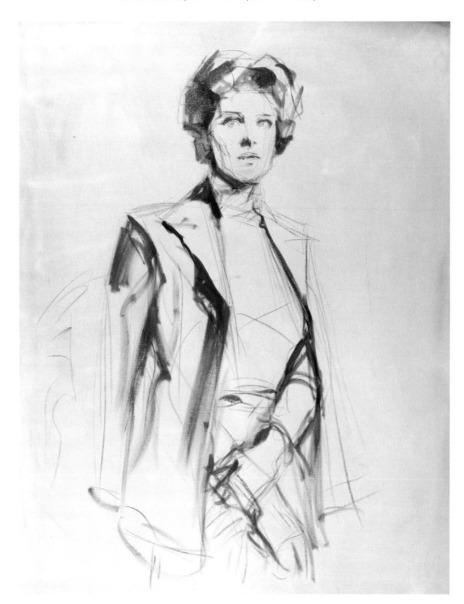

STEP 1

Although this is a simple, standing pose, the sitter and I discussed a lot of other options. I first thought about painting this very handsome woman in an evening dress, but then, when we discussed the portrait, we both agreed on informal clothes. At first she sat, but then I asked her to stand. I don't know how we arrived at the idea of her just wearing the coat over her shoulders. We might have arrived at that idea purely by accident: perhaps she was wearing the coat and started to take it off; or maybe she was posing in her sweater and started to put the coat on. There was certainly more trial and error than you might think. At any rate, the pose, the informal clothing, and the jacket over her shoulders all combined to give the whole portrait a nice, relaxed feeling. Now I start by indicating the shapes with a charcoal stick, and then I block in the picture with chromium oxide green, burnt sienna, and turpentine, using more burnt sienna in the coat. As you can see, I'm working on a canvas that's been toned grayish blue.

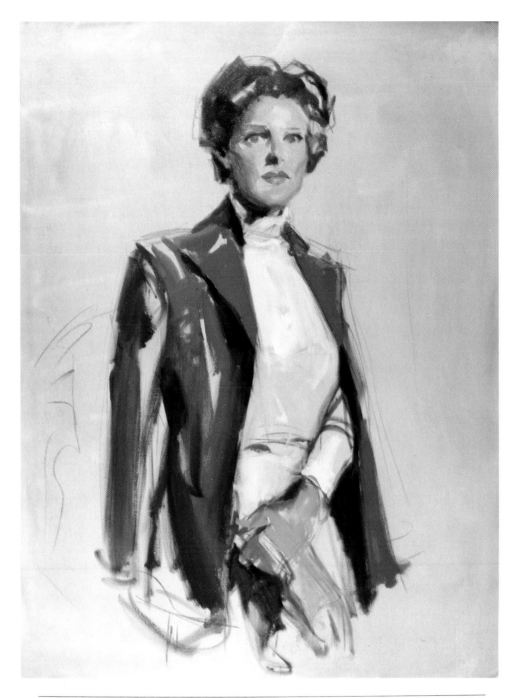

STEP 2

I'm beginning to block in the colors. I use cadmium yellow light, cadmium red light, a touch of alizarin crimson, and white for the flesh tones on the head and hands, adding some chromium oxide green for the shadows on the skin. The lips are the same mixture as the flesh but with more red. The big strokes of the jacket are cadmium red light, alizarin crimson, and burnt sienna, with more burnt sienna and a touch of chromium oxide green in the darks under the arm and collar and inside the coat. The white sweater is mostly white, but it's an off-white because I add a touch of raw umber and a little cerulean blue. I never use any color straight from the tube; I always add a hint of one other color, at least.

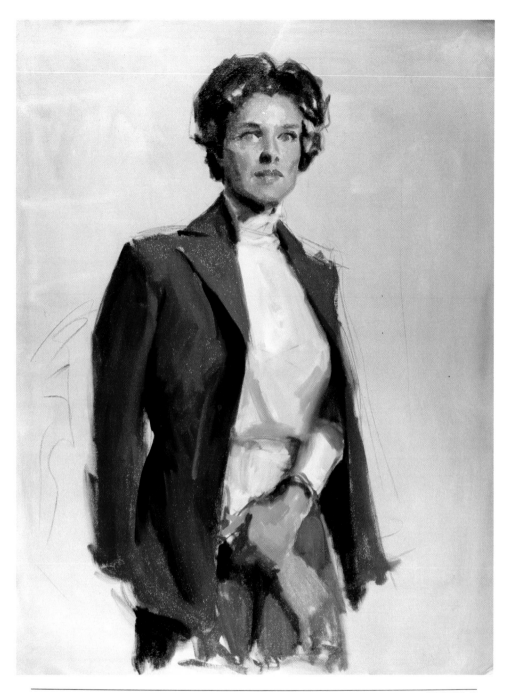

I'm still not paying any attention to the background but concentrating on strengthening the head and figure. I'm aware of the background, of course, but I've already made the decision to keep it very simple, almost flat. I like the outline of the body against the simple background. I strengthen the forms of the head, making no conscious attempt to achieve a likeness at this stage, although I'm always aware of the structure and proportions of the face. I build up more color in the head with the same mixtures I've used in step 2. Now, instead of thinning my color with pure turpentine, I'm beginning to add copal painting medium, which makes my mixtures rich and creamy. The coat is covered more solidly with the original mixtures. I'm working on the sweater, suggesting shadows with raw umber, chromium oxide green, and white—then carrying this same mixture down into the skirt. The hands are much larger than they will be later; I tend to work a bit large and then cut things down as I sharpen them in later stages of the painting.

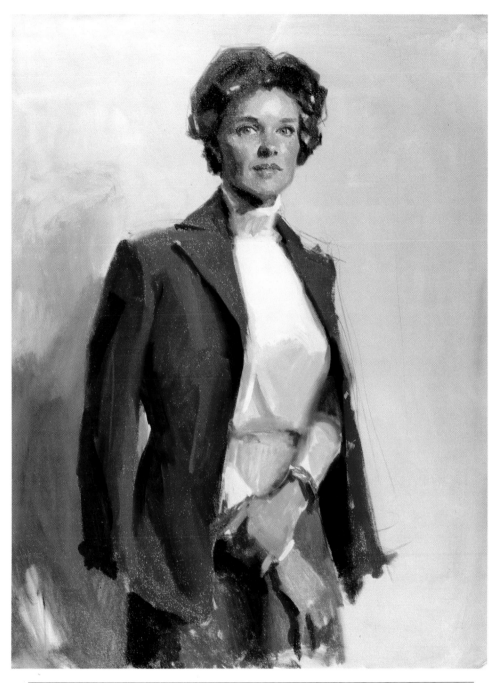

I'm gradually refining the face, working more carefully around the eyelids, cheekbones, and jaw. The hair also has a more solid, distinct shape. For the first time, fingers are beginning to appear within the hands, although I still haven't carried the hands as far as the head. The lower hand swings out more because I emphasize the cast shadow on the skirt. Just inside the hanging sleeve of the coat, I paint that little triangle of white very carefully to give the coat a trim, feminine look. The shape of the sweater becomes more three dimensional as I add a tone under the turtleneck and another tone beneath the bustline. Finally, I begin to suggest the shadow on the wall with raw sienna, cerulean blue, and white, giving a feeling of space between the sitter and the wall behind her. The shadow also creates the feeling that the figure is no longer at the absolute center of the canvas. I define the shapes of the jacket and skirt more precisely, carrying the skirt down to the lower edge of the canvas.

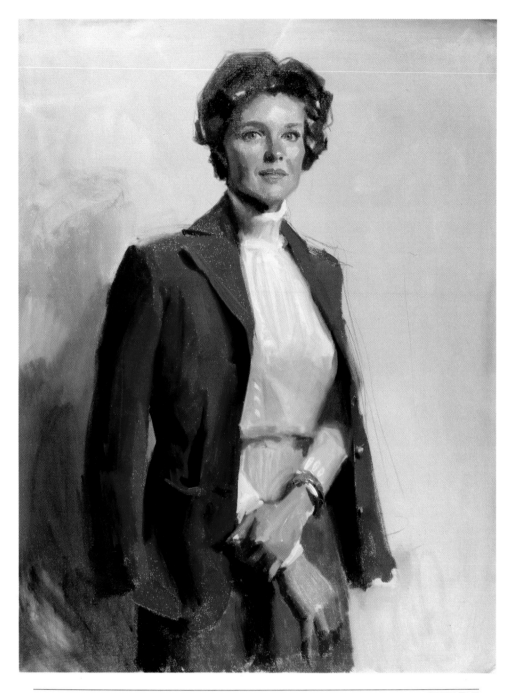

Now I'm really beginning to sharpen and define my subject. I'm concentrating on the face and hands. There's much more detail around the mouth and within the eyes. The color is both richer and softer, losing that "raw" look that every portrait starts out with. The hands start to become smaller as I begin to tighten up the edges and the details. Over the off-white of the sweater, I drag long strokes of almost pure white to suggest the texture of the weave. I add details like the pockets and buttons to the jacket. The bracelet is suggested with strokes of raw umber, raw sienna, cadmium yellow, and a bit of white. The portrait is beginning to become a person, but I'm still holding back on the final detail, the blending, and the other refinements, which I save for the last stage. For as long as possible, I like to keep my brushwork broad and loose.

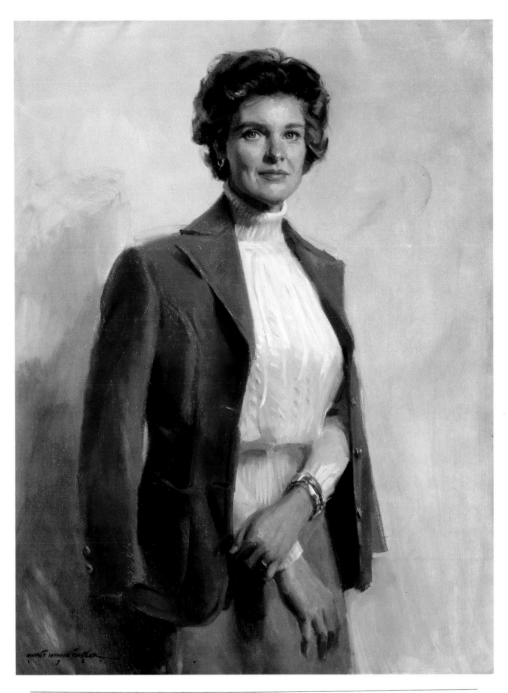

In the final stage, I really concentrate on the likeness, refining the features, softening and blending the lights and shadows, and adding sharp, lively touches, such as the highlights in the eyes and the bright touches on the nose, cheeks, chin, and forehead. I save the details of the hair for the end, suggesting the curls without too much detail. Now the hands are finally in correct proportion to the head, although you'll notice that they're painted a bit more broadly. I also add a bit more detail to the sweater and coat, but these are still painted very broadly. A soft, thin tone is brushed over the entire background and blended into the shadow at the left. These background mixtures are various combinations of raw sienna, raw umber, cerulean blue, and ultramarine blue, plus lots of white and hints of some of the other colors in the portrait. As you run your eye around the edges of the shapes, you'll see that some edges are sharply defined while others merge softly into the background.

John Wayne

Oil on canvas, 25″ × 20″ (63 × 51 cm). Collection of the artist.

STEP 1

Although this is just a study of the actor's head, I want to suggest an outdoor portrait, and so I tone my canvas with cerulean blue, a touch of raw umber, and white. This subdued, cool tone gives me a feeling of outdoor atmosphere. Now I begin working on the head and the hat, placing the features accurately to give the head a sense of structure but not really concentrating on a likeness. I think it's especially important to capture the open mouth, characteristic of John Wayne, and I try to convey this and hold onto it throughout the painting. I'm not really working with outlines here but with touches of shadow in all the right places to give me the "signposts" to follow in later stages of the painting. The colors of the face are all mixtures of burnt sienna and chromium oxide green, with a bit of white, diluted with turpentine. It's surprising how much color you can get when you work with just two colors like burnt sienna and chromium oxide green—one warm color and one cool—plus white.

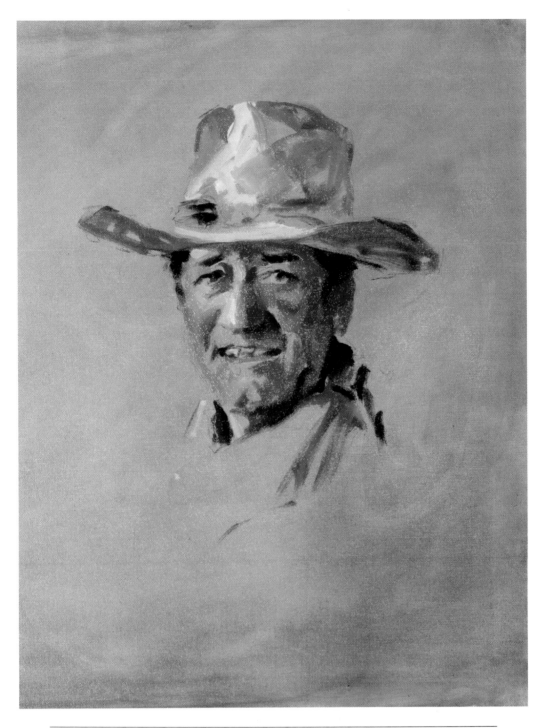

STEP 2

Now I begin to block in the colors of the face with cadmium yellow light, cadmium red light, alizarin crimson, and white, working with quick strokes and letting the cool tone of the canvas shine through between the strokes. The warm colors of the cheeks and lips are really really the same mixture as the other flesh tones but with more crimson. I strengthen the darks of the face with burnt sienna and ultramarine blue. That same mixture appears on the shadow beneath the chin. Because I want to emphasize that flash of light on Wayne's hat, I pick up a thick brushload of white plus a hint of cerulean blue and scrub this over the canvas, allowing the tone of the canvas to shine through. It's typical of Wayne to wear a battered hat, which I suggest with scrubby strokes of raw sienna and ultramarine blue.

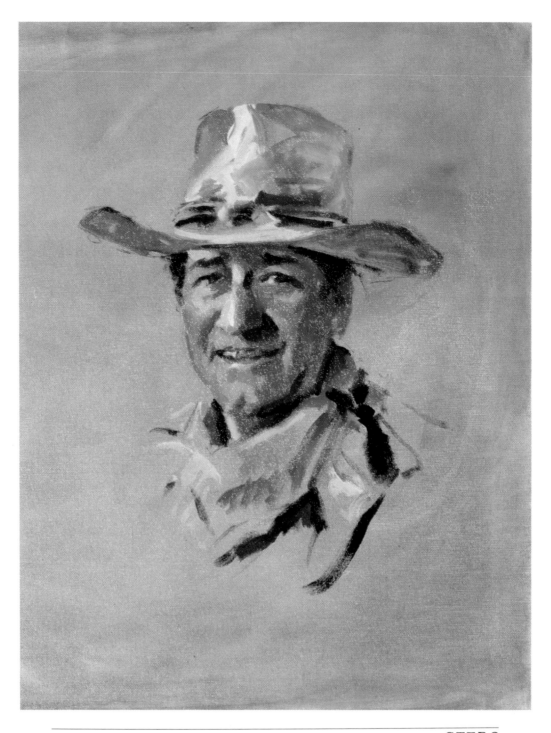

STEP 3

I'm beginning to focus on the special character of John Wayne's head. I develop the flesh tones, building up the lights and halftones and brushing them together on the face. (The underlying tone of the canvas is beginning to disappear now.) Now there are distinct lights, halftones, and shadows; you can see this gradation clearly on the neck. I brighten the eyes by adding the whites; these aren't pure white, straight from the tube, but white with a hint of cerulean blue. I frame the lower part of the head by brushing in the bandanna, which contains some of the same tones that I've already brushed into the hat. Comparing steps 2 and 3, you can see that the earlier step consists of a lot of patches of color, while these patches gradually become planes in the later step, where the head looks more solid and three-dimensional.

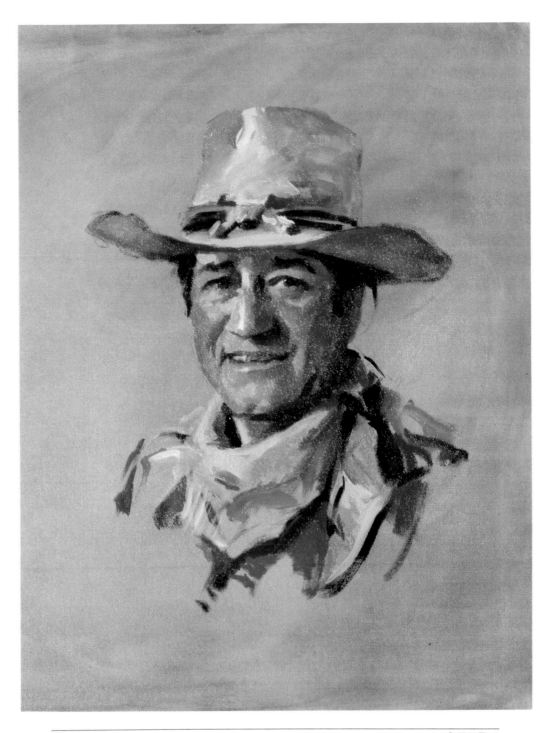

STEP 4

Now I think the portrait really looks like John Wayne. I'm working very carefully on the planes of light, halftone, and shadow around the eyes, mouth, and chin. There are stronger contrasts in the eyes, along the underside of the nose, on the shadow side of the nose, and within the lips—which form Wayne's distinctive, crooked smile. The hat now becomes a very specific hat, with those decorative details around the crown and the battered shape of the brim. I'm also very specific about the shape and texture of the bandanna, which is painted in stronger versions of the same colors that appear on the hat: ultramarine blue, raw sienna, burnt sienna, alizarin crimson, and white in various combinations. I could really stop the portrait here and have what I consider a satisfactory oil sketch. But I do want to go on and refine it further.

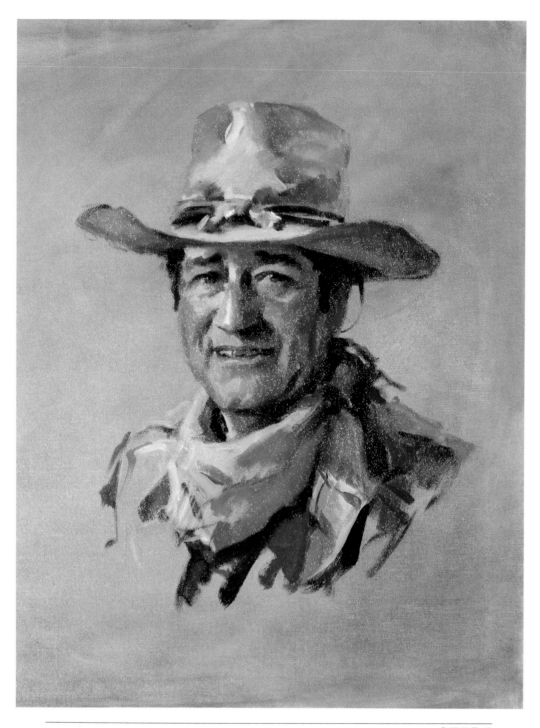

STEP 5

The refinements are becoming very subtle, but they're important. I'm still working on the eyes, for example, so that you can see the details a little more distinctly. I'm also working on the lips, where I've taken out a distracting highlight that appears on the lower lip in the previous step. Now the planes of the lips and chin are better integrated. To frame the head more dramatically, I've built up the shadow planes of the hat with darker colors and I've also gone down to strengthen the planes of the bandanna, which now has a big shadow on one side, making the shape look more three dimensional. I also add little touches of color to the bandanna, particularly on the right, to suggest decorative stripes. Notice how his ear is still just a flat patch of color with no detail.

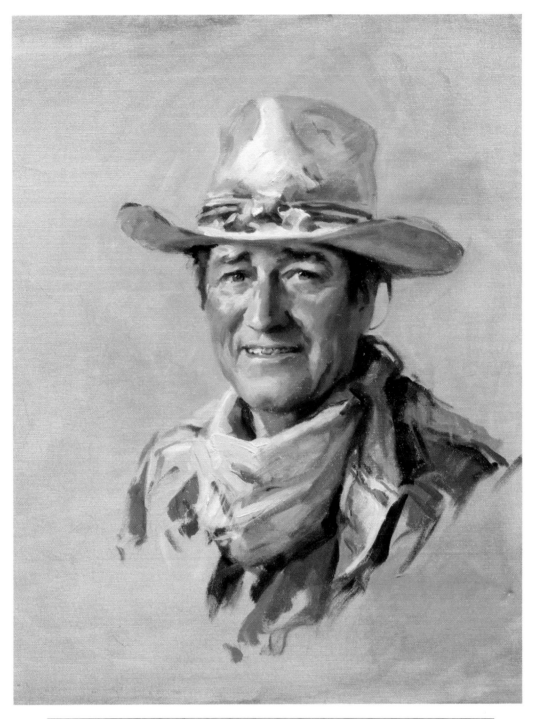

The final job is to pull the entire head into focus. I want to make everything clearer now. The hat has a more distinct shape, and so do the tassels on the hat. I've worked on the eyes and eyebrows, lightening the color of the eyes a bit, so that now they're definitely John Wayne's eyes. I also refine the crooked mouth and the teeth, which are characteristically uneven. I try to heighten the glow of outdoor light on the hat, the face, and bandanna, all of which now have a more golden feeling, I think. As much as possible, I save the blending of the flesh tones for the final stage, carefully softening the edges where one plane meets another but trying not to overdo it. On the chin, for example, there are much softer transitions than you see in the earlier stages, where the individual patches of color are more evident. In this last stage, I try to tie the colors together, making them more subtle and less "raw." There's now more of an interplay between the colors, more of a sense of music.

James Cagney
Watercolor on paper, 13½″ × 10½″ (34 × 27 cm). Collection of the artist.

STEP 1

The initial purpose of this portrait sketch of my friend James Cagney is to help me do a lithograph of him for the Players Club. I'm working from life on a pad of watercolor paper that I bought in Paris over twenty years ago, and the paper has developed a slightly creamy tone with the passage of time. Looking at Cagney, I like his profile with the strong chin and the overall strength of his head, and so I decide to paint him from that view. Making some pencil indications of the structure of the head, I plan the portrait so that the white of the paper will form the background and also the lights within the head. Dipping into my box of watercolor pans —always convenient when I'm working on location— I begin to block in the tones of the forehead, around the cheek, and along the jaw with various mixtures of cerulean blue, burnt sienna, new gamboge, and a tiny touch of phthalocyanine green. I want to suggest the structure to some extent, but I'm not really sure how much of this I'll paint over and how much I'll keep at later stages of the portrait.

STEP 2

I work quickly as the colors move and spread, drifting into each other. I work around the bare paper that becomes the light planes of the forehead, cheek, brow, nostril, jaw, and lower lip. Shadows and halftones begin to appear within the eyes, under the nose, beneath the upper lip, and along the underside of the chin. There's a bit more warm color in the nose and cheeks. My color moves toward green and brown around the eyes. The cool color on the cheek and jaw suggests the color of the beard. The gray hair is mostly white paper.

STEP 3

Now I try to get more character and depth to the shadow areas. I work carefully over the dark area that starts above the ear, curves around the back of the head, and then moves down over the cheek, jaw, and chin. This makes the head look more solid. I also add darker notes to the other shadows that appear around the eye, under the nose, and beneath the upper lip. I warm up the cheek and ear with alizarin crimson and a little cadmium red, and I move more of this warm color into the nose, upper lip, and chin. I'm still doing my best to hold onto the patches of bare paper within the head.

Working with raw umber, burnt sienna, cerulean blue, and a sub-green like chromium oxide (which I have in my pan box but not among my tubes), I start to introduce really strong darks. I solidify the darks around the ear, along the jaw, and under the chin with a mixture of raw umber and chromium oxide green; then I add a little more umber to this mixture to build up the darks of the features. There's more cerulean blue in the areas of the face where the beard produces a slightly cooler tone. I delineate the shape of the ear more precisely and build up the halftone on the side of the brow. I'm consciously trying to think in terms of planes and proportions, working broadly, even though my brushes are fairly small: numbers 4, 5, and 6 round sables. So far, I've been working for about an hour.

STEP 5

Now the changes become more subtle—not nearly as dramatic as the initial lay-in. I'm still working over the darks along the back of the head and down the jaw, which I darken even more, squaring up the jaw and emphasizing the fact that this whole dark area is a series of interconnecting shapes. I also add more touches of tone to the hair, but I still let the bare paper show through. You can see more halftones along the side of the brow, on the front of the chin, and on the rim of the ear, just above the lobe. I always like to see how much I can leave out, letting the paper do the job. For example, the bridge of the nose is bare paper that curves upward and continues through the brow on the far side of the head. All I need is that touch of darkness for the far eye; I don't really need to suggest the contour of the bridge and brow. But without that touch of darkness for the eye and the bare paper above, the head wouldn't have that feeling of roundness, solidity, and completeness—the feeling that there are more shapes on the other side of the head.

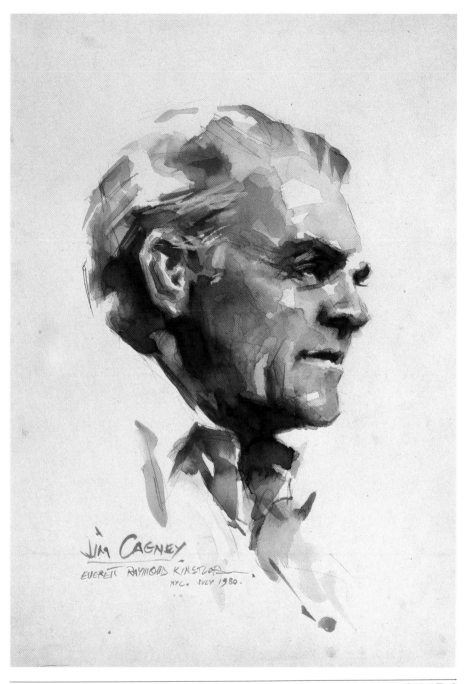

I'm worried about that strong shadow on the side of the cheek and jaw; I feel it's too isolated from the rest of the head. Working with a brushload of clear water, I begin to move those tones around and integrate them more softly with the rest of the cheek and jaw. Now I like them a lot better. At the same time, I move the color around the edge of the ear to give it a more precise shape. As I move this color up over the cheek, I establish broad, simple halftones on the side of the face and over the side of the brow. I think the head now has a simpler, more solid look. I've still managed to hang onto those patches of bare paper on the forehead, cheek, brow, nose, and chin. And there's still a patch of bare paper on top of the head to suggest the white hair. However, I turn to opaque white for those few strokes that suggest wisps of hair just above the ear, and I finish the hair with a few scratches of the razor blade. In an oil painting I'd normally get rid of the charcoal lines of the original sketch, but I keep the pencil lines in the watercolor since I think they lend movement and character.

Tree

Pastel on paper, 19″ × 24″ (48 × 61 cm). Collection of Lea Nation Kinstler.

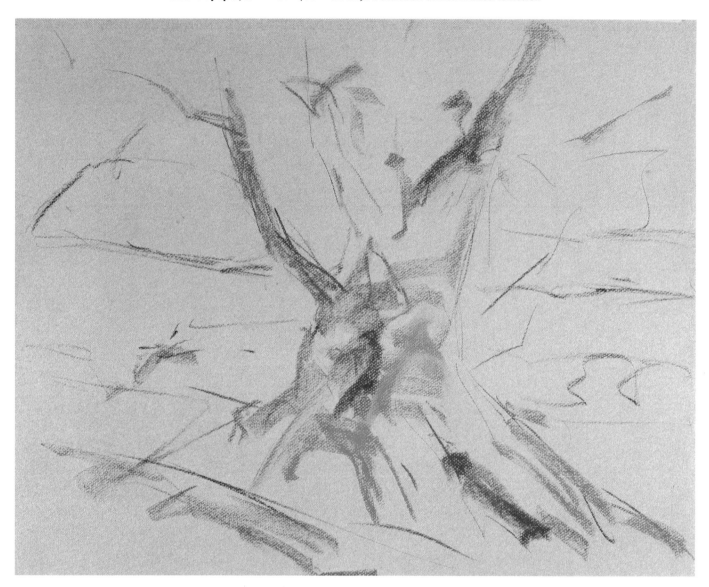

STEP 1

Since I don't do pastels outdoors, I'm recreating this painting from my oil of the same size, which you'll see in the gallery of pictures at the end of the book. I select a blue-gray shade of Canson paper and tape it to a large piece of hardboard that I place upright on my easel. Working with a charcoal stick, just as I do when I start an oil painting, I block in the shape of the tree, trying to keep it a bit off center. I also suggest a few of the surrounding shapes without drawing them precisely. I know that pastelists often work with a palette of hundreds of chalks, but two dozen (or less) are usually enough for me. For the first step, I begin to block in the colors with just three sticks: a blue-gray and a violet for the shadows and a raw sienna for the golden light of the sun. As you'll see in the later stages of this painting, these three chalks establish the general feeling of the color throughout the tree—and I'm going to stick with that general feeling.

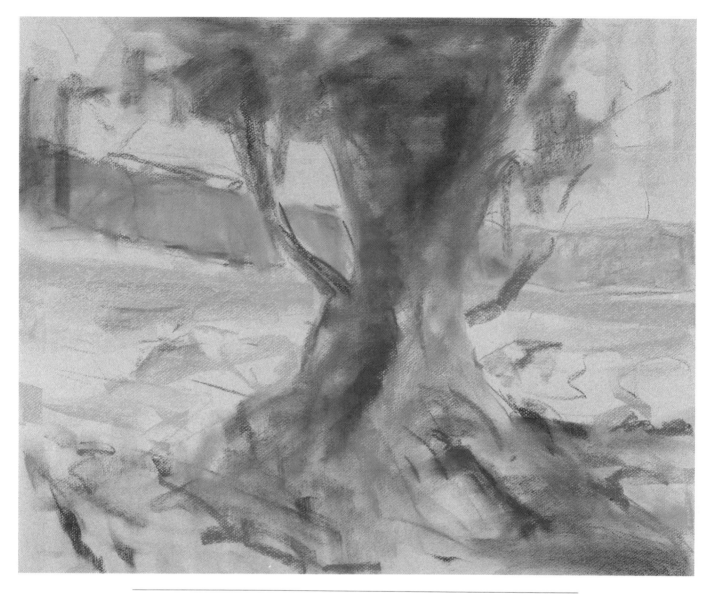

STEP 2

I continue to cover the tree with loose strokes of the raw sienna chalk, and then I introduce a green that's something like terre verte and a violet chalk, working these three tones over and into one another on the trunk, branches, and foliage at the top of the tree. Then I use blue chalks—ultramarine blue and cerulean blue—to block in the curving shape of the distant mountains, which becomes darker at the left and fades away to a paler tone at the right. For the strip of sunlit ground and for the hints of sunlight in the sky, I use a gamboge chalk. Around the base of the tree, I add some hints of pink and the same blues that appear on the mountains.

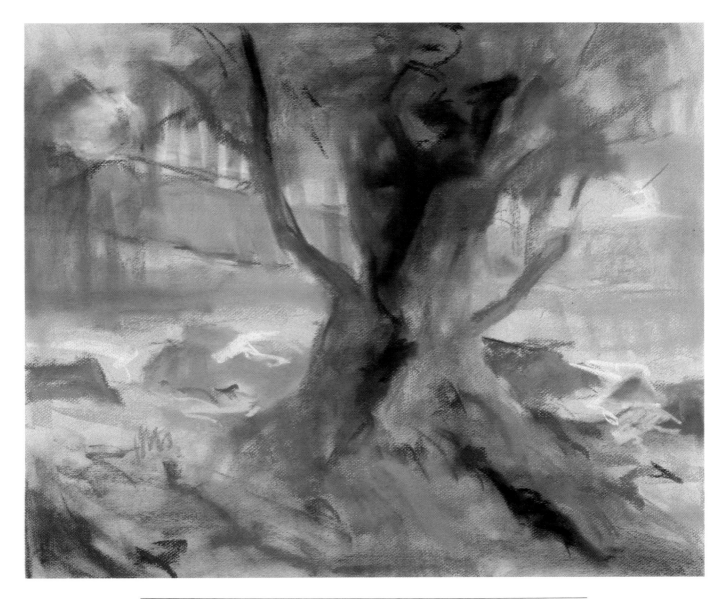

STEP 3

I continue to build up the shadow side of the tree with the violet chalk. Then I reach for a deep brown, like a burnt umber, to indicate those strong darks that not only suggest shadows but also solidify the structure of the tree. The trunk of the tree still isn't dark enough, and so I spray on fixative to deepen the tone. As I develop the color of the rocks around the tree with pinks, blues, and oranges, I use an off-white chalk to suggest the top planes where the light hits the rocks.

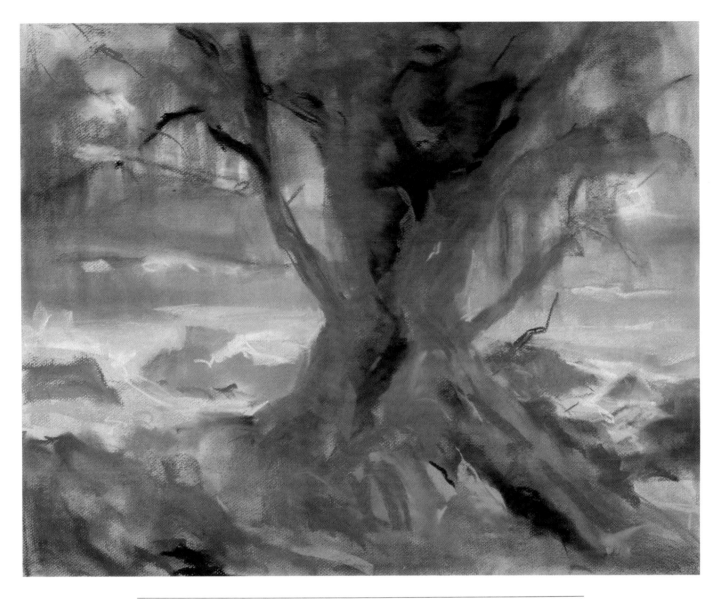

STEP 4

I darken the foreground and indicate a strip of shadow on the distant grass. But now I really want to focus on the shape of the tree itself. There are interesting color changes within the bark: lovely reflections of violet and blue on the left side, merging into golden browns like raw sienna and burnt sienna. I also work in a little bit of my gray-green. Then I strengthen the shapes of the branches and I add more foliage. But I'm not just piling on color at random—I'm solidifying the shapes and tying the colors together, interweaving the colors so that they penetrate one another and form a kind of harmony. With a pale cerulean blue tone, I build up the shadowy shapes of the rocks, and then I strengthen the sunny yellow of the field around and behind them. I also begin to add some strokes of very pale cerulean blue to the sky, showing gaps of sky color through the foliage.

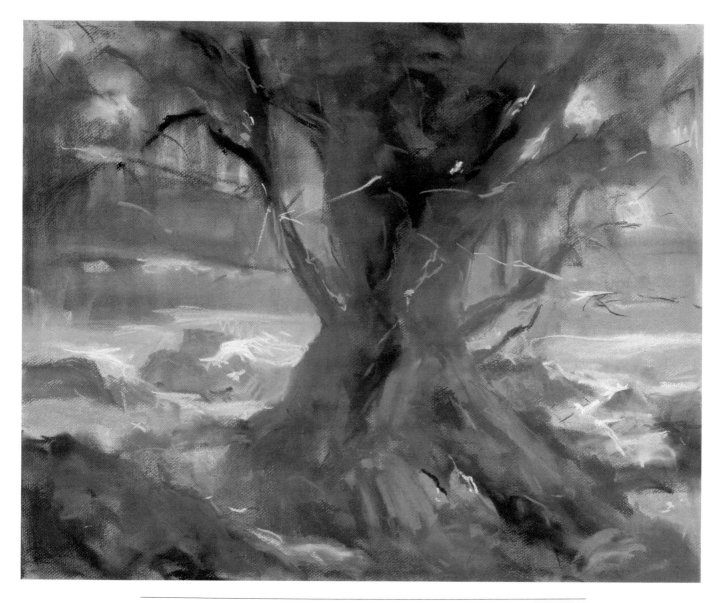

STEP 5

I continue to brighten the sky with touches of pale cerulean blue and pale gray, showing through the branches and foliage. I also darken the foreground so that there's more contrast between the shadowy lower part of the picture and the sunny middle part. With the sharp corner of a stick of golden yellow, I begin to suggest light-struck branches moving around the trunk. These branches pick up the more subdued golden tone at the right side of the tree and the patch of sunlight down among the roots. I have a good time working some bright colors into the trunk, such as the violet and russet that you see at the left. I also accentuate the warm reflections within the cool shadows of the rocks, such as the dark shape in the lower left.

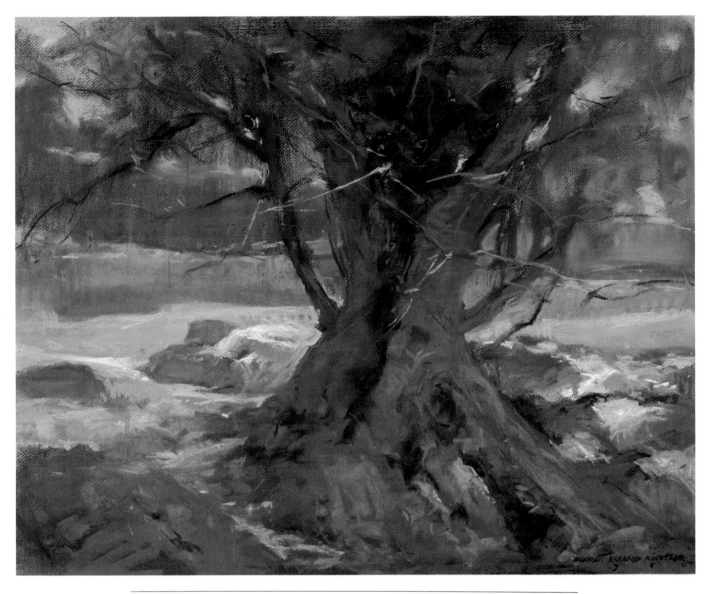

STEP 6

In this final stage I extend the mass of leaves at the top of the tree and simplify the tree itself into a more solid shape. I go over the trunk and branches with middle tones and then add lights and darks selectively to get the gnarled, weather-beaten character that appealed to me at the beginning. Farther up, I add more twigs and branches over the middle tone of the foliage. I'm structuring and simplifying things. In the grass I want more green and less yellow. Both the grass and the mountains beyond are just simple planes of color. I also simplify the shapes of the rocks and unify the tone of the foreground. The whole secret of unifying these areas is to stick with middle tones. Even though I'm using different colors like blues, violets, and grays, they're all essentially the same value. Now the finished picture consists almost entirely of simple masses of color rendered with big strokes. And the painting is mostly middle tones. The few strong darks and details are mostly in the upper part of the tree. The few strong lights are concentrated on the sunlit grass and on the tops of the rocks against which the dark tree forms a bold silhouette.

Russell Lynes

Charcoal on bristol board, 20″ × 16″ (51 × 41 cm).
Collection of Mr. and Mrs. Russell Lynes.

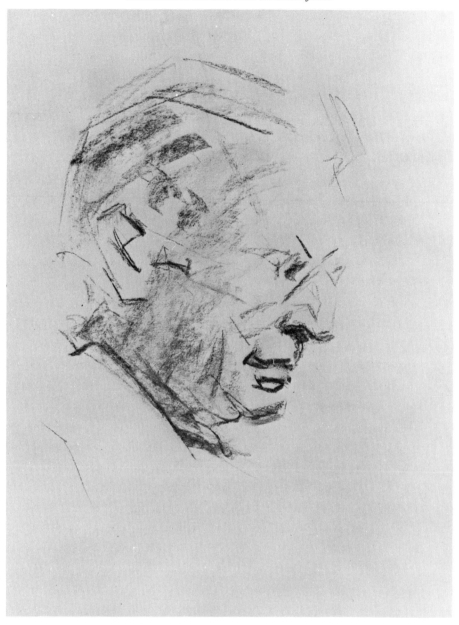

STEP 1

I begin by indicating the structure of the face with quick, fairly straight lines, followed by broad strokes to suggest the shadows on the planes. I use charcoal very much the way I use oil paint, freely pushing the lines and tones around and finishing with a drawing that's more tonal than linear. I don't regard these first "guidelines" as the final lines of the drawing. Most of these lines will soon disappear as I begin to blend and manipulate the charcoal on the surface of the paper. Right now I'm concerned mainly with the overall shape of the head and the placement of the features within that shape.

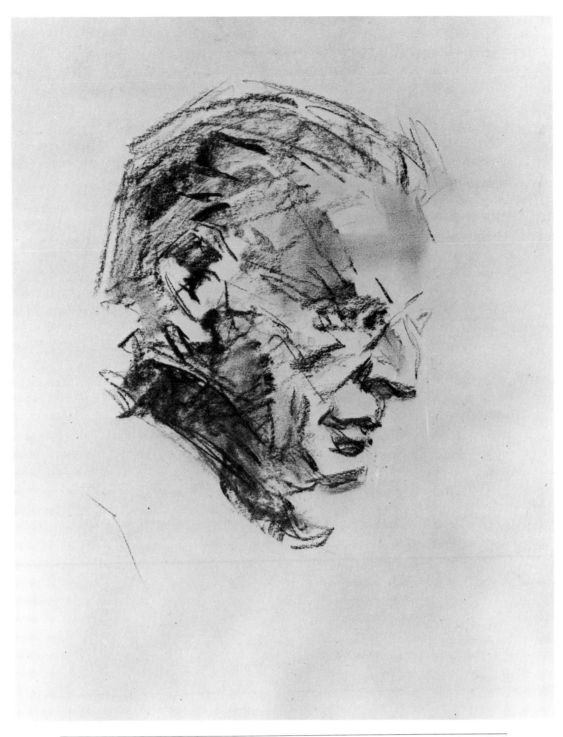

Holding the charcoal stick at an angle to the paper, I begin to rough in the halftones and shadows with broad, ragged strokes that look very much like brushstrokes. I work with a rapid, back-and-forth motion, building up the tones with clusters of parallel strokes. You can see these strokes on the hair and jaw. I begin to blend a few tones with my thumb, like the plane on the side of the sitter's forehead. And I use my blackened thumb like a brush to pull a big strip of tone across the lighted front plane of the forehead. I add a few more lines to define the features more precisely, but the drawing consists mainly of rough patches of tone.

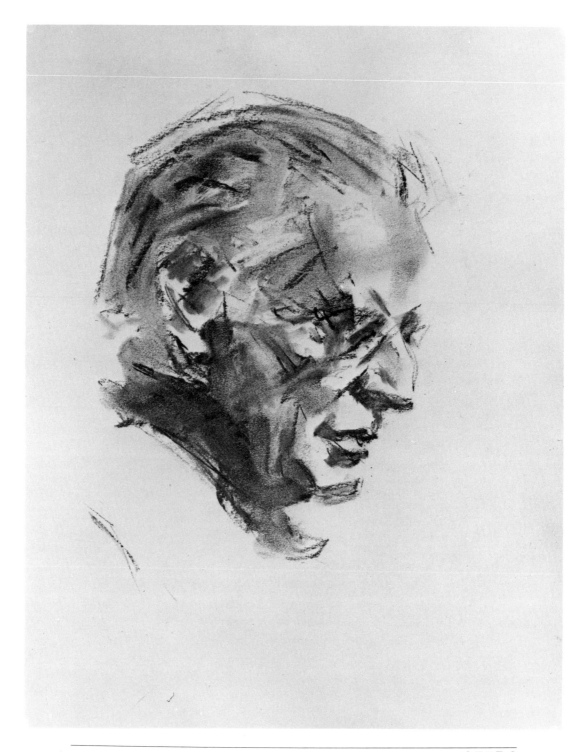

STEP 3

This is the stage at which I really begin to push the soft charcoal around like wet oil paint. Moving my thumb over the surface of the paper, I begin to blend and fuse the clusters of strokes that you saw in step 2. A lot of these strokes have disappeared and become halftones and shadows: compare the hair, brow, cheek, jaw, and chin in step 2 with the same areas in step 3. I also use a finger to soften the dark shadows within the features. I should point out, however, that all this blending is done very selectively. I try not to overdo it, and I work with the fewest possible strokes of the thumb. Thus, the drawing doesn't have a smooth, overworked feeling but still looks free and spontaneous.

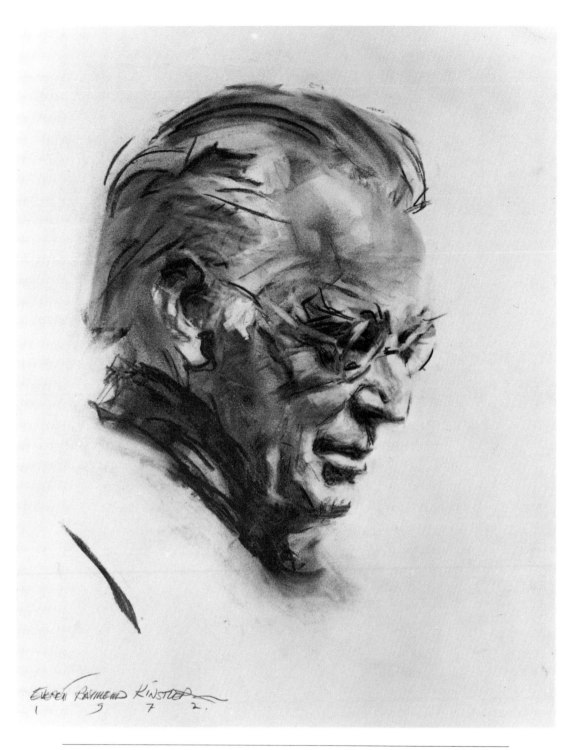

STEP 4

In the finished portrait of the well-known writer Russell Lynes, I continue to build up the tones with more strokes of soft charcoal, and then I blend them carefully with a thumb or fingertip. In the process of blending and moving the tones around, I obliterate nearly all the original strokes that you saw in the previous three steps. Now I go back in with the sharpened point of the charcoal stick to add a few lines that redefine the features, the hair, and the collar. I also use the point of the stick to strengthen the darks within the eye sockets and ear and beneath the nose and lips. I squeeze a kneaded rubber eraser to a sharp point that lifts away some touches of tone on the lighted planes of the features, brow, and hair.

Gallery

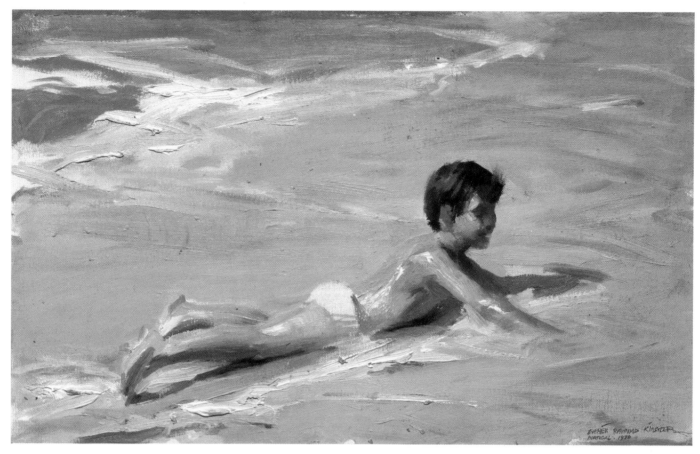

Beach, Portugal (above), oil on canvas, 9" × 11" (23 × 28 cm). Collection of the artist. This little painting was inspired by Sorolla, the great Spanish painter of sunlight, whom I've always admired. We were traveling with the painter Charles Apt and his family; the little boy in the painting is his son. I made some pencil notes on the beach and shot some photographs. This is the kind of material I save for a rainy day or some kind of day when I can't paint outdoors. The finished painting is a good example of how I like to vary my brushwork to match the subject. The sandy beach was painted thinly, but I laid the paint on very heavily when I came to the surf, the bright reflections on the beach, and the highlights on the boy's skin. I decided to leave his swimming trunks bare canvas. Notice how I interwove the cool tones of the water with the warm color of the beach. Some of these same cool colors appear within the shadows on the skin and in the shadow that the body casts on the sand.

Algar Seco (right), oil on canvas, 18" × 23" (46 × 58 cm). Collection of the artist. This coastal landscape shows what really fascinated me about the Mediterranean: the light rocks that picked up not only the tones of the sun but also the rich, cool colors of the water and the sky in the shadow planes. This was a chance to go to extremes in using my full palette—touching upon almost every color and working with definite strokes that were left intact and not blended. When I get back to the studio, I often find things that I could improve in such paintings, but I try not to touch them because all the accidents and crudities give them character and freshness. If I have second thoughts about this kind of painting, I usually find it better to start over on a new canvas and try to make a new statement rather than to risk wrecking the painting I did in the first place.

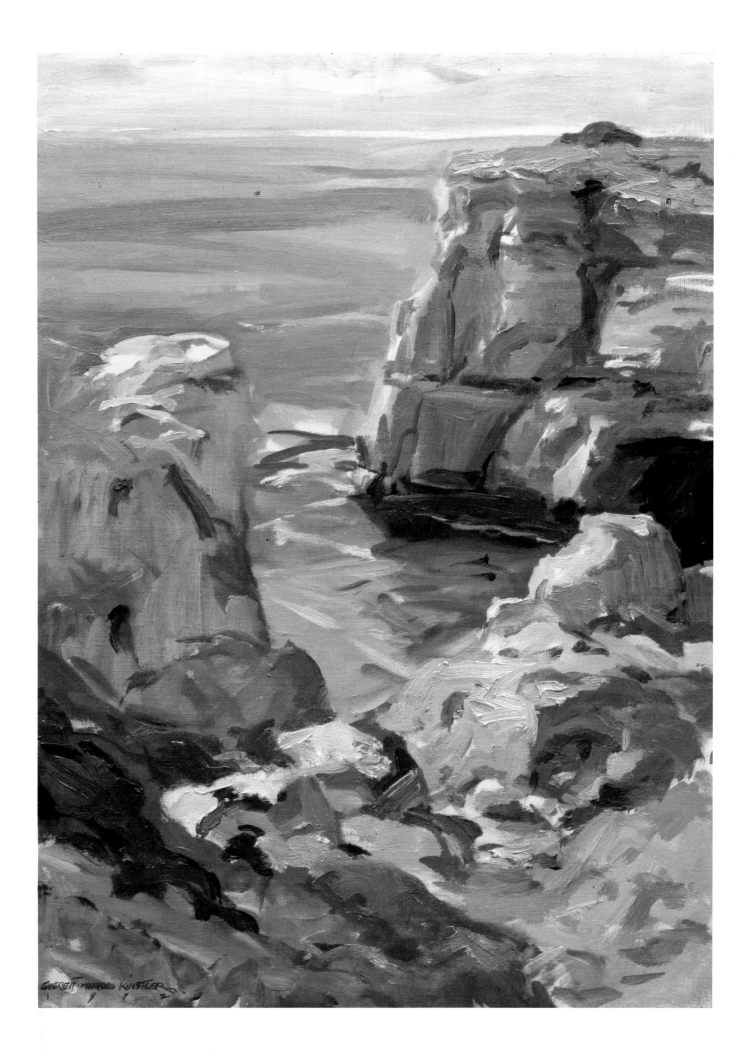

Tree Patterns, Portugal, *oil on canvas,
26" × 32" (66 × 81 cm). Collection of
the artist. I liked the shapes and the
movement of this fallen tree, and I also
liked the way the light hit it. I painted this
picture on two successive mornings, going
back at the same time the second
morning to make sure that the light would
be the same. As usual, I took some
photographs when I finished painting.
When I got the pictures back, I decided to
add the little house at the extreme left to
suggest the distance between the tree in
the foreground and the landscape behind
it. There's so much action in the subject,
so much movement among the roots and
branches, that I decided to keep the sky
fairly quiet in order to play up the lively
shape of the tree. Notice how I worked
some of the cool sky colors into the warm
shadows on the trunk.

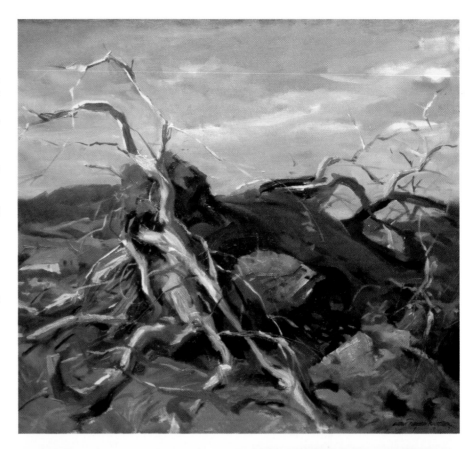

Olive Tree, Portugal, *acrylic on canvas,
16" × 20" (41 × 51 cm). Collection of the
artist. The more I looked at this olive tree,
the more I liked the effect of the light on
the twisted shapes. I painted most of the
picture on location and then took some
photographs on the chance that there
might be something I wanted to add or
change later on. Actually, all I think I did
was add some leaves and a few accents
when I got back to the studio and got my
pictures developed. The strategy of the
painting was to silhouette the dark shape
of the tree against the sunlit field and
then pick up the sunny color on the edges
of the curving shapes of the tree. I like to
match my strokes to the gesture of the
subject — as Wayman Adams taught
me — and you can see that the movement
of the strokes follows the form of the tree.

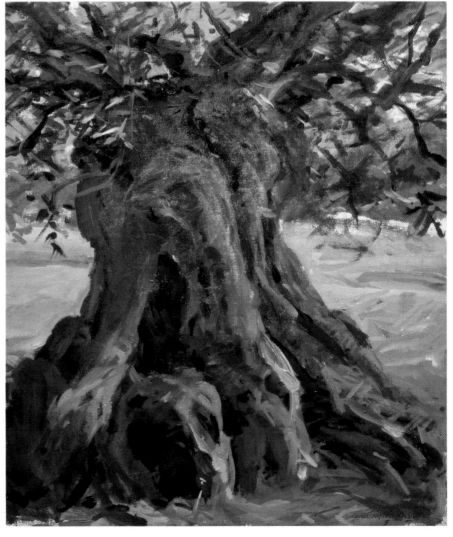

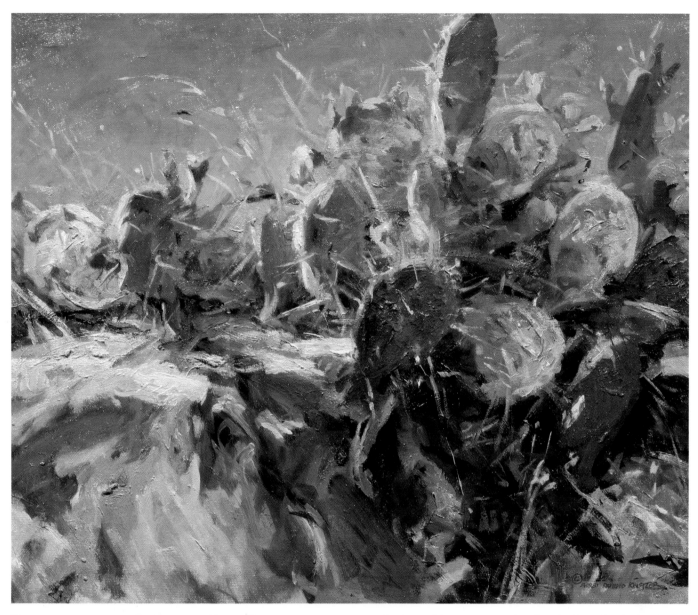

Flowering Cactus, *oil on canvas, 24″ × 30″ (61 × 76 cm). Collection of Mr. and Mrs. C. H. Black. To paint a closeup of the cactus, which was at ground level, I had to sit very low on the ground and risk collecting some needles in my seat. The forms and details were also very complicated: dark shadows on one side of the cactus, with light flickering on the needles and moving around the edges of the shapes. Worse still, the light changed radically as I worked. When I got the painting back home, my colors seemed totally* washed out. *Since we were leaving for New York, I quickly took some photographs, hoping that they'd help me finish the picture. This was one of those few paintings that I completely redid in the studio. I think I finally managed to organize the profuse detail. There's a clear feeling that the light is coming from the left, placing the right sides of the forms in shadow. There's also a good contrast between the flickering, complicated brushwork of the cactus, the broader strokes of the sand in the lower left, and the simple sky tone.*

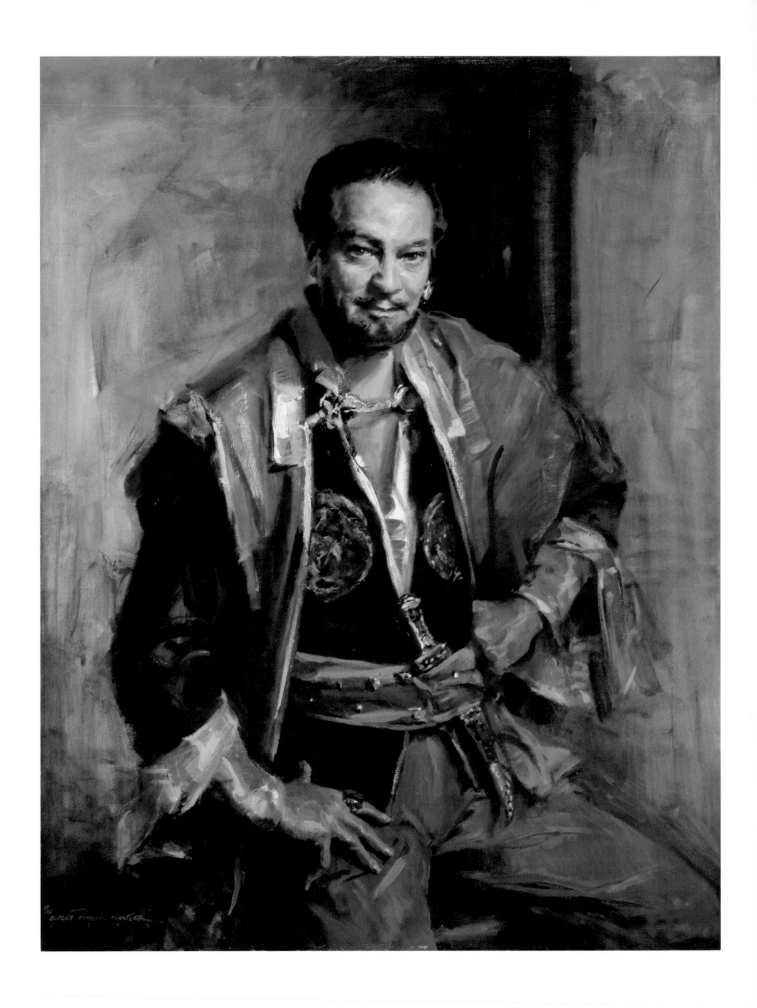

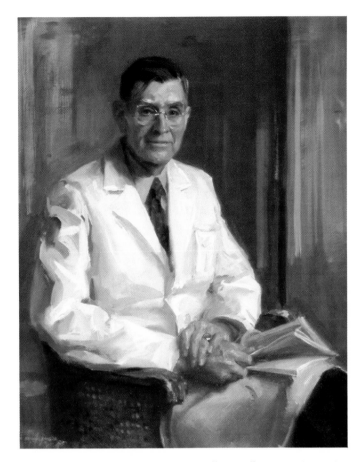

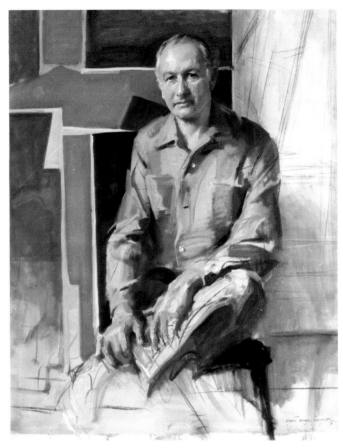

Dr. Wiley Forbus, *oil on canvas, 40″ × 34″ (102 × 86 cm). Collection of Duke University. The portrait was to go to the medical school at Duke University, where Dr. Forbus was Dean of Pathology. It was characteristic for him to be shown in his white medical jacket, which I enjoyed painting. The challenge—and the fun—of painting white is to capture all the other colors in it, colors reflected from the surroundings, such as violets and siennas. I did the jacket with big, slashing strokes and thick color. It's tricky to paint rimless eyeglasses; I suggested them by just painting the highlights, not the edges of the lenses.*

Will Barnet, *oil on canvas 48″ × 38″ (122 × 97 cm). Private collection. I always enjoy painting pictures of my fellow artists, like the distinguished painter and printmaker Will Barnet. I can do people I admire, and I can interpret them in my own, personal way. For some reason it seemed right to hold onto a lot of the charcoal sketch lines on the toned canvas. In fact, the entire figure and background are sketchy, focusing attention on the artist's head and on the strong abstract pattern of his work in the background. This sort of thing might not be acceptable in a portrait that's commissioned for a public building, a corporate headquarters, or a government office, but these "personal portraits" are fun because I have more freedom to experiment.*

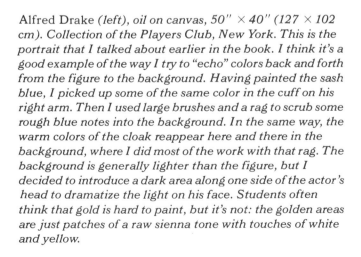

Alfred Drake *(left), oil on canvas, 50″ × 40″ (127 × 102 cm). Collection of the Players Club, New York. This is the portrait that I talked about earlier in the book. I think it's a good example of the way I try to "echo" colors back and forth from the figure to the background. Having painted the sash blue, I picked up some of the same color in the cuff on his right arm. Then I used large brushes and a rag to scrub some rough blue notes into the background. In the same way, the warm colors of the cloak reappear here and there in the background, where I did most of the work with that rag. The background is generally lighter than the figure, but I decided to introduce a dark area along one side of the actor's head to dramatize the light on his face. Students often think that gold is hard to paint, but it's not: the golden areas are just patches of a raw sienna tone with touches of white and yellow.*

115

Estoril, *oil on canvas, 24" × 30" (61 × 76 cm). Collection of the artist. The storm clouds, gathering in the distance, threw dark shadows on the horizon—both on the strip of sea at the left and on the narrow strip of land in the upper right. This gave me a dramatic contrast between the dark, stormy distance and the sunlit foreground. I wanted to capture the way the light flashed on the beach and on the unfinished structure—and then the sudden shift to the dark, shadowy face of the promontory beyond the beach. Rapidly changing skies can be a nuisance to paint, but they also produce bold light effects that can transform an ordinary landscape into something exciting.*

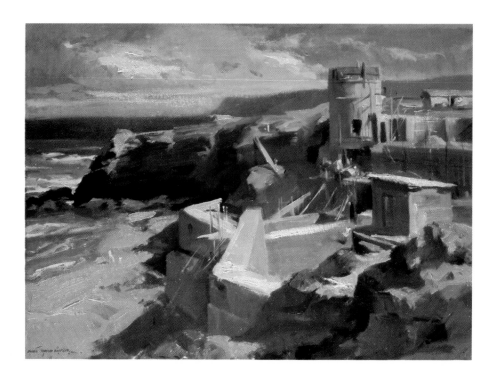

Fishing Boats, Portugal, *watercolor on paper, 22" × 30" (56 × 76 cm). Collection of the Columbia Museum of Art, Columbia, South Carolina. As I walked the beach I was struck by the shapes of the fishing boats, and I was also impressed with the figures of the fishermen mending their nets. I made sketches of the boats and the fishermen. The finished watercolor, a full sheet, was painted in the studio. When I was well into the painting, the sky began to look very leaden—very heavy in color and value—so I repainted that area with a little ultramarine blue, raw sienna, and some opaque white. The completed sky is still thin and washy enough to harmonize with the transparent color in the rest of the picture.*

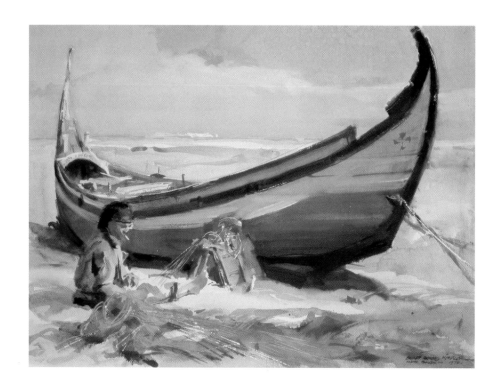

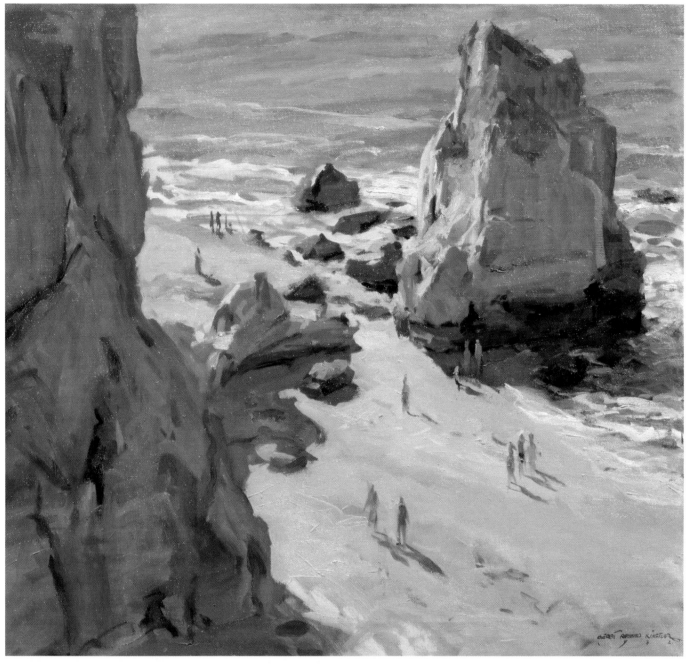

Praia de Rocha, *oil on canvas, 32″ × 34″ (81 × 86 cm). Collection of the artist. I went back day after day, late in the morning, climbing the rocks to paint this coastal landscape from the right vantage point. I thought it was important to include the huge, dark rock at the left as a kind of frame for the sunlit beach, which looked even brighter by contrast. I also wanted to get a good view of the big, cool shadow that was cast by the small rock in the middle of the beach. From this high angle, I was able to compose the picture so that the* horizon was cut off and didn't compete with the big rock at the edge of the water in the upper right. In painting a landscape, as in painting a portrait, finding the right viewpoint can make all the difference between an ordinary pictorial design and a dramatic one. Notice that the figures, like the rocks, cast cool shadows on the warm tone of the sand. The shadows actually reflect the cool tone of the sky and water.

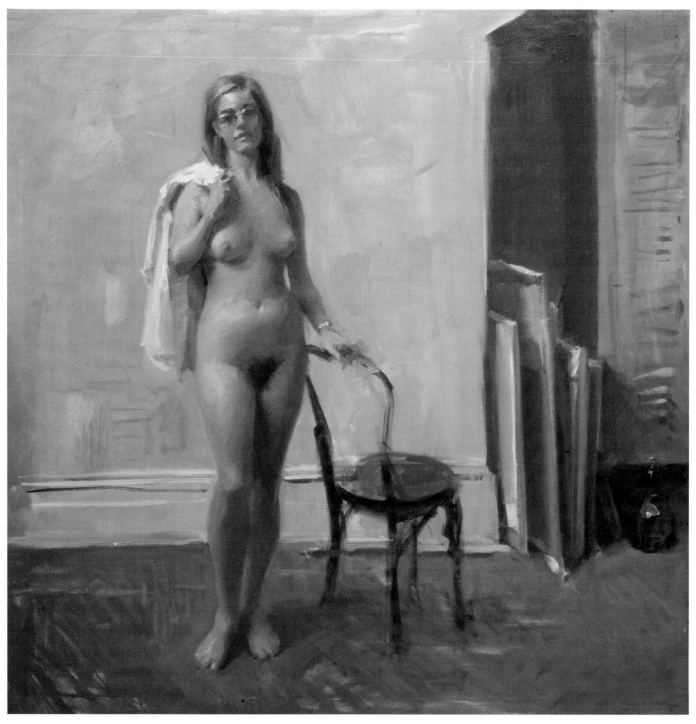

My Nearsighted Model, *oil on canvas, 40″ × 40″ (102 × 102 cm). Collection of the artist. This was a demonstration painting at the Art Students League, and the model was a student there. I asked her to pose for me in one of the classrooms, and I suggested that she stand if it wasn't too difficult. She didn't mind standing and started to remove her glasses, when I suddenly got the impulse to tell her to leave the glasses on. Somehow, she looked much more human and appealing that way, less like a model and more like a person. I like the way the curves of the body and the chair are framed by the rectangular shapes of the wall, floor, canvases, and locker around the corner. The bottle on the floor was an afterthought, but it seemed to help balance the picture.*

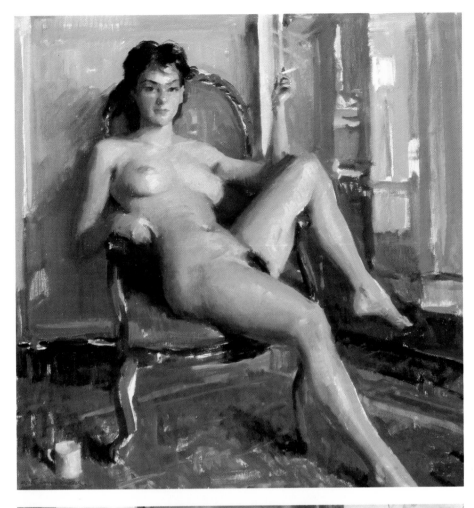

Coffee Break, *oil on canvas, 24" × 24" (61 × 61 cm). Collection of the artist. While I was setting out my paints, the model drank a cup of coffee and had a cigarette. She sat in a pose that felt natural to her —and such a pose is often best because it's easiest for the model to hold and most natural for the artist to paint. So I told her to sit there, just that way. I liked the complicated shapes and colors of the studio background, but I kept them off to one side to balance the model, not conflict with her. When a painting has a generally warm tone, like this one, it usually needs a cool note of relief like the bluish shape above her knee. That bluish tone is picked up in the rug.*

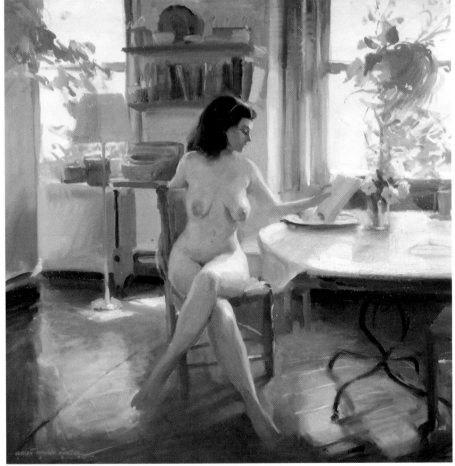

Interior, *oil on canvas, 34" × 34" (86 × 86 cm). Collection of the artist. This is my kitchen. I always enjoy the afternoon sun as it streams through the window, and I felt that the light would look lovely on a figure. I started out with a toned canvas that was essentially the color you see in the window, where the canvas is left almost untouched. To compensate for the fact that the figure was almost in the dead center of the picture, I changed the shapes of the windows slightly so that they weren't quite so regular. I also emphasized the light on the table and on the floor to make the picture look less symmetrical.*

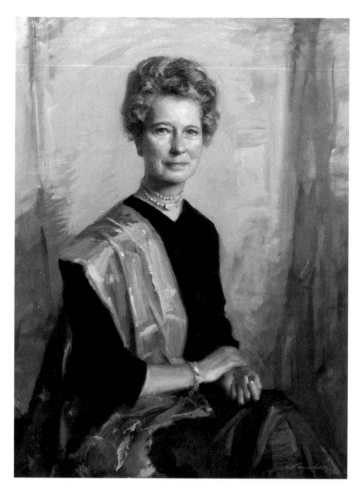

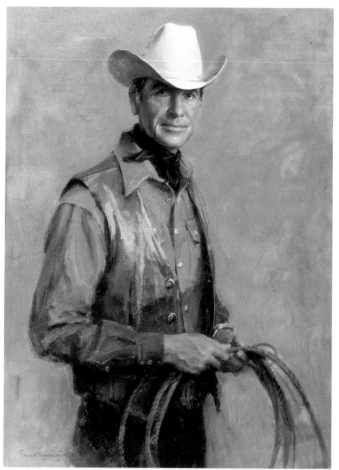

Mrs. Chester F. Carlson, *oil on canvas, 40″ × 32″ (102 × 81 cm). Collection of Mrs. Chester F. Carlson. Mrs. Carlson is a warm, contemplative, spiritual woman, and I wanted my portrait to capture her inner strength and dignity. Her dark dress and skirt seemed right, but just a little too stark. She mentioned that she had a favorite Indian silk, and she brought it with her to New York. We decided to drape it over her shoulder to add a little note of elegance and style without, I hope, taking away from the spiritual quality of this fine lady.*

Robert Norris, *oil on canvas, 46″ × 34″ (117 × 86 cm). Collection of Mr. and Mrs. Robert Norris. The sitter is a real cowboy, a cattleman-rancher who stands 6 feet 4 inches and gave me a marvelous discourse on how to use a lariat while I painted him. This is the kind of painting that proves the importance of details that seem small but really mean a great deal. As I worked on the portrait, I was troubled by the fact that the light was equally bright on the head and the hands. I remembered the wonderful western paintings of Frederick Remington, Harold Von Schmidt, and Tom Lovell, in which the tops of the mountains would catch the late afternoon light while a dark shadow would fall across the lower part of the landscape. I thought I'd try the same thing in the portrait, placing a shadow across the lower half of the figure and darkening the hand slightly so that it wouldn't compete with the head. It's also characteristic that Norris's hat was crisp and tailored, while John Wayne's hat was battered, stained, and misshapen.*

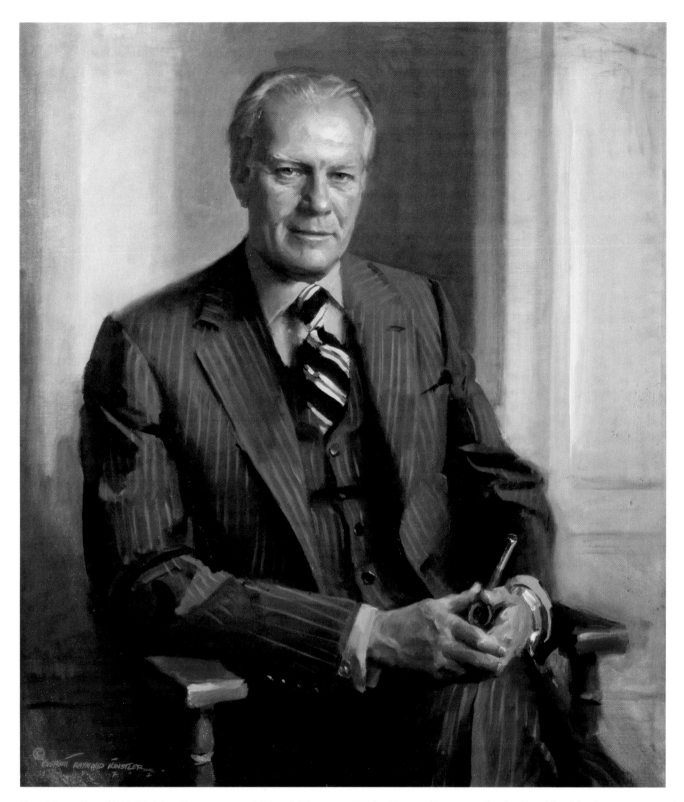

President Gerald R. Ford, *oil on canvas, 40" × 34" (102 × 86 cm). Collection of the White House. This portrait was actually painted in Vail, Colorado, when Mr. Ford was no longer President. He posed for me on five consecutive mornings from nine to twelve, and the portrait was 80 percent completed by the end of the five days. I took some Polaroid photos to record details like the pipe in his hands, his wristwatch, and the necktie. There was actually a large fieldstone fireplace behind him, but I found that distracting, and I also thought it was out of keeping with the portrait's future location in the* White House. *Fortunately, the President had some picture books that showed his offices in the White House. So I was able to eliminate the fieldstone fireplace and improvise the molding that had been part of his outer office. I finished the background when I got back to my New York studio, and I also did some work on the details that I'd recorded with my Polaroid camera. Notice how I tied the figure to the background by blending his elbow into the shadow at the left and by softening some of the edges of his suit.*

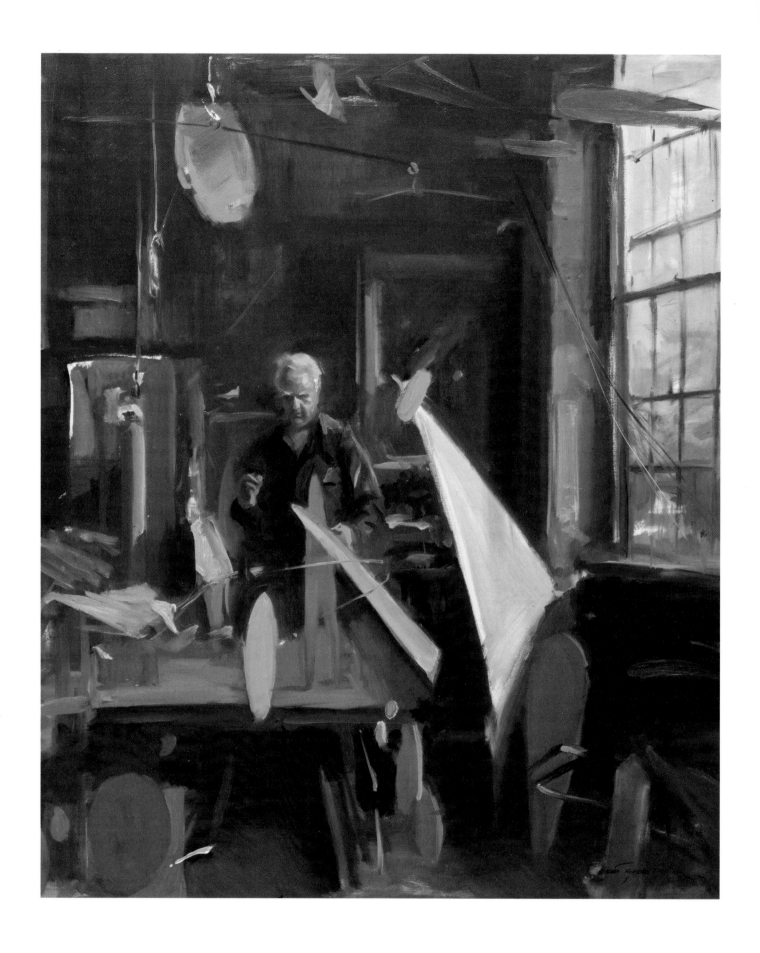

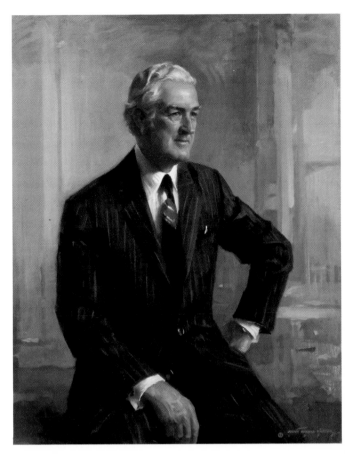

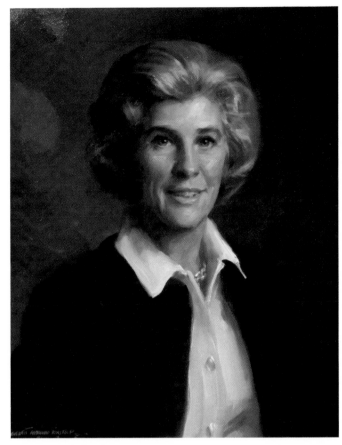

Governor John Connally, *oil on canvas, 44" × 34" (112 × 86 cm). Collection of the United States Department of the Treasury. This was the sitter's official portrait as Secretary of the Treasury—actually my second portrait of the governor. As I worked on the first one, I kept noticing that he'd go over and sit on the edge of a card table during our breaks. He'd look out the window and put his hand on his hip. I thought this gesture was characteristic somehow, and I also liked the way that the light from the window created strong contrasts on his handsome head and played up the leonine character of his face. So I started the second portrait, and that's the one you see here.*

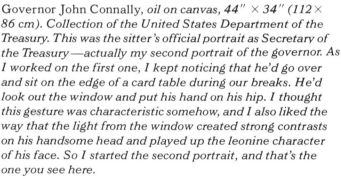

Roxbury Studio *(left), oil on canvas, 40" × 34" (102 × 86 cm). Collection of the artist. This is really a portrait of the great sculptor Alexander Calder as he worked in his Connecticut studio, which was near my summer place. Going back and forth to our house, I always passed Calder's studio and saw him through the window, working. We planned sittings, but he was always too busy to pose for a painting; I made sketches and photographs, and then I painted the picture from them. I placed Calder's figure in the shadows and just "spotlit" his head, which picked up light from the window at the right. Then I surrounded him with all the metal shapes with which his studio was cluttered—the shapes of his sculpture—and arranged these so that they caught the light from the window too.*

Mrs. Marian H. Littleford, *oil on canvas, 25" × 20" (64 × 51 cm). Collection of Mr. and Mrs. William D. Littleford. I was struck by this attractive lady's warm, vivacious personality, and I decided to emphasize these qualities by borrowing a familiar device from the work of the Dutch old masters of portraiture. I placed her against a dark background that would dramatize the lighter tones of her head. At the same time, I allowed the dark tone of the sweater to melt away into the background so that the crisp white blouse would carry the viewer's eye directly to the head, which is framed by the white collar. Thus, only the head and blouse emerge from the darkness, which provides a sharp tonal contrast and plays up the sitter's lively good looks.*

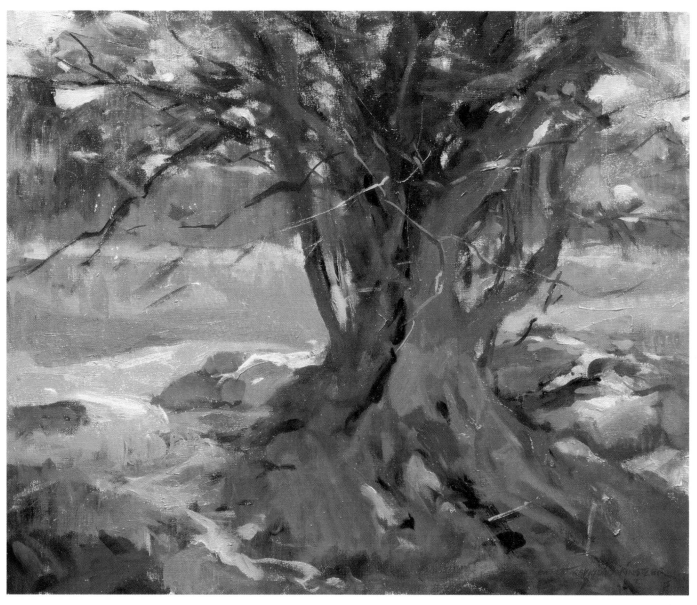

Tree, Connecticut, *oil on canvas, 20″ × 24″ (51 × 61 cm).
Collection of the artist. It's interesting to compare the oil
version of this tree with the pastel version in the
demonstration section. I did the oil on location and then I
did the pastel later on in the studio. Something that's done
on the spot always has a spontaneous, improvised quality
that has its own special charm, even though there might be
things you'd do differently when you're working in the more
leisurely atmosphere of the studio. For one thing, painting
outdoors usually means putting things down with the fewest*
*possible strokes, as you see in the tree and in the bands of
color that form the background. There's not much time to
refine the pictorial design, and so you paint things quickly
and simply, and then you stop. Everything looks rather raw
and impulsive in contrast with the gradual buildup of
strokes and colors in the pastel that was done in the studio.
I've never actually painted a pastel outdoors, but I'm sure
that an outdoor pastel would be as rough and impulsive as
this oil.*

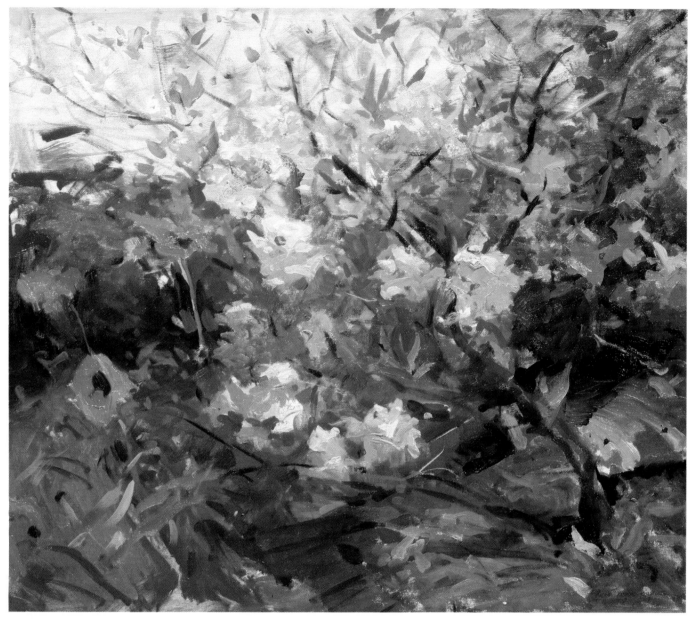

Flowering Poppies, *oil on canvas, 34″ × 40″ (86 × 102 cm). Collection of the artist. This closeup of flowers was done one morning in Connecticut. I was working on a white, untoned canvas. For some reason, when I finished the flowers, the upper left-hand corner of the canvas was still bare white. I knew that this patch of bare canvas was wrong because it seemed so bright that the rest of the picture* looked dull by comparison. I took the painting back to a studio and let it dry. Then I mixed up a blue-gray glaze and wiped it with a rag across the whole top third of the canvas, suggesting a sky in the upper left and generally toning down the upper part of the picture just enough to let the flowers stand out.

125

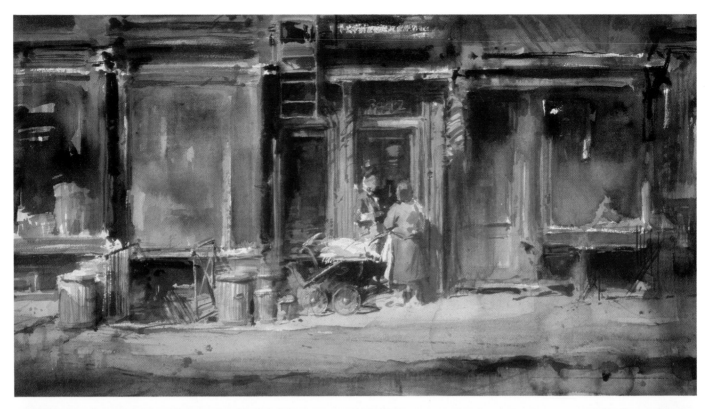

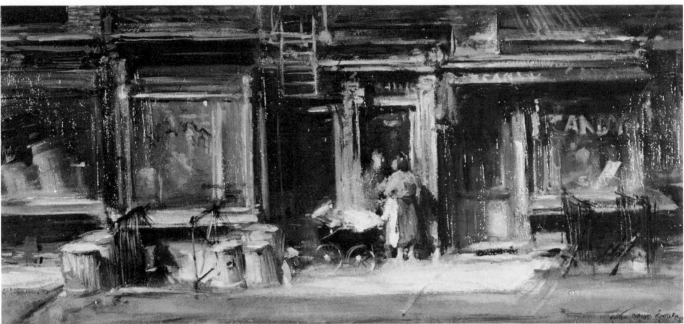

Morning (*top*), *watercolor on paper, 17″ × 27″ (43 × 69 cm). Collection of the artist. This watercolor was adapted from a photograph of an old neighborhood in New York City. I struggled with this painting for a long time, working on it, putting it aside, taking it out again, and working on it some more. The rich texture of the old architecture gradually built up as I kept working on the picture, groping, stumbling, and slowly developing the image by trial and error. Although it's true that the ideal way to paint a watercolor is quickly and spontaneously, it's not the only way. You can build it up gradually, wash over wash, slowly adding texture and detail over many days, as I did here. I still think it looks fluid and spontaneous, as you can see in the wet washes of the windows and the drippy tones in the foreground.*

19th Street (*above*), *oil on canvas, 17¼″ × 36″ (44 × 91 cm). Collection of the Flint Institute of Arts, Flint, Michigan, a gift of the National Academy of Design. Here's the oil version of the same picture with some changes in the design. The oil painting is a lot longer than the watercolor. There's less street in the foreground, and the storefronts have been extended by making the windows squarish rather than oblong, as they are in the watercolor. I can't say which version is better. The oil version has a slightly more formal, abstract feeling, while the watercolor has a more casual look that's appropriate to watercolor.*

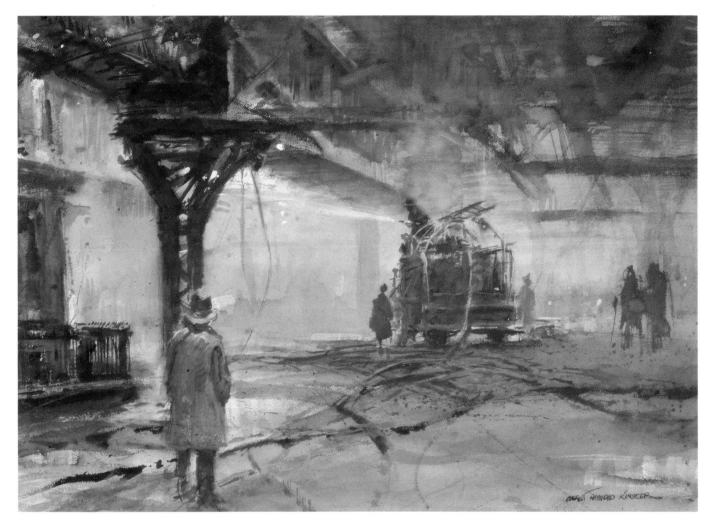

South Street Fire, New York City, *watercolor on paper, 22"*
× 30" (56 × 76 cm). Collection of the artist. I was doing a
series of illustrations for a magazine, based on all sorts of
photographs and clippings. The fire took place under one
of the old elevated subways, now gone, and I liked the
mysterious feeling of the mist, the shadows, and the
silhouetted figures. I often like to use watercolor in a loose,
scrubby, unpredictable way, like the ragged strokes at the
top of the picture and the irregular textures on the ground.

I'm also not a purist about transparent watercolor. I don't
mind using opaque color now and then, which I found
necessary to delineate the fire truck and the spray coming
out of the fire hose. You often need just a little bit of detail to
suggest that the picture is full of detail. Actually, everything
in the picture is pretty vague except for the metal fence and
the architectural detail at the left, the figure in the
foreground, and the fire truck. But you think you see
everything.

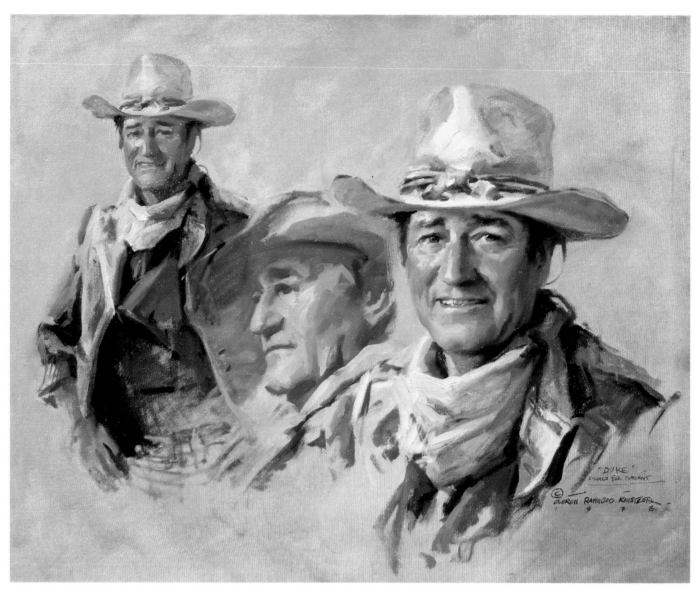

Study for Portrait of John Wayne, *oil on canvas, 24"* *× 32" (61 × 81 cm). Collection of the artist. Here are three head studies—my way of "thinking" about the portrait of John Wayne on the facing page. I was trying out different ideas, although I eventually used the head on the right. I was tempted by the head in the middle because I really responded to that granite jaw and the strong look of the head at that angle. But his characteristic pose, with his hands on his hips and his crooked smile, seemed right to me, and so I settled on the front view at last. The figure at the extreme left is a study of that typical stance.*

John Wayne (right), *oil on canvas, 44" × 34" (112 × 86 cm). Collection of the National Cowboy Hall of Fame. The man himself was so imposing that I knew that I wanted nothing in the background. All I wanted was a feeling of sky and desert, and so I scrubbed a cool tone across the top and then blended it into a warmer tone toward the bottom of the canvas. Then I added a few of those graphic blue notes to suggest a bit of blue sky coming through over his shoulder. The pale tones of the background echo the muted gold tones of Wayne's hat and vest and the dark blue of his shirt. By placing Wayne's big, dark figure against a light background, I also dramatized the man's heroic proportions. I tried to keep my brushwork as loose and casual as possible to reflect the actor's rugged, relaxed style.*

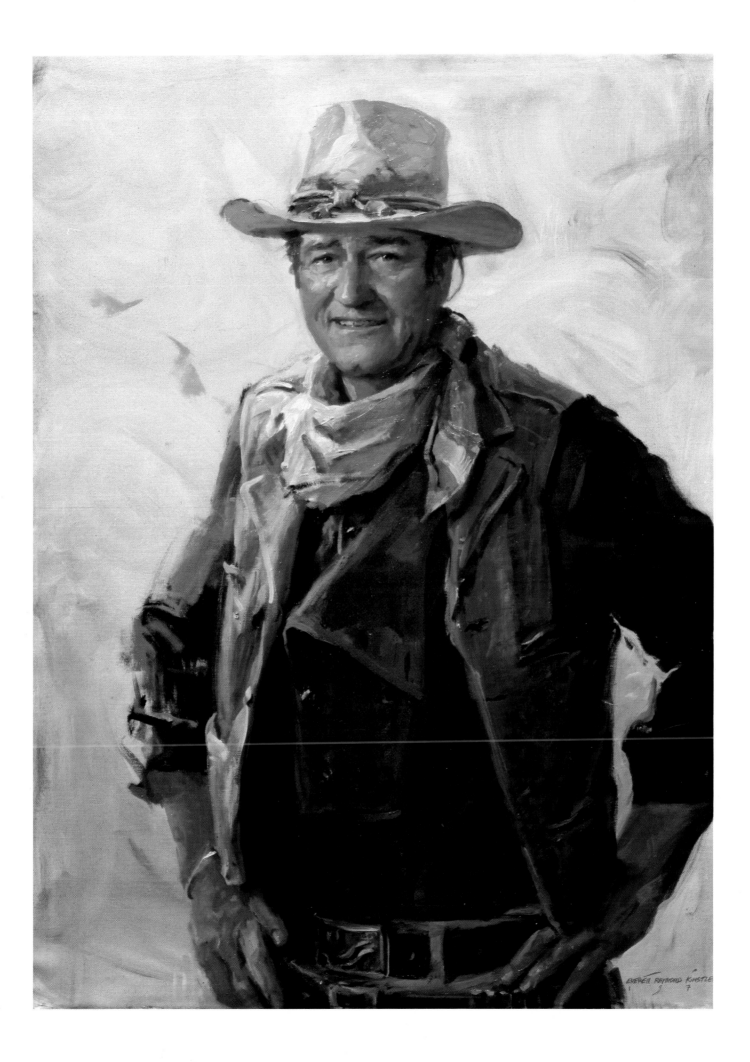

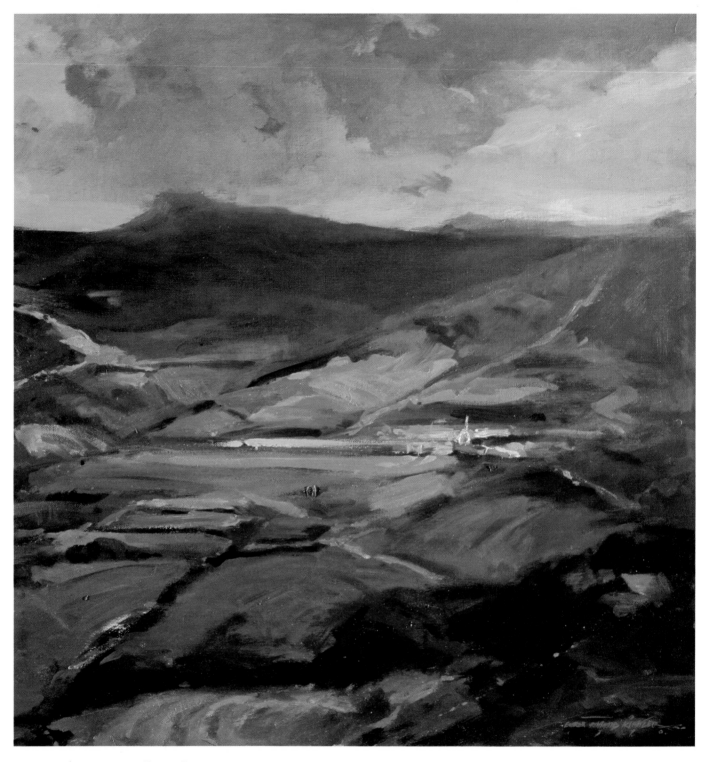

Sintra, *oil on canvas, 26" × 26" (66 × 66 cm). Collection of the artist. The Portuguese town of Sintra is inland among mountains and great valleys. I kept going back for several afternoons, working on the painting outdoors. At one point the weather took a dramatic turn: the clouds gathered at that far peak on the horizon, and the light broke through to spotlight the little village with the church steeple and the slope beyond. I immediately started to revise the painting and did my best to capture that effect as quickly as I could. I* got most of it done on the spot, but then I had to do some more work indoors, sharpening the touches of light on the buildings and strengthening the shadows in the foreground. This is a striking example of the way that some accidental effect of weather can add drama to a picture. The distant mountain is so dark because the clouds cast a big shadow over it. And the village is so brilliantly lit because a break in the clouds allowed some sunlight to come through at just that spot.

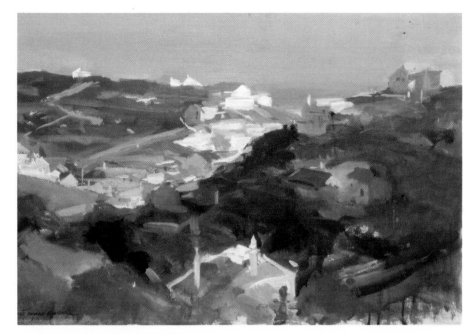

From My Terrace, *acrylic on canvas, 22" × 30" (56 × 76 cm). Collection of the artist. When I paint outdoors in acrylic, I usually work on canvas because I use the color rather thickly, almost like oil paint. This was the view from the terrace of a house we rented in Portugal. It was late afternoon, with the sun fairly low in the sky, hitting the buildings from the right-hand side and creating strong contrasts between the sunlit planes and the surrounding darks. In general, I think early morning and late afternoon are the best times to paint because you get more dramatic light effects than you're likely to get at midday. The hills are painted with rough, scrubby, slightly blurred strokes that contrast nicely with the sharp, crisp strokes of the lighted buildings.*

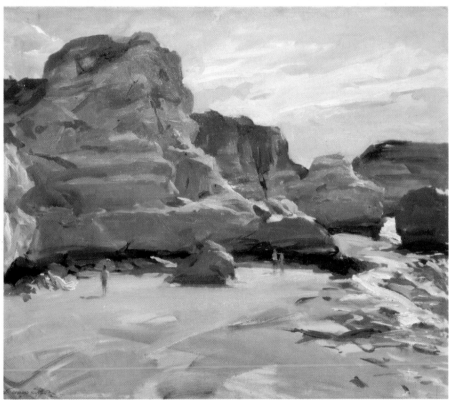

Beach, Algarve, *oil on canvas, 30" × 36" (76 × 91 cm). Collection of the artist. The composition emphasizes the loftiness of the rocky cliffs. I made the cliffs look tall and dramatic by pushing them up toward the top of the picture and using the entire lower third of the canvas for the flat beach. The little figures also give a sense of the massive scale of the rocks. The brushwork on the sand is fairly thin and washy, while the flickering light on that small patch of water is rendered with thick strokes. The cool tone of the sky is reflected not only in the water but also in the shadows on the rocks.*

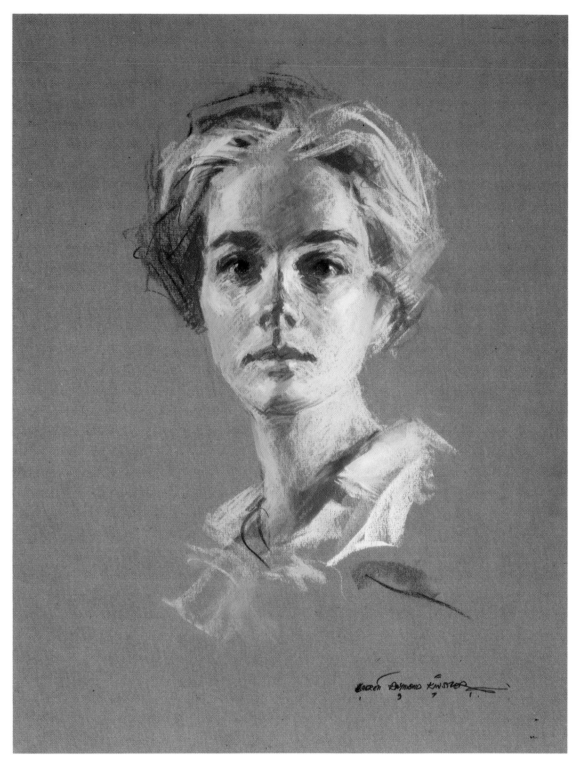

Lea (above), pastel on board, 20″ × 16″ (51 × 41 cm). Collection of the artist. I used no more than ten chalks for this portrait, letting the tone of the paper show through to help me, as you can see in the dark strip that runs down the center of the neck —and throughout the head. The light hits the head from both sides, and so all the darks are concentrated toward the center of the face, on the forehead, features, chin, and neck. This gives the head a very luminous feeling against the shadowy tone of the pastel paper. This portrait of my wife is one of my first experiments with pastel. Because I was accustomed to painting portraits in oil—with just a few colors—I didn't find it necessary to use the huge palette that's typical of pastel painters. And I still don't.

Lea (right), oil on canvas, 24″ × 20″ (61 × 51 cm). Collection of the artist. I painted this head of my wife outdoors on a Portuguese vacation—one of those rare opportunities to paint a head in bright sunlight. She had a nice, healthy, outdoor tan, which was dramatized by the pale, transparent outdoor light surrounding her. I was particularly eager to capture the luminous shadows that you get outdoors—much more luminous than the shadows indoors. You can see this in the rich colors on the shadow planes of her finely structured face.

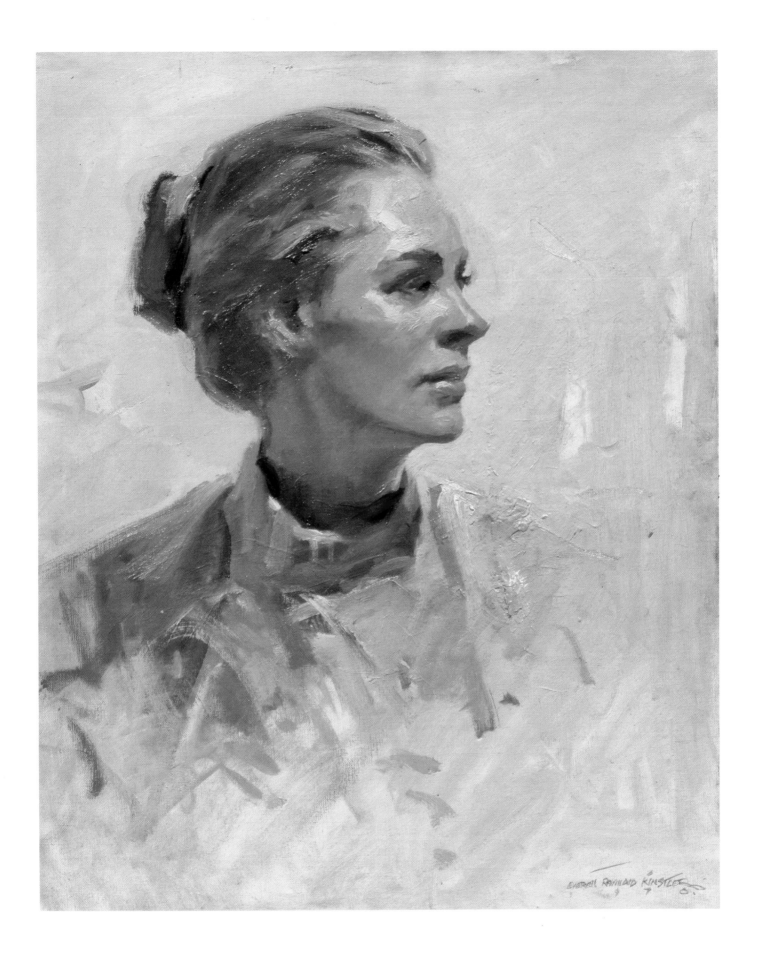

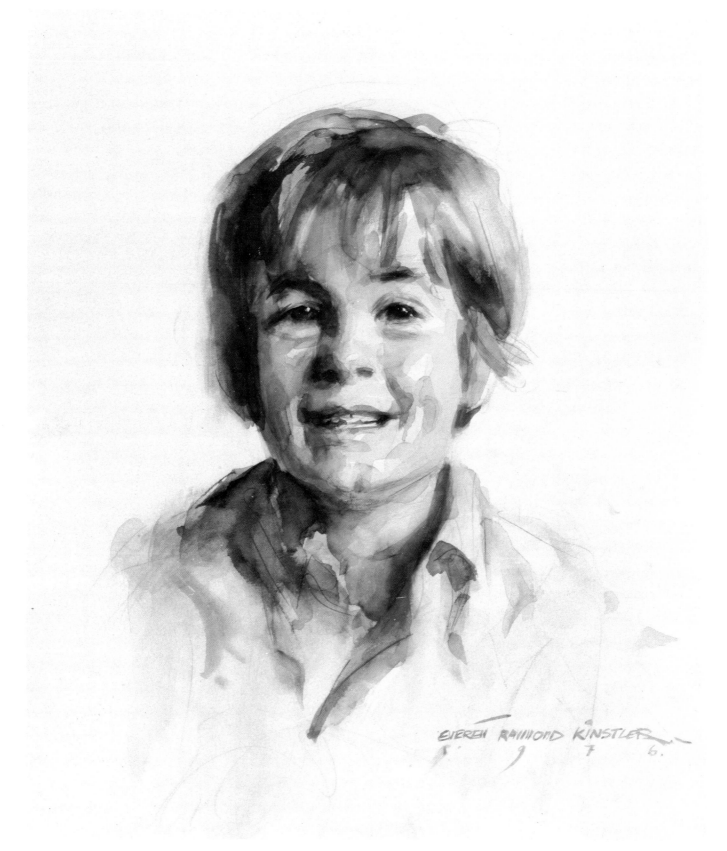

Peter Toot, *watercolor on paper, 20″ × 16″ (51 × 41 cm). Collection of Mr. and Mrs. Joseph Toot. When Peter was in my studio, I made a little watercolor sketch and some pencil notes. Then, while I was photographing him, I asked him, "How is school?" He saw right through me. He looked up at me—with his marvelous face and hair all over his forehead—pointed a finger at me, and said: "I know what you're trying to do. You're trying to make me talk so you can* take pictures. Mommy, I want to go to the zoo!" *Well, I did manage to take extensive photographs of him because I knew it would be difficult to get him back into the studio again. The final watercolor portrait was my fifth attempt, after tearing up the previous four because I'd failed to get a likeness or because the painting had lost its freshness. Watercolor portraits are exceptionally hard but very satisfying when they come off.*

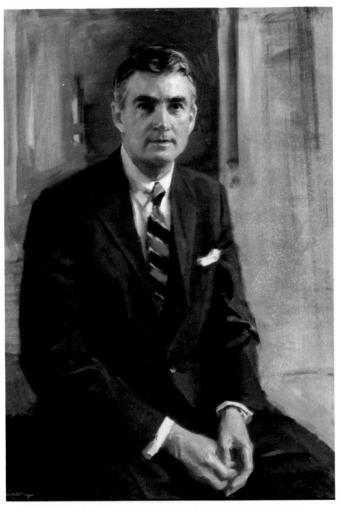

Louis L. Stanton, Jr., *oil on canvas, 44" × 34" (112 × 86 cm). Collection of the Union Club. The sitter is an attorney, but the purpose of the painting was to show him as president of the Union Club of New York City. The sitter had very striking, strong features, which I decided to bring out with a kind of light that I rarely use—strong light on one side of the face with deep shadows around the features. I asked him to sit on the edge of a table, rather than on a chair, so that the portrait would convey his height. The dark, squarish architectural detail behind his head dramatizes the light on the curves of his face. (I remember that Johansen once told me that a sharp line and a curve are more interesting together than two straight lines or two curves.) The portrait took five morning sittings, plus a lot of studio work in between. When the portrait was finished, the only criticism was that I'd given Stanton the necktie of some other club! The Union Club sent me the right tie—so I could correct the portrait—and I still have it.*

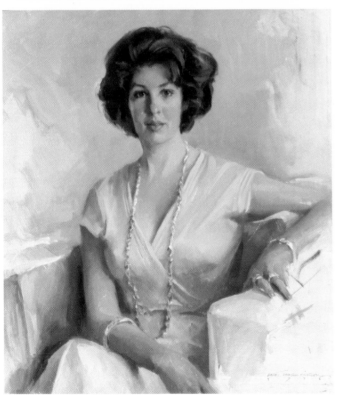

Celeste Weisglass, *oil on canvas, 34" × 32" (86 × 81 cm). Collection of Mr. and Mrs. Stephen Weisglass. The challenge of this portrait was to capture the brightness and sophistication of a good-looking, contemporary woman. She had a dramatic mass of dark hair, and I decided to emphasize this in order to frame her fresh, alert features. So the strong contrasts of the head became the focal point of the painting, which I kept fairly pale throughout. She was actually wearing a darker blue, but I made it a good deal lighter. I also kept the furniture pale and sketchy so that its massive shape wouldn't distract from the sitter's marvelous head. And the background is roughly the same soft tone as the chair she's sitting in. There are a few darks around the figure in the chair, but no contrasts as strong as the dominant tones of the head.*

J. B., Mexico, *oil on canvas, 15" × 33" (38 × 84 cm). Collection of the artist. I once made the mistake of going to Mexico on a painting holiday during the rainy season, when I was confronted with endless periods of deluge. So was stuck indoors a lot of the time and had to find a way of inventing paintings by combining photographs, clippings from magazines that happened to be lying around, and anything I might see out the window. Somewhere I found a photograph of the painter James Brooks and combined a figure that looked something like him with the architectural detail I could see from the window of my improvised studio.*

Tennessee Williams *(right), lithograph, 30" × 22" (76 × 56 cm). This lithograph was commissioned by the National Arts Club. I enjoyed the freedom to do a rather unorthodox kind of portrait. As you can see, the entire portrait consists of his features and the contour of one side of his face melting into a moonlit landscape with some flowers in the foreground. The rest of his head simply isn't there, and I don't think it's necessary. My idea was to combine his likeness with the poetic atmosphere of his work, as symbolized by the surrounding landscape, which actually represents lines from his writing. The lines appear at the lower left.*

Facade, Bermuda, *acrylic on canvas, 26" × 24" (66 × 61 cm). Collection of the artist. When I was cleaning another canvas, some color splattered onto this one and made the streaks you see at the left. That accidental, irregular tone seemed to harmonize with the building, and so I let the streaks show. They fit in nicely with the casual, spontaneous brushwork that you see in the rest of the building and in the palm trees. This picture is a good example of how simple you can paint something on the spot, suggesting detail with a few strokes —as you see in the windows.*

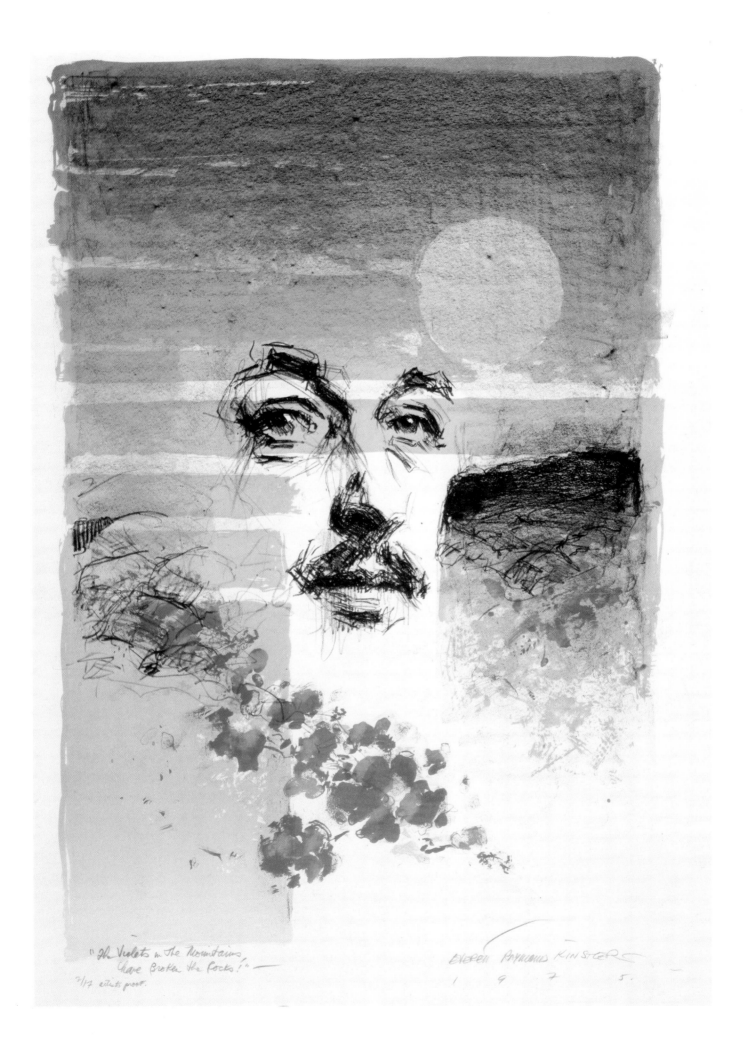

"The Violets in The Mountains
have Broken the Rocks!" —
2/17 artists proof.

EVERETT RAYMOND KINSTLER
1 9 7 5.

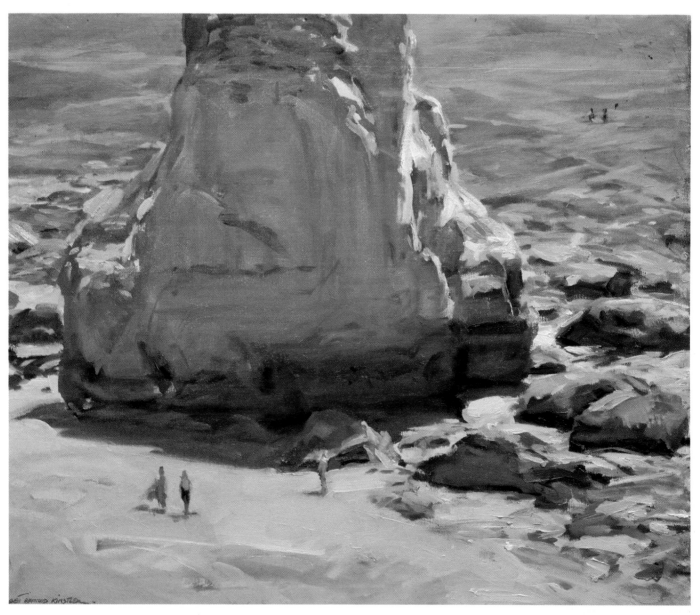

Algarve, Portugal (above), oil on canvas, 16" × 20" (41 × 51 cm). Collection of the artist. I was thrilled by the images of these great rock formations that just appear at the edge of the water—and sometimes half a mile out into the water—with that gorgeous golden light that reflects off the sand and bounces into the shadows, contrasting so strongly with the brilliant blue of the water at the rim of the beach. The picture started out bigger, showing the horizon, but I cut off the top to make the composition simpler and more dramatic. Those little figures were actually farther up the beach, but I moved them in front of the big rock to balance my composition and give a sense of scale. The rock wouldn't look so big without them. The golden shadow side of the rock actually contains a lot of cool touches, and the distant water contains lots of warm touches. I like the contrast between the warm tone of the beach and the cool shadow that the rock casts on the sand.

Fishing Village, Mexico (right), oil on canvas, 34" × 24" (86 × 61 cm). Collection of the artist. I don't usually sell my landscapes, but I keep them around the apartment or the studio to remind me of things I've seen and enjoyed on my vacations with my family in exotic places like Portugal and Mexico. This landscape was painted on one of those rainy days when I couldn't go out and had to work on my little terrace studio. I'd seen a fishing village that had an interesting pattern of houses going up a hill and nets hung out to dry. I made some pencil drawings and shot some photos, which I held onto for just such a rainy day. I emphasized the steepness of the hill by painting the village as if I were standing down on the beach looking up. I was particularly interested in the abstract pattern of the nets, with the diagonal nets catching the sunlight and the horizontal nets in shadow. Notice how I keep interweaving and repeating colors: here and there on the beach, you can see the blue of the sky and the warm color of the rooftops reappearing in small touches like the little figure at the edge of the water.

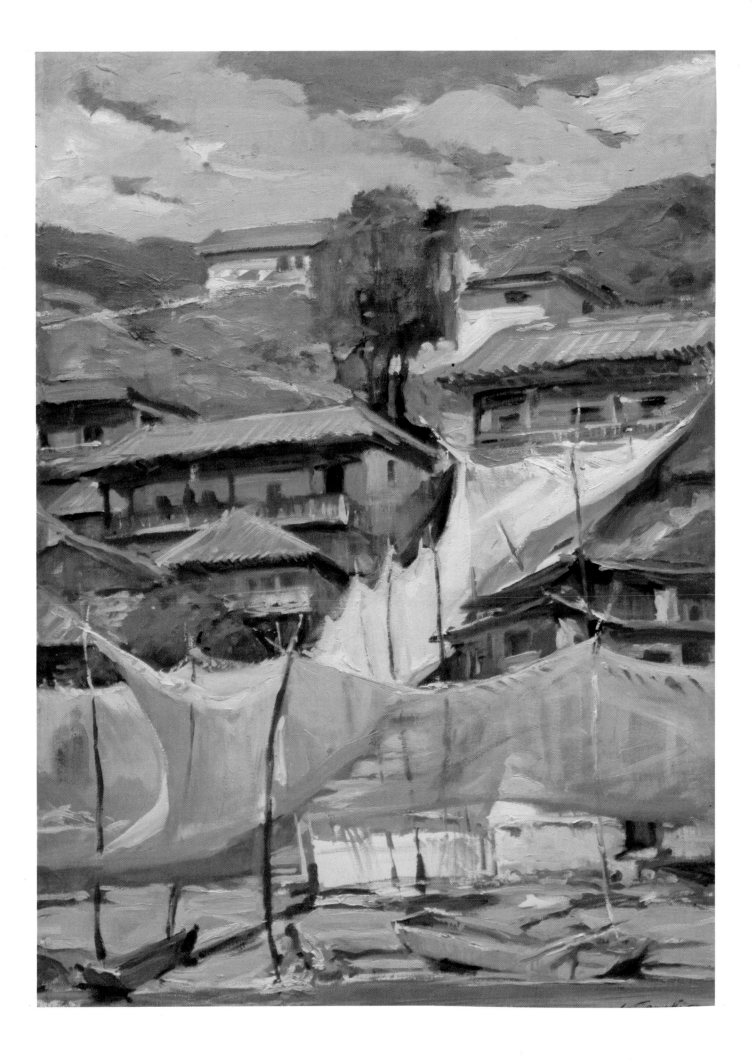

Partial Listing of Portraits by Everett Raymond Kinstler

Charles F. Adams, *Chairman, Raytheon Corp.*

Leslie Arends, *U.S. Congress (Illinois), Minority Whip*

George W. Ball, *U.S. Under Secretary of State*

William Beinecke, *Chairman, Sperry & Hutchinson Corp.*

Truman Bidwell, *Chairman, N.Y. Stock Exchange*

James Binns, *Chairman, Armstrong-Cork Co.*

W. Michael Blumenthal, *U.S. Secretary of the Treasury*

Otis R. Bowen, *Governor of Indiana*

Ted Bowen, *Director, Texas Medical Center*

William Bowen, *President, Princeton University*

Alan S. Boyd, *U.S. Secretary of Transportation*

James Cox Brady, *Chairman, N.Y. Racing Commission*

Peter J. Brennan, *U.S. Secretary of Labor*

Robert S. Brustein, *Dean, School of Drama, Harvard University*

Earl Butz, *U.S. Secretary of Agriculture*

James Cagney

Joseph Califano, *U.S. Secretary of Health, Education and Welfare*

Astronaut Scott Carpenter, *official NASA portrait*

John W. Chandler, *President, Williams College*

Charles W. Cole, *President, Amherst College*

John B. Connally, *U.S. Secretary of the Treasury*

W. H. Conzen, *Chairman, Schering-Plough Corp.*

Lammot duPont Copeland, Jr., *Delaware*

Frederick Dent, *U.S. Secretary of Commerce*

George H. Dixon, *Chairman, First National Bank, Minneapolis*

Gaylord Donnelley, *Chairman, R.R. Donnelley Corp.*

Mrs. Irenee duPont, Jr., *Delaware*

James H. Evans, *Chairman, Seamans Bank*

Douglas Fairbanks, Jr.

T. R. Faragher, *Chairman, Ranier National Bank, Seattle*

Robert Floweree, *Chairman, Georgia-Pacific Corp.*

President Gerald R. Ford, *official White House portrait*

Orville Freeman, *U.S. Secretary of Agriculture*

Herbert Frensley, *Chairman, Brown & Root Corp.*

Henry Friendly, *Senior Judge, U.S. Court of Appeals*

Robert Froehlke, *U.S. Secretary of the Army*

General A.J. Goodpaster, *Superintendent, U.S.M.A., West Point*

J. Roycroft Gordon, *Chairman, International Nickel Corp.*

Kermit Gordon, President, *Brookings Institution, Washington, D.C.*

Randolph Guthrie, *Chairman, Studebaker-Worthington*

T. Marshall Hahn, Jr., *President, Georgia-Pacific Corp.*

Willard Hampton, *Chairman, Brooklyn Savings Bank*

Roland Harriman, *Chairman, Union-Pacific Corp.*

Philip B. Harris, *Chairman, Northwestern National Bank, Minn.*

Robert Hatfield, *Chairman, Continental Group*

Gabriel Hauge, *Chairman, Manufacturers-Hanover Trust Co.*

James P. Hodgson, *U.S. Secretary of Labor*

J. Edgar Hoover, *official F.B.I. portrait*

Lionel S. Jackson, Sr., *Publisher, New Haven Register*

John Jeppson, *Chairman, Norton Co.*

John Kemeny, *President, Dartmouth College*

David Kennedy, *U.S. Secretary of the Treasury*

Grayson Kirk, *President, Columbia University*

Thomas Kleppe, *U.S. Secretary of the Interior*

John Knebel, *U.S. Secretary of Agriculture*

Melvin R. Laird, *U.S. Secretary of Defense*

Herbert Lehman, *U.S. Senator*

Edward Levi, *U.S. Attorney General*

John MacGrath, *Chairman, East New York Savings Bank*

John J. Mackowski, *Chairman, Atlantic Insurance Group*

Orison Marden, *President, Association of the Bar, City of New York*

Dr. Paul A. Marks, *Dean, Faculty of Medicine, Columbia University*

Forrest E. Mars, Jr., *President, Mars, Inc.*

David Mathews, *U.S. Secretary of Health, Education and Welfare*

Burnet R. Maybank, *U.S. Senator (South Carolina)*

Howard McCall, *Member, Board of Directors, Chemical Bank*

William McCarthy, *President, N.Y. Athletic Club*

James McFarland, *Chairman, General Mills*

John L. McLucas, *U.S. Secretary of the Air Force*

Rene McPherson, *Chairman, Dana Corp.*

Richard K. Mellon, *Rolling Rock, Pa.*

Charles Miller, *Chairman, Dime Savings Bank*

G. Russell Moir, *Chairman, Transway International Corp.*

Mr. and Mrs. Kenneth Montgomery, *Northbrook, Ill.*

William Moore, *Chairman, Bankers Trust*

Rogers C.B. Morton, *U.S. Secretary of the Interior*

Byron Nelson, *official portrait, U.S. Golf Association*

Emil Pattberg, *Chairman, First Boston Corp.*

Pennzoil Corp., *Houston: Seven members, Board of Directors*

Charles J. Pilliod, Jr., *Chairman, Goodyear Corp.*

John Polite, Jr., *Chairman, Essex Chemical Corp.*

Dr. David H.C. Read, *Rector, Madison Avenue Presbyterian Church*

William Renchard, *Chairman, Chemical Bank*

Elliot Richardson, *U.S. Secretary of Defense*

John B. Ricker, Jr., *Chairman, Continental Corp.*

John D. Rockefeller III

Roy Rogers and Dale Evans, *Collection of National Cowboy Hall of Fame*

George Emlen Roosevelt, *Chairman, Board of Trustees, New York University*

Steven Ross, *Chairman, Warner Communications*

Donald Rumsfeld, *U.S. Secretary of Defense*

Carl Sanders, *Governor of Georgia*

William F. Sauder, *Chairman, Marsh & McLennan Insurance Corp.*

Mrs. Richard Mellon Scaife, *Pittsburgh*

James R. Schlesinger, *U.S. Secretary of Defense*

Martin J. Schreiber, *Governor of Wisconsin*

Charles Scribner, Jr., *Chairman, Charles Scribner's Sons*

Frederick Seitz, *President, Rockefeller University*

Thaddeus Seymour, *President, Rollins College*

Paul Sharp, *President, University of Oklahoma*

Astronaut Alan B. Shepard, Jr., *official NASA portrait*

George P. Shultz, *U.S. Secretary of the Treasury*

William E. Simon, *U.S. Secretary of the Treasury*

Philip Smith, *President, Copperweld Steel Corp.*

Mr. and Mrs. Franklin C. Snyder, *Pittsburgh*

Jerome Straka, *Chairman, Cheseboro-Ponds Corp.*

Robert E.L. Strider, *President, Colby College*

Dwight Stuart, *Chairman, Carnation Co.*

Frank Sullivan, *Chairman, Mutual Benefit Life*

Daniel J. Terra, *Chairman, Lawter Chemical Corp.*

James Thomson, *Chairman, Merrill-Lynch*

John S. Toll, *President, University of Maryland*

Robert Tucker, *Chairman, Beneficial Finance Co.*

Willie Usery, *U.S. Secretary of Labor*

Dr. Kurt Waldheim, *Secretary General, United Nations*

John Wayne, *Collection of National Cowboy Hall of Fame*

Caspar W. Weinberger, *U.S. Secretary of Health, Education and Welfare*

John T. Wilson, *President, University of Chicago*

W. Willard Wirtz, *U.S. Secretary of Labor*

Richard D. Wood, *Chairman, Eli Lilly Corp.*

George Woods, *President, World Bank*

Index

Edited by Betty Vera
Designed by Jay Anning and Brian Mercer